IMAGES
of America

HUNTSVILLE

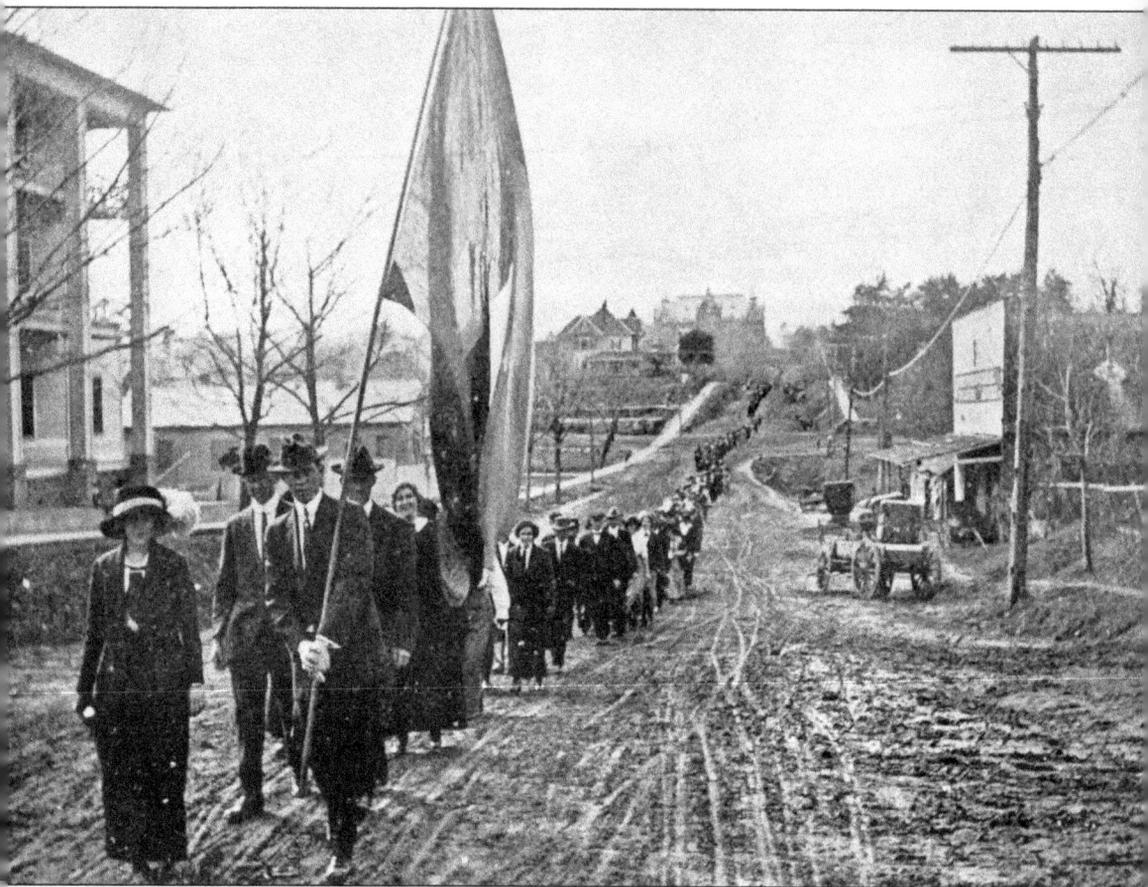

The annual march to Sam Houston's grave has long been a Huntsville tradition. This celebration is held on March 2, the general's birthday, which is also designated as Texas Independence Day and Texas Flag Day. (Courtesy Sam Houston State University Archives.)

ON THE COVER: Students at Sam Houston Normal Institute investigate new farming techniques in the shadow of Old Main, a Gothic Revival–style structure that dominated Huntsville's rural landscape for more than a century. (Courtesy Huntsville Arts Commission.)

IMAGES
of America

HUNTSVILLE

Jeff Littlejohn and the
Walker County Historical Commission

ARCADIA
PUBLISHING

Published by Arcadia Publishing
Charleston, South Carolina

Library of Congress Control Number: 2008941564

For all general information contact Arcadia Publishing at:
Telephone 843-853-2070
Fax 843-853-0044
E-mail sales@arcadiapublishing.com
For customer service and orders:
Toll-Free 1-888-313-2665

Visit us on the Internet at www.arcadiapublishing.com

This book is dedicated to the memory of two great men who shared similar names. The first, Gen. Sam Houston, stood against the forces of secession and paid the price. The second, Samuel Walker Houston, inherited the promise of freedom and made it real. Both men play a prominent role in the story presented here.

CONTENTS

ACKNOWLEDGMENTS

The majority of the photographs presented in this book were collected by the Walker County Historical Commission and the Huntsville Arts Commission. Additional images were used courtesy of the following organizations: Sam Houston State University Archives, Sam Houston Memorial Museum, Texas Prison Museum, Samuel Walker Houston Museum and Cultural Center, and the Jackson Davis Collection at the University of Virginia.

Special thanks go to the following: James Patton, Walker County Historical Commission; Mac Woodward, Sam Houston Memorial Museum; Linda Pease, Huntsville Arts Commission; Cheryl Spencer, Paul Culp, and Barbara Kievit-Mason, Sam Houston State University; Bernadette Pruitt, Sam Houston State University; Naomi W. Ledé, Heritage House and Samuel Walker Houston Museum and Cultural Center; Jim Willett and Sandra E. Rogers, Texas Prison Museum; Bob Shadle and the Boettcher Mill Oral History Project; Linda Dodson, city librarian; Wendell Baker, local activist; Bonnie Thorn, First Baptist Church; and my fabulous students, Nathan Pope, Charity Hughes, and Jared Gamble.

INTRODUCTION

Tucked in among the lakes and piney woods of East Texas, Huntsville is one of the grand old cities in the Lone Star State. Founded in the 1830s by a bold adventurer named Pleasant Gray, the city emerged as a trading post and social center in the mid-19th century. Churches, schools, and businesses popped up in the 1840s, just as Sam Houston, the former president of Texas, moved to the area. With the arrival of Houston and his young wife, Margaret, Huntsville's promise was secured. During the next three decades, the state legislature located the Texas Penitentiary and the first normal college for teacher education in Huntsville. Today the city remains a vibrant, thriving community known for its small-town charm and historic attractions.

When Pleasant Gray arrived in Texas in 1834, the entire region was ruled by Mexico. In fact, Gray was drawn to the area by the Mexican government's generous new colonization policy, which promised hundreds of acres of land to anyone willing to settle in Texas. To capitalize on this policy, Gray submitted a request for land to the Mexican government on November 16, 1834. Eight months later, he rejoiced to find that Mexico had granted his request. On July 12, 1835, Gray and his wife, Hannah, received one league of land (4,428 acres). This tremendous grant set the stage for a new trading post and city center, which developed over the course of the following decade.

Although Gray initially traded with the local Bidai Indians, he soon expanded his operations and began selling land to Anglo migrants moving into the area. In quick order, Gray's settlement grew into a small town, and he named it Huntsville in honor of his former home in Alabama. In January 1845, the city of Huntsville was incorporated, and the following year, it was selected as the seat of Walker County.

As Huntsville grew, the city took on a life and character of its own. Pleasant Gray left with his son Michael in 1849 to seek his fortune in the California Gold Rush, but he died on the journey westward. At home in his absence, local business and religious leaders shaped Huntsville for decades to come. Some of the most important figures in local affairs included Thomas and Sandford Gibbs, Henderson Yoakum, Robert Goodloe Smither, Rev. Samuel McKinney, and John Slater Besser.

The most famous man in Huntsville was Sam Houston—the "Raven." A powerful military and political figure, Houston was a personal friend and confidant of Pres. Andrew Jackson. In 1836, he led the army that won Texan independence from Mexico at the Battle of San Jacinto. After independence, Houston was elected as the president of the Republic of Texas, a position he held on two separate occasions. Then, when Texas was annexed by the United States in 1845, Houston was elected as a senator and later governor of the state.

The Civil War brought dramatic changes to Huntsville and the surrounding county. To begin with, the city's hero, Sam Houston, was deposed as governor in 1861 when he refused to take an oath of allegiance to the Confederacy. He returned to Huntsville a disheartened man and died of pneumonia in July 1863. Despite this loss, however, local citizens pressed on through the conflict. In fact, many of Huntsville's prominent white families disagreed with Houston's

position on the war. They sent men—including James Gillaspie, Anthony Martin Branch, and Thomas Jewett Goree—to serve and fight for the Confederacy. When the war ended in 1865, and the South lost, feelings of anger and resentment ran deep. It would take decades to heal the old ties of camaraderie that had existed between the North and South before the war.

The African American community in Huntsville was elated by the outcome of the Civil War. The end of the conflict brought the 13th, 14th, and 15th Amendments to the U.S. Constitution, ending the old regime of slavery and promising a new era of freedom and equality. Local black leaders included Joshua Houston, Memphis Allen, Joseph Mettawer, and C. W. Luckie. These men taught and trained a whole generation of young people, who took the reins of Reconstruction and fashioned a new life for themselves and their families. Chief among these innovators was Samuel Walker Houston, an African American educator who founded a school in the nearby Galilee community and became one of the state's leading educational figures.

As the citizens of Huntsville struggled with Reconstruction, a disastrous yellow fever epidemic swept through the city in 1867. The outbreak killed some 10 percent of the local population and slowed development for years to come. Ultimately, it may be argued, Huntsville owes its recovery and growth to two of its largest institutions—the Texas Penitentiary and Sam Houston State University.

The Texas State Penitentiary, also known as the Walls Unit, was founded in 1848. It is the oldest prison in Texas and has long served as home for some of the state's toughest criminals. Infamous offenders including John Wesley Hardin, Clyde Barrow, and Fred Carrasco spent time in the Walls, and their stories remain a powerful part of local lore. For much of the 20th century, the Walls Unit also hosted the Texas Prison Rodeo, a popular—if dangerous—attraction supported by inmates and the public. Today the rodeo no longer operates, but the Texas Prison System employs more than 40,000 people, many of whom live and work in Huntsville and its regional facilities.

A stone's throw from the Texas Penitentiary, one may find another side of Huntsville at Sam Houston State University. Founded in 1879, the school was the first public institution for teacher education in Texas. In its 130 years of history, the university has grown into a vibrant, diversified community that places a premium on academic excellence and hard work. In recent years, its leaders have overseen a tremendous period of growth, positioning the university to become one of this century's great centers of learning.

One

FOUNDING FAMILIES

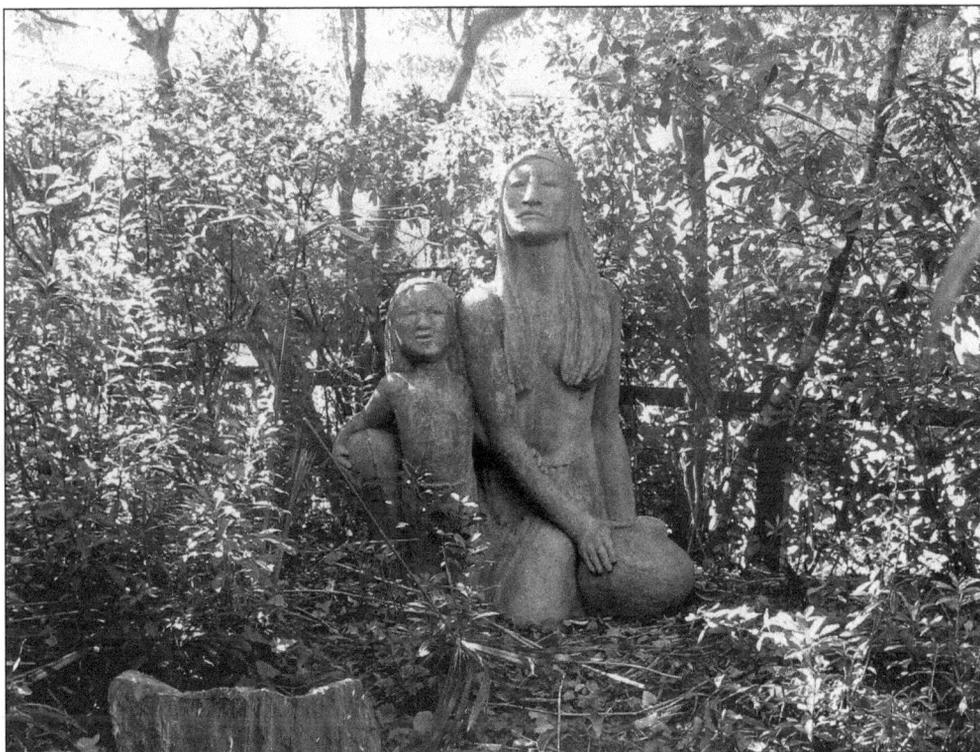

This sculpture by Monica Taylor and Lawrence Zink, entitled *The Source*, depicts the Bidai Indians, the first modern people to inhabit the Huntsville area. The Bidai lived in small villages and subsisted on a diet of fish, deer, and maize. During the year, they traded with other Native American groups and arriving settlers from the East. By the 19th century, the Bidai were engulfed by a wave of American migrants. (Courtesy the author's collection.)

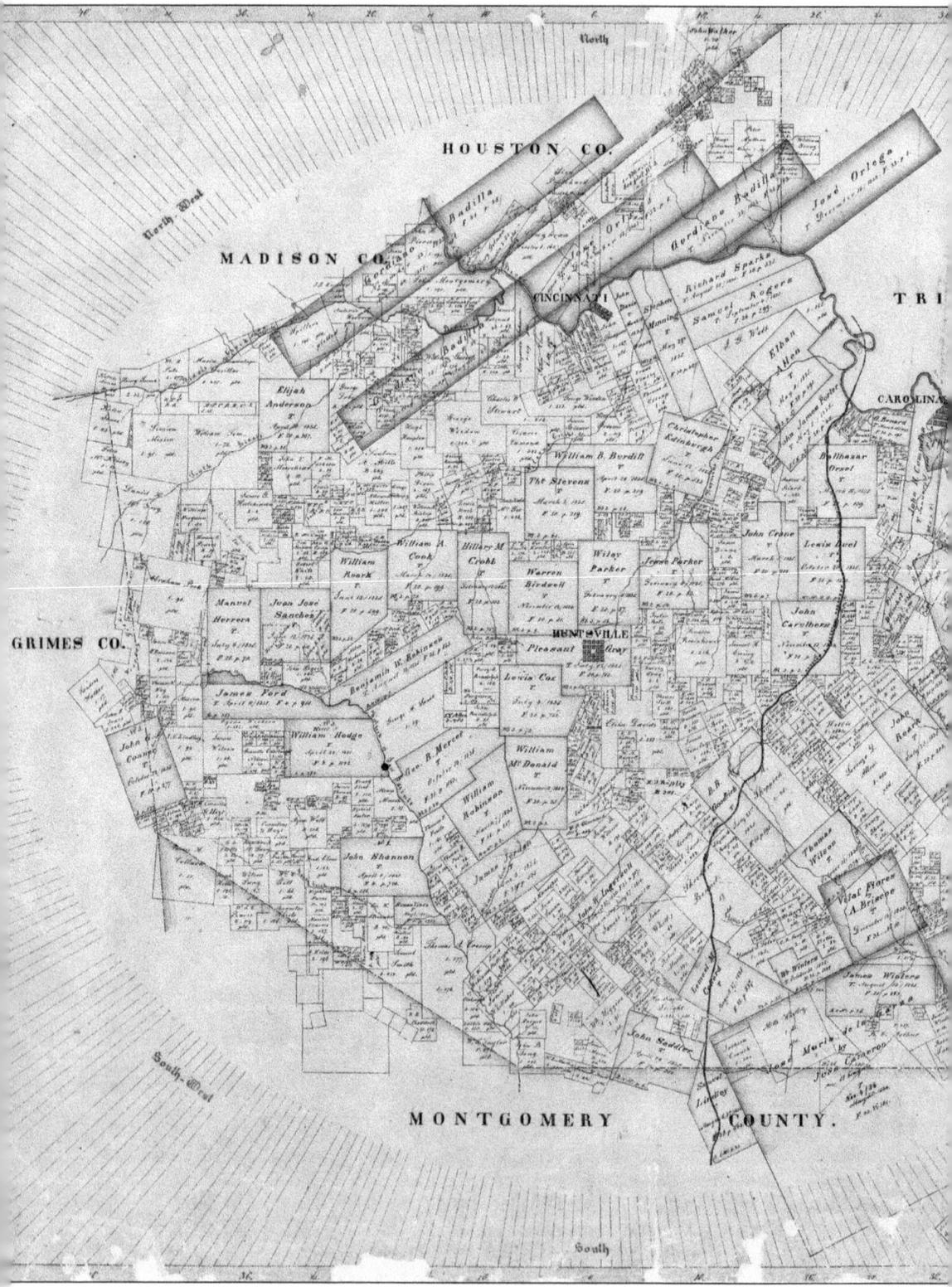

HOUSTON CO.

MADISON CO.

GRIMES CO.

TRI

CAROLINA

CINCINNATI

HUNTSVILLE

MONTGOMERY COUNTY.

North

North West

South West

South

Elijah Anderson

William Roark

William A. Cook

Hillary M. Crabb

Manuel Herrera

Juan José Sanchez

Benjamin W. Robinson

James Ford

William Hodge

John Shannon

George R. Merier

William Robinson

William McDonald

Warren Birdwell

Lewis Cox

Wiley Parker

Jesse Parker

John Crane

Lewis Duel

John Carothers

Christopher Edinburgh

William B. Burditt

Thos. Stevens

Richard Sparks

Samuel Rogers

Elijah Allen

Balthazar Orcul

John Roark

Vital Flores A. Briscoe

James Winters

John Sadilier

Maria de la

John Cameron

Thomas Wilson

MAP OF

WALKER COUNTY

created

*by an Act of the 1st Legislature, approved April 6th 1846,
which Act has been amended by the subsequent Acts of the
11th Legislature approved March 6th 1848, of the N.2 Legislature
at the Extra Session approved January 17th 1853, and of the VIIth
Legislature approved January 20th 1858;*

originally

MONTGOMERY LAND DISTRICT.

*Compiled from the documents on file in the General Land Office
by W. Von Rosenberg, Assistant Draftsman,*

August 1858.

POLK CO.

Key

Austin's Colony Titles.

Vehlein's Colony Titles.

Titles by C. S. Taylor.

Large Grants.

LIBERTY CO.

Walker—1858

This map shows the original land grants that were bestowed on settlers in the Walker County area. Of particular significance is the grant given to Pleasant Gray, the founder of Huntsville. He and his wife, Hannah, received one league of land (4,428 acres) from the State of Coahuila and Texas on July 12, 1835. Gray quickly established a trading post on his new land and named his settlement "Huntsville" after his former home in Alabama. When the Republic of Texas won its independence from Mexico in 1836, Huntsville sat within the boundaries of Montgomery County. Ten years later, however, after Texas had been annexed by the United States, Huntsville was selected as the seat of the newly formed Walker County. (Courtesy Texas General Land Office, Austin.)

11

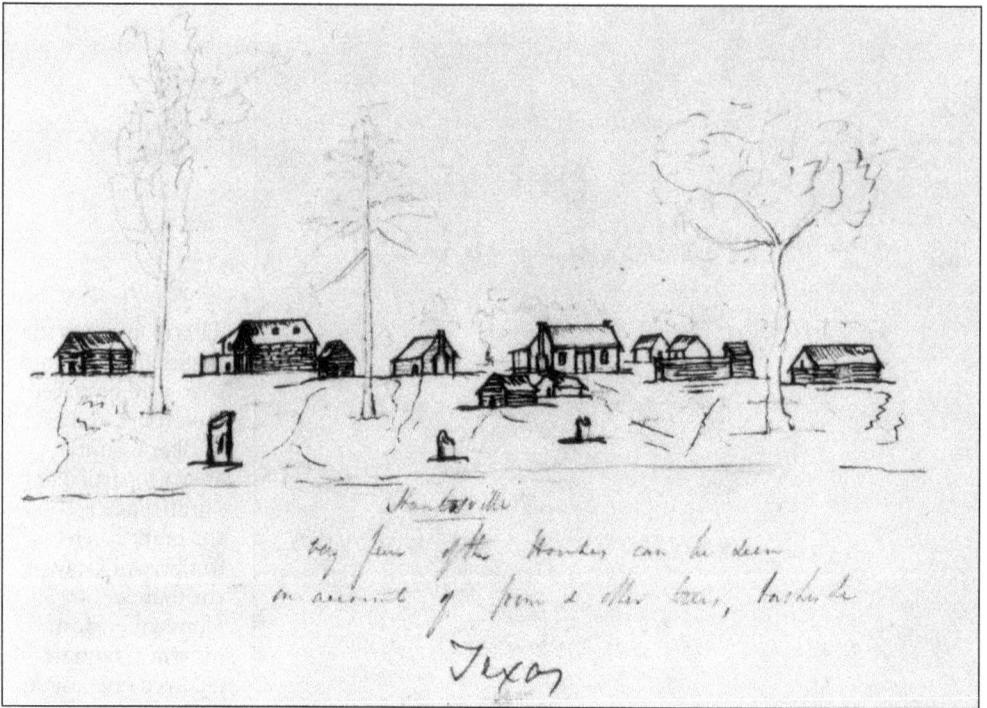

In the two years between 1842 and 1844, British scientist and ethnographer William Bollaert traveled through Texas to prepare a report for the British Admiralty. This early sketch of Huntsville (1843) comes from his famous work of the period, entitled *William Bollaert's Texas*. (Courtesy Huntsville Arts Commission.)

In November 1846, Pleasant and Hannah Gray affixed their signatures to a deed granting the people of Walker County ownership of the Huntsville public square for 1¢. The square would serve as the location for the county's first courthouse. Two years after signing this deed, Pleasant Gray took part in the California Gold Rush, and he died en route to the West Coast in 1849. (Courtesy Walker County Clerk's Office.)

Michael Gray (right) was the oldest son of Pleasant and Hannah Gray. He was born in 1829 and died in California. John A. W. Gray (left) was born a year after his older brother. He died in Terrell, Texas, in 1874. (Courtesy Walker County Historical Commission.)

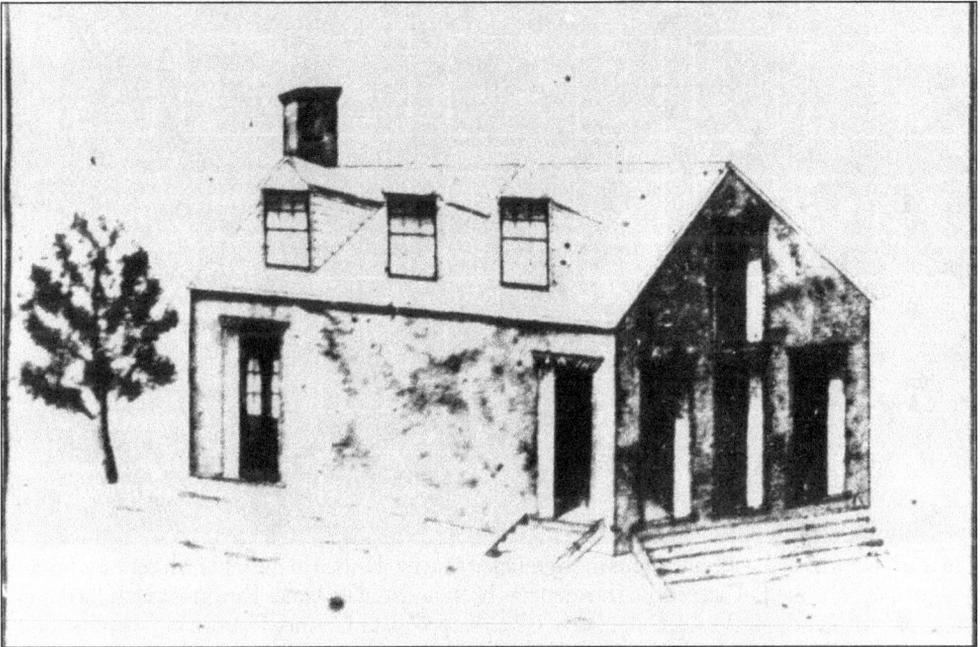

A friend and associate of Nicholas Adolphus Sterne (a merchant who helped finance the Texas Revolution), Alexander McDonald built one of the first brick buildings in Huntsville in 1843. This structure served as a store and early meeting place for the Masons of Forrest Lodge, one of the first Masonic groups in Texas. It sat on the corner of Spring and Main Streets, now Twelfth Street and University Avenue. (Courtesy Huntsville Arts Commission.)

ANDREW
FEMALE
COLLEGE

OAKWOOD
CEMETERY

MILAM STREET

FANNIN STREET

11
8
14

7

2

5 6

10

CEDAR STREET

PUBLIC
SQUARE

1
3

STREET

SPRING STREET

9

4

Brick
Academy
Lot

12

FARRIS

BELL

JACKSON

MAIN

BURTON

TRAVIS

HOUSTON

ACADEMY

STREET

STREET

STREET

STREET

STREET

STREET

STREET

STREET

LAMAR STREET

State
Prison

TYLER STREET

13

1. Gray's Trading Post
2. Gray's Campsite
3. Gray's Home
4. A. Mcdonald's Store
5. Gibb's Store/Bank
6. Masonic Lodge
7. Globe Hotel
8. Eutaw Hotel
9. Keenan House
10. Cumberland
 Presbyterian Church
11. Methodist Church
12. Baptist Church
13. First Jail
14. Home of Harvey Randolph
 (first Courthouse)

CANNON STREET

WASHINGTON STREET

AUSTIN
COLLEGE

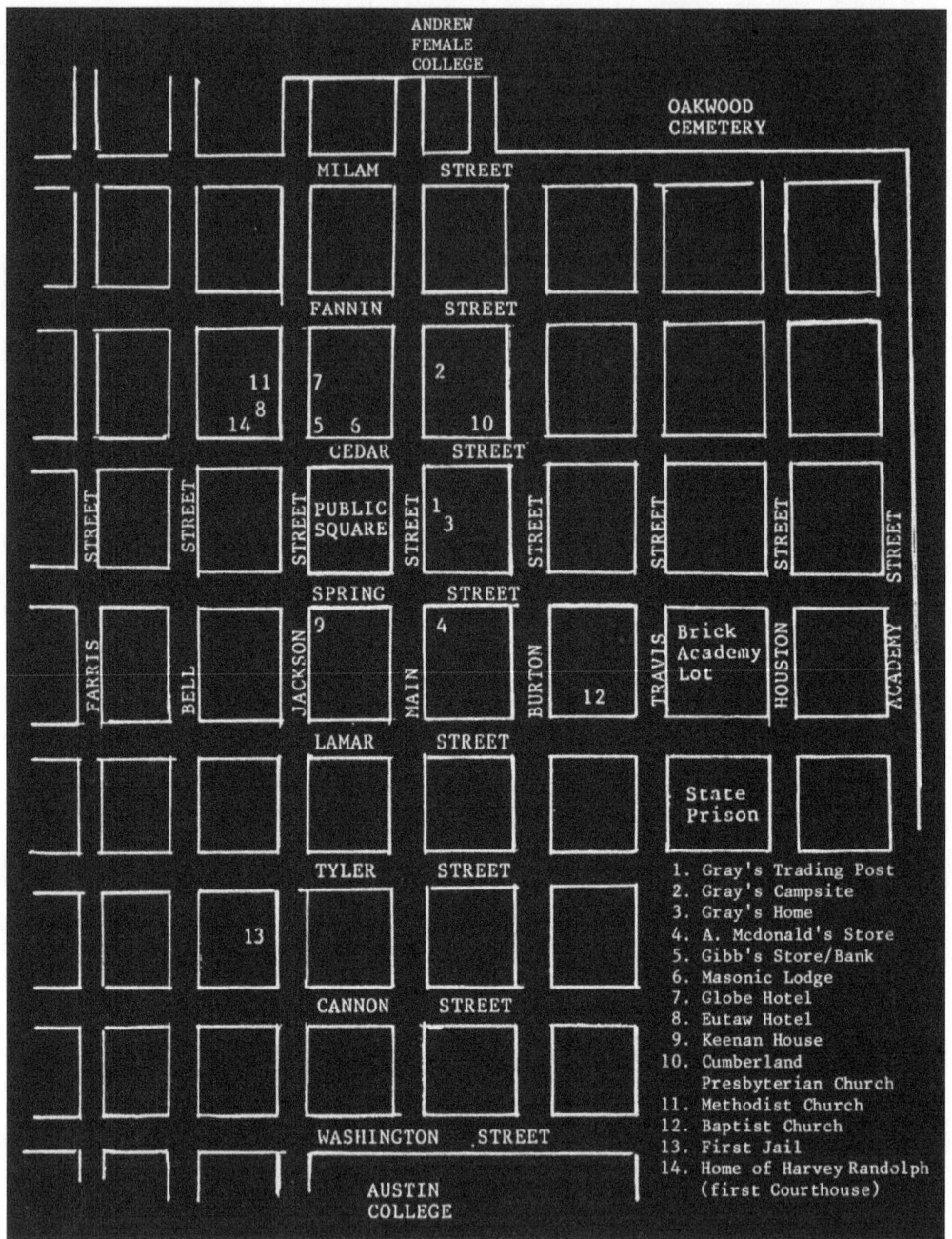

This early map of Huntsville highlights the significant sites established in the mid-19th century. Initially designed by Johnnie Jo Dickenson, the map has been updated by James Patton and Jeff Littlejohn to accord with early settlers' recollections. (Courtesy Walker County Historical Commission.)

A native of South Carolina, Thomas Gibbs (1812–1872) arrived in Huntsville in 1841 and soon established a mercantile business with partner Gardner Coffin. When Coffin died in 1844, Gibbs asked his brother Sandford to join him in business. On January 26, 1847, the two men formed a new partnership, T. and S. Gibbs, which remains the oldest continually operating business in Texas on its original site and under its original ownership. (Courtesy Walker County Historical Commission.)

Sandford St. John Gibbs (1819–1886) arrived in Huntsville in 1846 and joined his brother Thomas in business the following year. The two men operated a prosperous mercantile store, purchased land and other investments, and oversaw a private banking house. After Sandford's first wife, Mary Wilmuth Gary, died in 1863, he lived three years as a widower. Then, in 1866, he married Sarah Elizabeth Smith (1844–1918), and the couple had six children. Pictured below are Sandford and his second wife, Sarah. (Courtesy Walker County Historical Commission.)

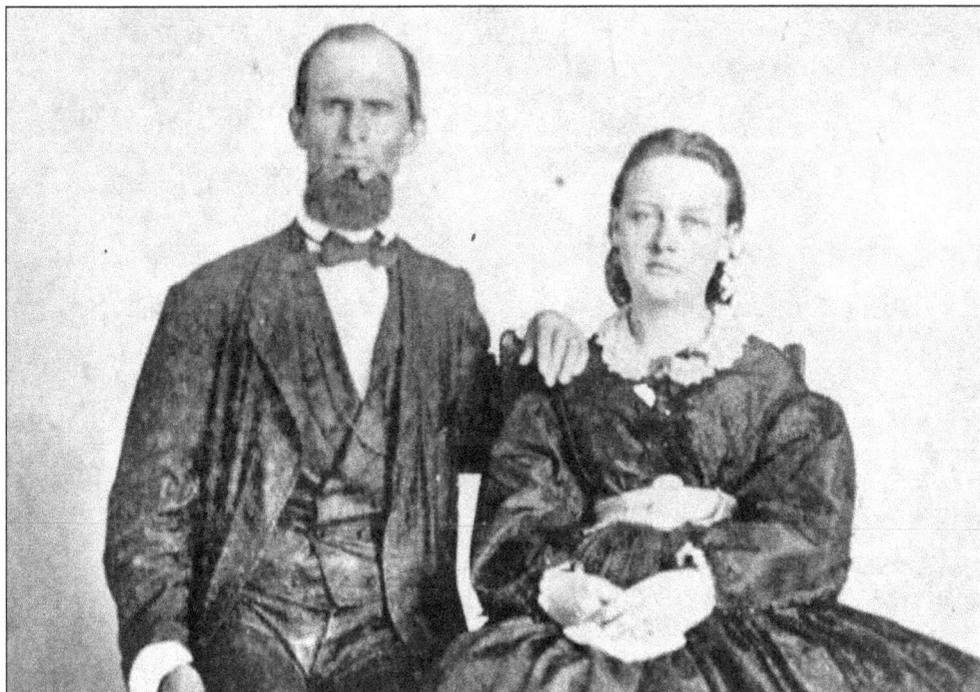

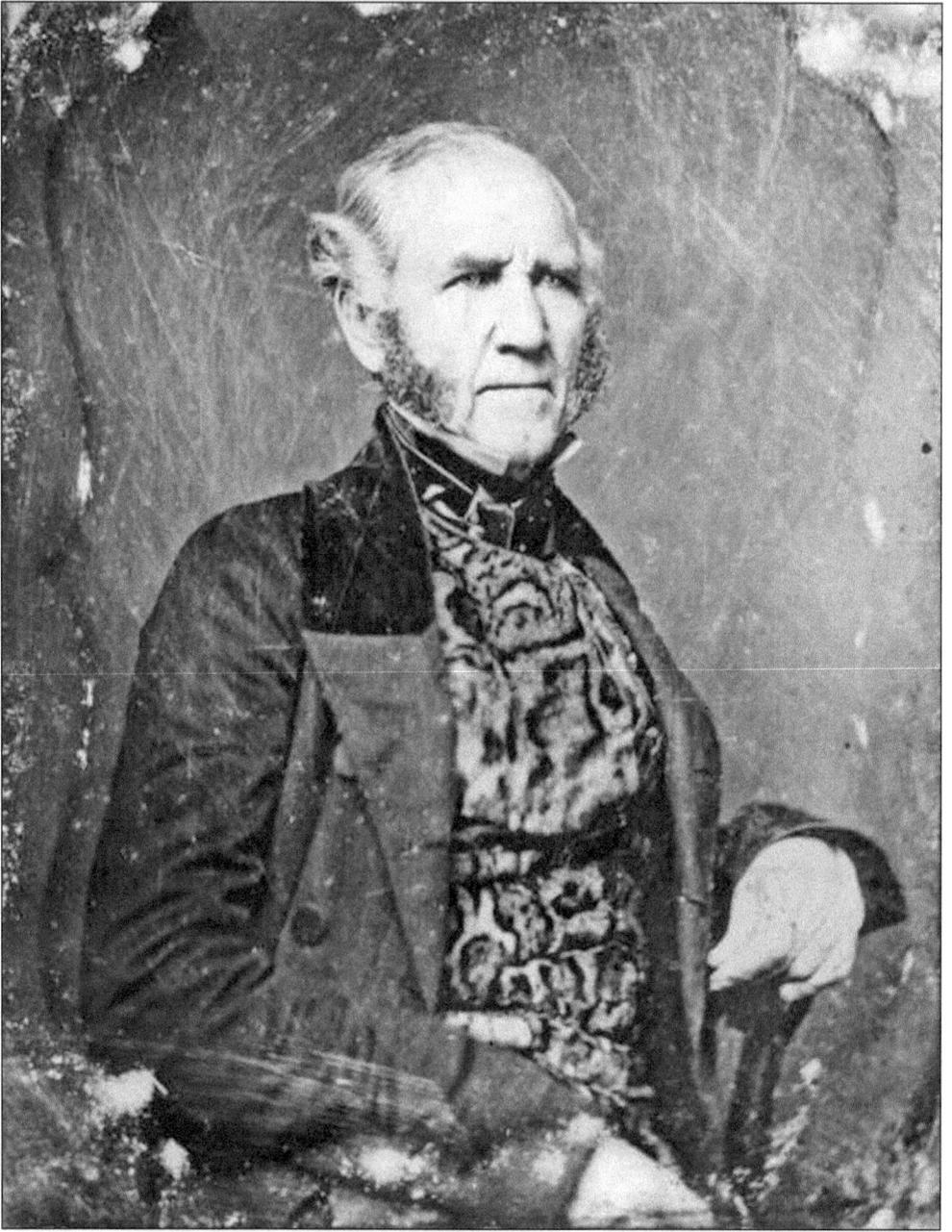

Born in Virginia, Sam Houston (1793–1863) was a contemporary and friend of Andrew Jackson. He is the only man in American history to serve as the governor of two states (Tennessee and Texas). Houston is most famous for his role as the commander of the Texas army that defeated Mexican general Santa Anna, securing independence for Texas in 1836. After independence, Houston was elected as the president of the Republic of Texas, a position he held on two separate occasions. When Texas was annexed by the United States in 1845, Houston was elected a senator and later governor of the state. (Courtesy Sam Houston Memorial Museum.)

Margaret Moffette Lea (1819–1867) married Sam Houston on May 9, 1840, in her hometown, Marion, Alabama. After their wedding, the couple returned to Texas, where they had eight children together. Margaret was a well-educated, cultured woman who played the harp and wrote poetry in her spare time. She was a devout Baptist and convinced her husband to join the Baptist church at the height of his political career. (Courtesy Sam Houston Memorial Museum.)

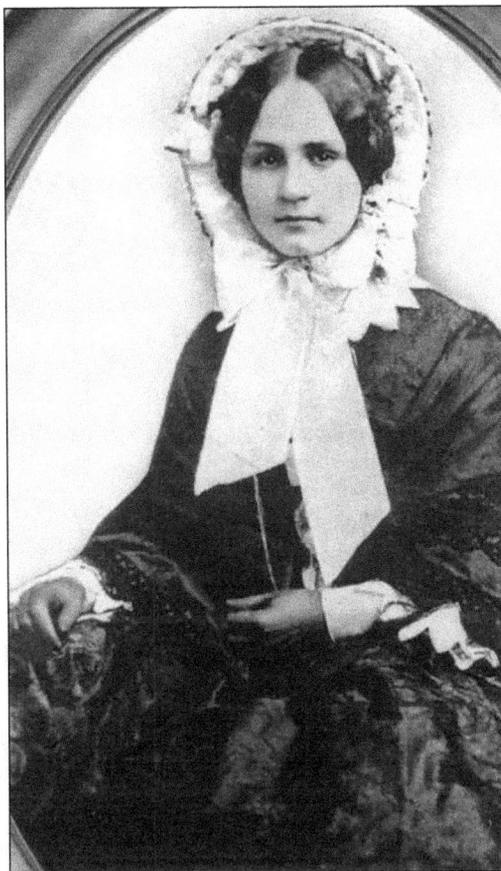

The Houstons lived in numerous homes throughout Texas during Sam's political career. In fact, the family had three homes in Walker County. The first, Raven Hill Plantation, was purchased in 1844. It sat 14 miles northeast of Huntsville near Oakhurst. The second—Woodland Home (pictured below)—was built in Huntsville during the mid-1840s, and the Houstons lived there between 1846 and 1858. Sam was forced to sell this property to pay several political debts. When he returned to Huntsville near the end of his life, Houston spent his last days in the Steamboat House. (Courtesy Sam Houston Memorial Museum.)

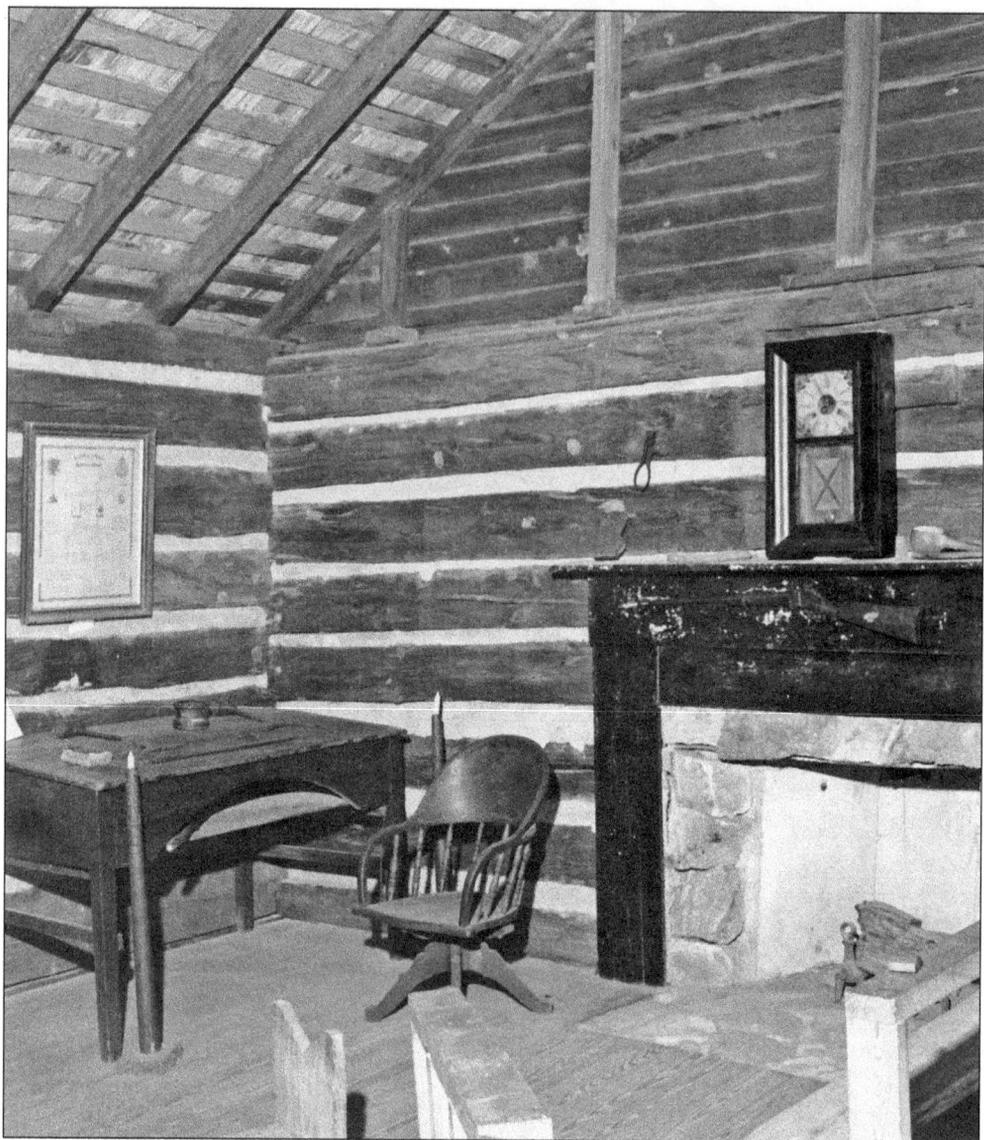

This photograph shows the interior of Sam Houston's law office in Huntsville as it has been reconstructed by the Sam Houston Memorial Museum. (Courtesy Sam Houston Memorial Museum.)

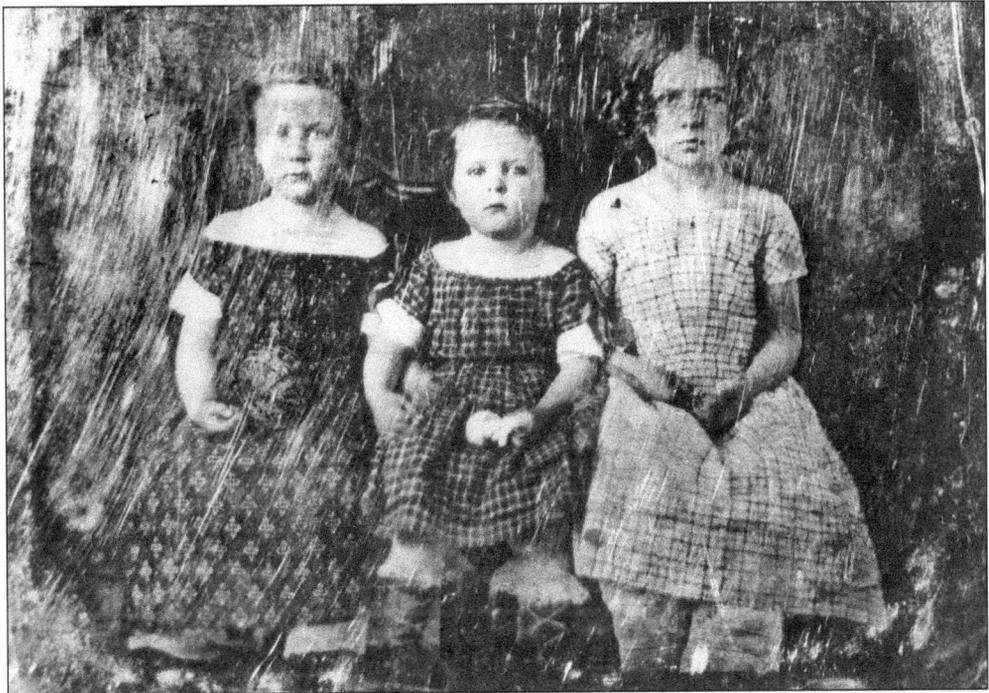

Pictured here is an 1852 daguerreotype featuring three of the Houstons' children: (from left to right) Margaret (4), Mary (2), and Nancy (6). In all, the Houstons had eight children: Sam Jr., Nancy Elizabeth, Margaret Lea, Mary William, Antoinette Power, Andrew Jackson, William Rogers, and Temple Lea. (Courtesy Sam Houston Memorial Museum.)

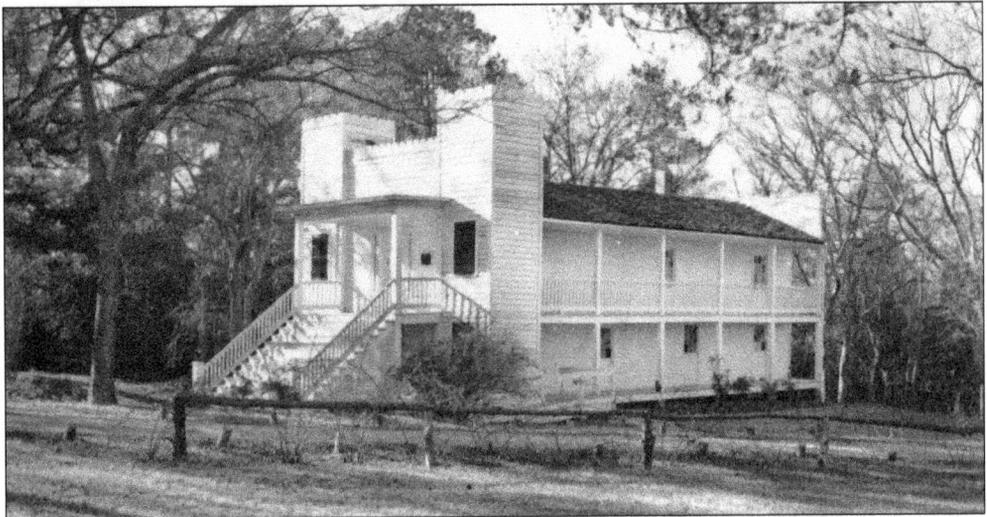

Dr. Rufus Bailey, an Austin College professor, built the Steamboat House in 1858 as a wedding present for his son. The young groom and his bride refused to live in the home, however, and in 1862, Sam Houston took up residence there after being deposed as governor. Houston died in the home on July 26, 1863. The Steamboat House then changed ownership numerous times before J. E. Josey, publisher of the *Houston Post*, bought the structure and moved it to the grounds of the Sam Houston Memorial Museum, where it was renovated in 1936–1937. (Courtesy Sam Houston Memorial Museum.)

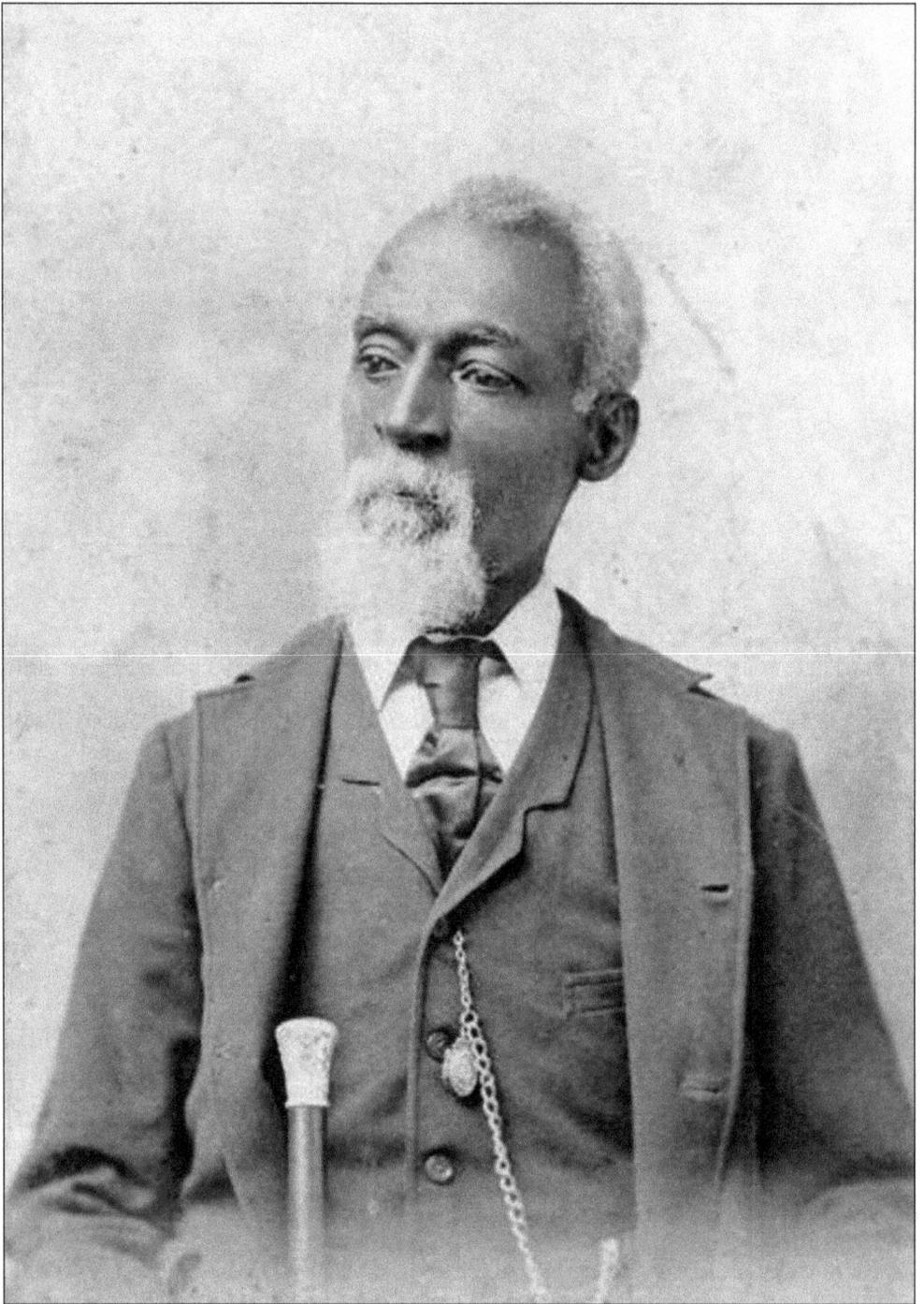

Joshua Houston Sr. was born a slave in Alabama in 1822, and he later traveled to Texas with Sam Houston and his wife, Margaret. Joshua served the Houston family as a blacksmith, wheelwright, carpenter, and driver. He learned to read and write, and hired out to earn his own money. After Sam Houston freed him in 1862, Joshua became a leading figure in Huntsville's African American community. (Courtesy Sam Houston Memorial Museum.)

Pictured here is Tom Blue,
Gen. Sam Houston's slave and bodyguard
during the Texas-Mexican War. (Courtesy
Sam Houston Memorial Museum.)

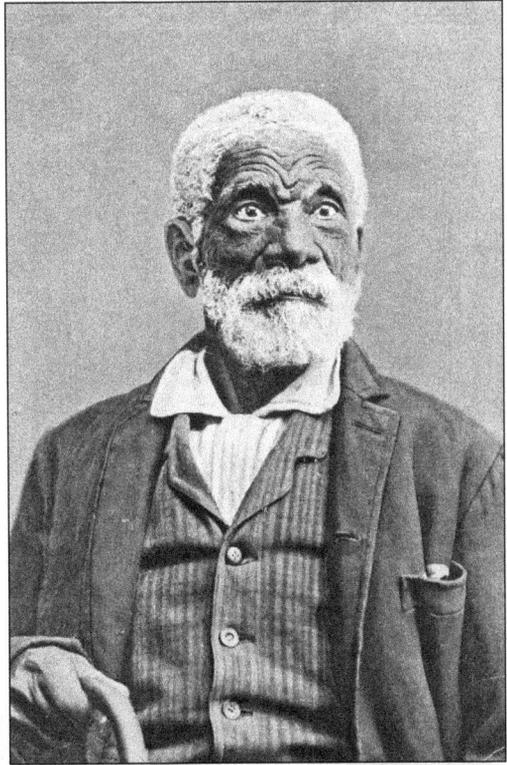

Margaret Houston moved to Independence,
Texas, when Sam Houston died in
1863. Pictured below are the Houston
children with "Aunt" Eliza, a former
family slave. This photograph was
taken sometime in the 1870s or
1880s in Independence. (Courtesy
Sam Houston Memorial Museum.)

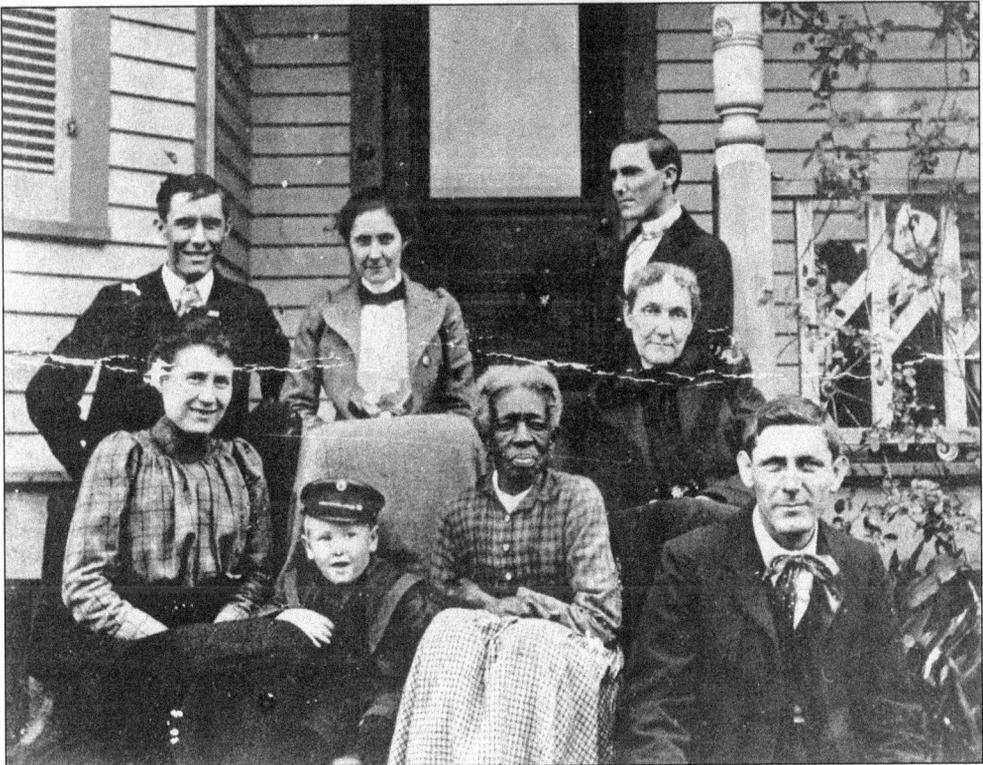

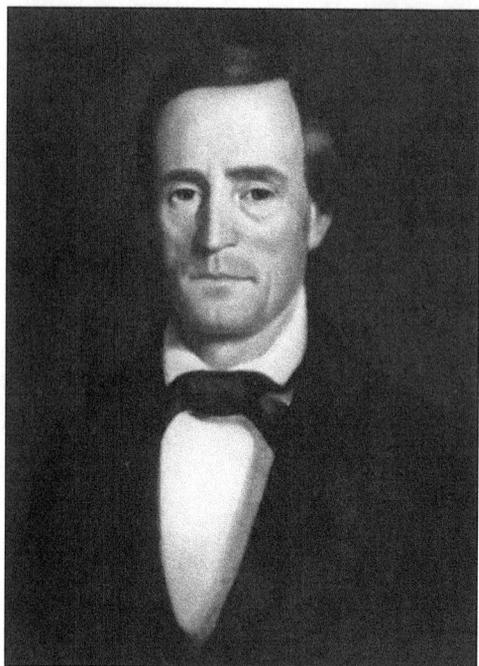

Born in Tennessee, Henderson Yoakum (1810–1856) moved to Texas at the age of 35, building a home east of Huntsville. A close friend of Sam Houston, Yoakum served in the Mexican War and then returned to Huntsville to become a key figure in the city's social and cultural life. Yoakum was instrumental in the effort to have Huntsville named the seat of Walker County in 1846. He was also involved in the construction of the Walker County Courthouse and Austin College, where he taught and served as librarian and trustee. Yoakum is best known for his pioneering *History of Texas*, published in 1855. (Courtesy Sam Houston Memorial Museum.)

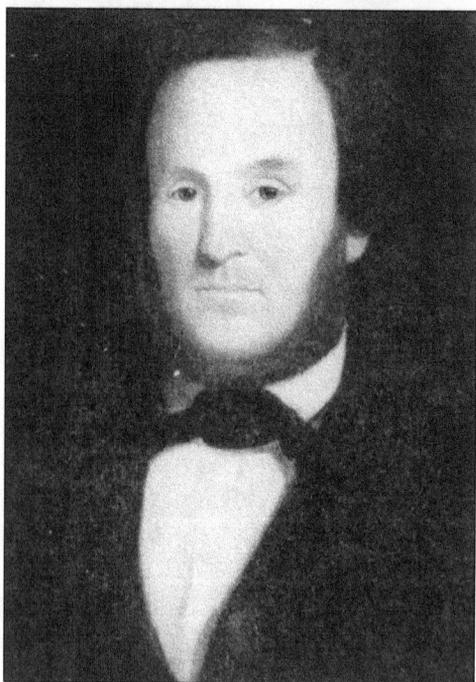

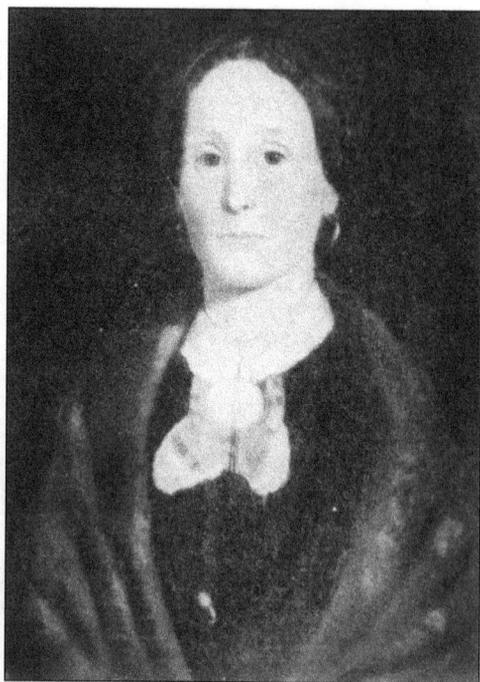

Robert Goodloe Smither (1811–1853) and his wife, Elizabeth, moved to the Huntsville area in 1839. Smither was a merchant and local booster who helped Huntsville secure the Walker County seat in 1846. Later he raised funds for the Texas Penitentiary, Austin College, and the *Huntsville Item*. In 1850, Smither's store opened on Sam Houston Avenue. Three years later, Smither died of yellow fever on a return trip from New York through Louisiana. (Courtesy Walker County Historical Commission.)

James Gillaspie (1805–1867) arrived in Texas in 1835. The following year, he commanded the 6th Company, 2nd Regiment of Texas Volunteers at the Battle of San Jacinto. After the Texas Revolution, he married Susan Faris of Walker County, and they had seven children together. Gillaspie went on to serve as an army officer in the Mexican War and the Civil War. In Huntsville, he acted as superintendent of the Texas State Penitentiary from 1850 to 1858. Gillaspie and his wife died of yellow fever in 1867. (Courtesy Walker County Historical Commission.)

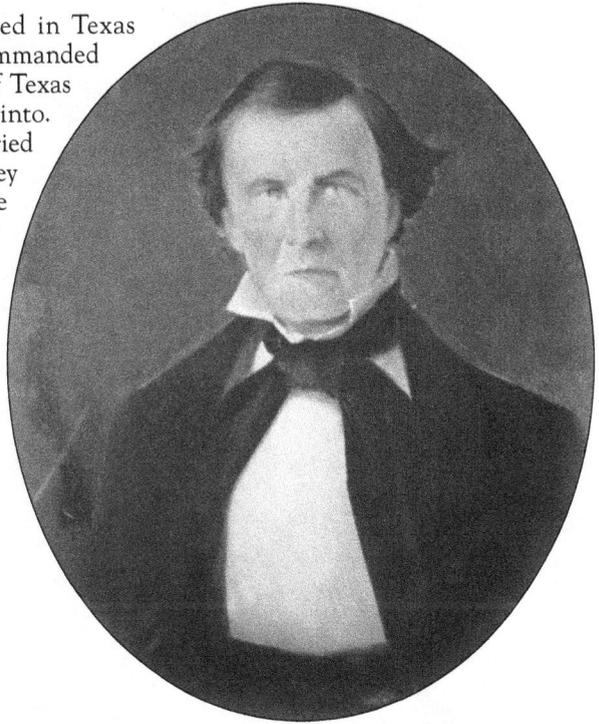

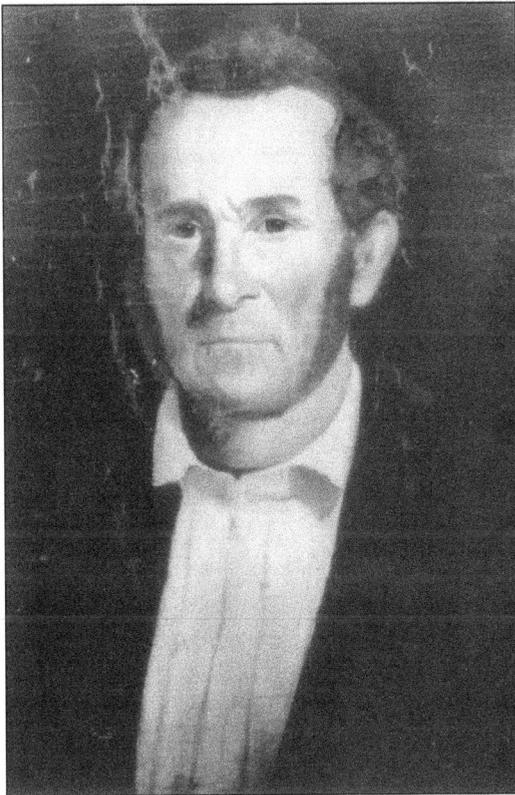

Born in Ohio, Isaac McGary (1800–1866) moved to Texas with Stephen F. Austin and fought at the Battle of San Jacinto. He served as sheriff of Montgomery County in 1843 and was elected as the first Walker County clerk in 1846. While he held this position, he also served with Capt. James Gillaspie in the Mexican War. McGary died on a trip through Galveston in 1866. (Courtesy Walker County Historical Commission.)

Pictured here is a collection of advertisements from the *Huntsville Item* (stage lines from March 19, 1853, and hotels from February 26, 1853). The Keenan House was built in 1848 and burned down in 1859. The Eutaw House was constructed in 1850 and operated for some 50 years. (Courtesy Huntsville Public Library.)

Rev. Samuel McKinney (1807–1879) was born in Ireland and immigrated to the United States as a child. He grew up in Tennessee and attended the University of Pennsylvania before becoming an ordained Presbyterian minister. In 1836, he married Nancy Woodside Todd in Illinois, and the couple had several children together. In 1850, the McKinneys moved to Huntsville at the urging of Rev. Daniel Baker, a prominent Presbyterian missionary. Dr. McKinney was offered the position as president of Austin College, which he held from 1850 to 1853 and again from 1862 to 1871. (Courtesy Walker County Historical Commission.)

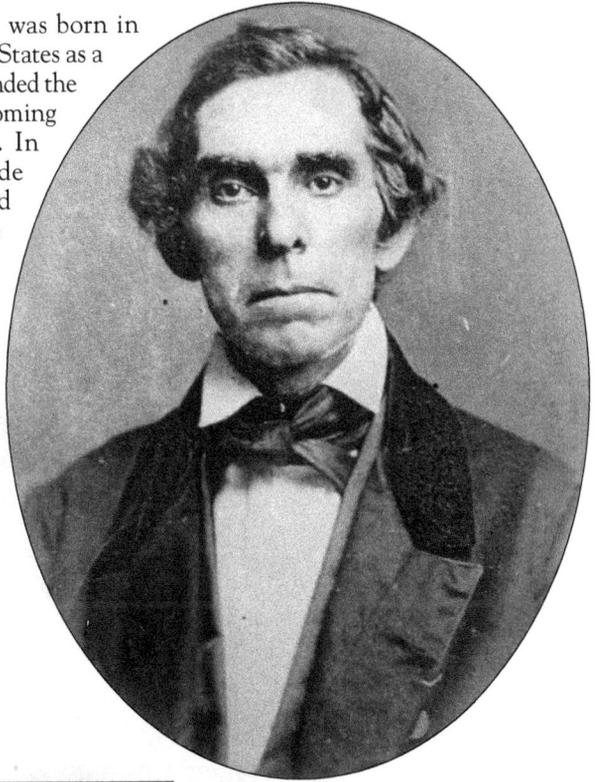

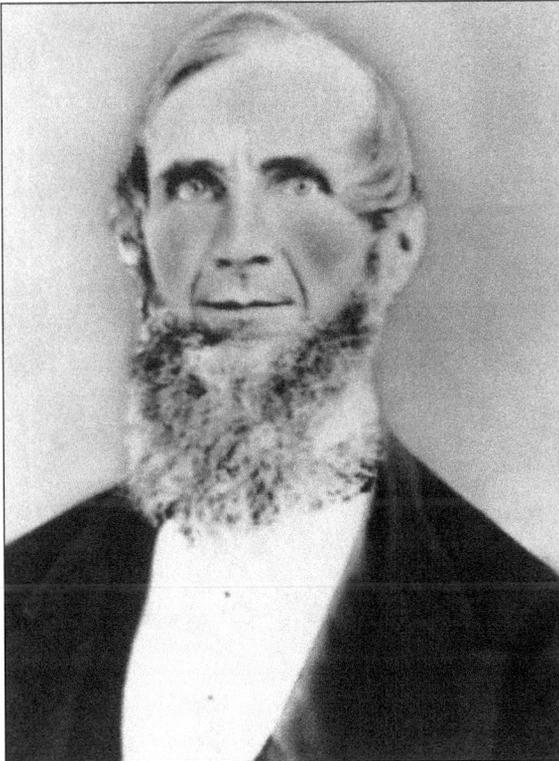

Born in Pennsylvania and raised in Missouri, John Slater Besser (1802–1893) moved his family to Texas in 1841. While living in Huntsville, he built the first jail in Walker County. Between 1852 and 1863, Besser acted as director and financial agent of the state penitentiary. Later he served as Walker County judge from 1878 to 1880. Married four times, Besser was the father of nine children born to his first wife, Julia Hampton. (Courtesy Walker County Historical Commission.)

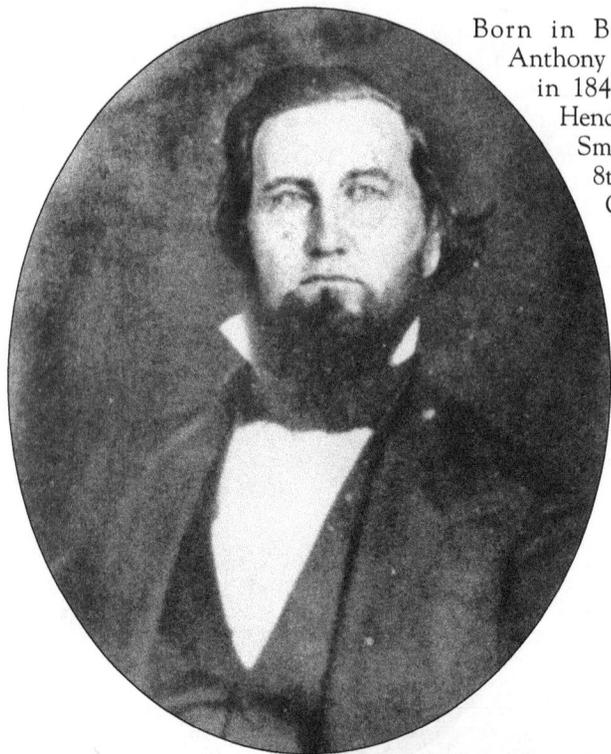

Born in Buckingham County, Virginia, Anthony Martin Branch came to Huntsville in 1847. He entered law practice with Henderson Yoakum and married Amanda Smith in 1849. Branch served in the 8th State Legislature (1859–1861), the Confederate army (1862), and the Congress of Confederacy (1863–1865). The U.S. Congress refused to seat him in 1866 because of his Confederate service. A friend of Sam Houston, he was named as coexecutor of Houston's will. Branch died in the yellow fever epidemic of 1867. (Courtesy Walker County Historical Commission.)

These notices from the November 18, 1864, edition of the *Huntsville Item* illustrate the painful story of slavery in the local community. Even as the Civil War drew to a close, there were advertisements to buy slaves and notices of runaways who had fled their masters. (Courtesy Huntsville Public Library.)

COMMITTED to me for safe keeping, by I. E Stanley, on the order of Judge Jas A. Baker, a negro woman named SOPHIA, says she belongs to on Cenet. of St. Mary's parish. La., that she run away from Wm. Deson of Houston co., Texas. Said woman is about 40 odd years old, black complexion. about 5 feet 2 inches high, and has a slight scar on the nose. The owner is requested to come forward, prove property, pay charges and take her away, or she will be dealt with as the law directs. P. ROYAL, Shff. Walker co. Huntsville, Tex., Nov. 4, 1864-6m

I WOULD like to buy or hire a negro boy, some 14 years old, or 40 to 50 years old, as it is a little too mnch for the Item to do well without a "black devil" If bought, it will have to be on time, as money is not an article of easy commerce with me at present. [o8tf] G. ROBINSON.

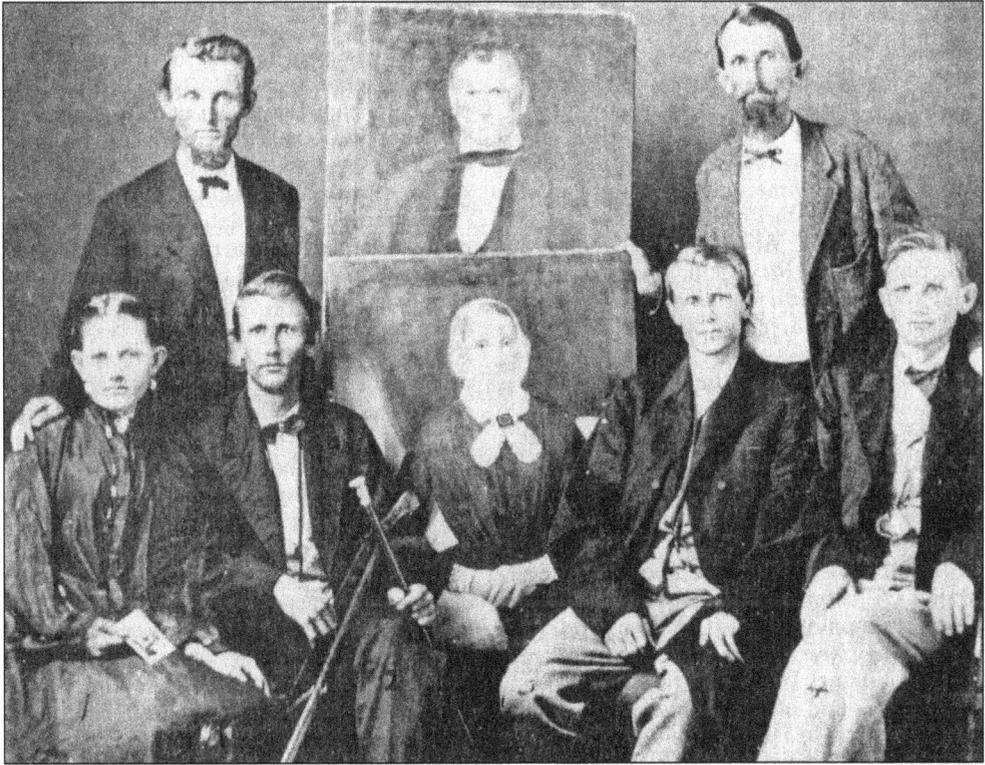

When Sam and Margaret Houston married in Marion, Alabama, in 1840, Sarah Williams Kittrell Goree (bottom center portrait) served as matron of honor at the wedding. Goree and her husband, Langston, moved to Huntsville at the suggestion of the Houstons in 1850. The Gorees brought their seven children with them, including, from left to right, Susan Margaret, Pleasant Kittrell, Edwin King, Langston James Jr., Robert Daniel, and Thomas Jewett. All five sons served for the Confederacy in the Civil War. (Courtesy Walker County Historical Commission.)

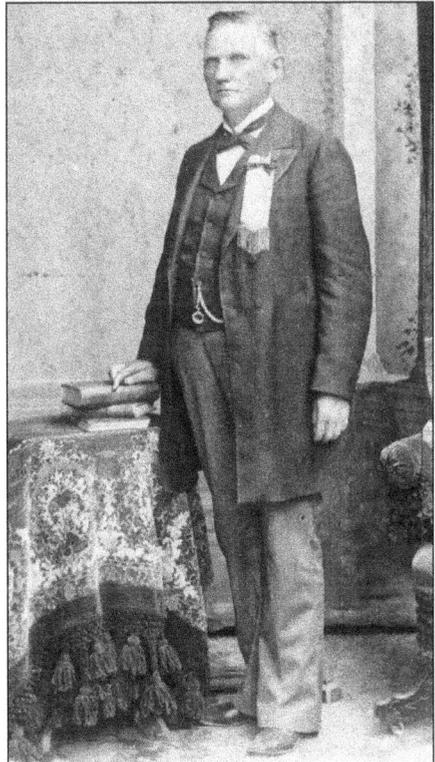

Born in Alabama, Thomas Jewett Goree moved to Huntsville at age 15 with his family. At 18, he attended Baylor College, taking a baccalaureate and law degree. With the start of the Civil War in 1861, he traveled to Virginia to volunteer for the Confederacy. En route he met James Longstreet, whom he served as aide de camp during the war. When Goree returned to Huntsville, he formed a law partnership and became superintendent of Texas Penitentiaries. Thomas Goree was the grandfather of John W. Thomason Jr., the famous Texas author. (Courtesy Texas Prison Museum.)

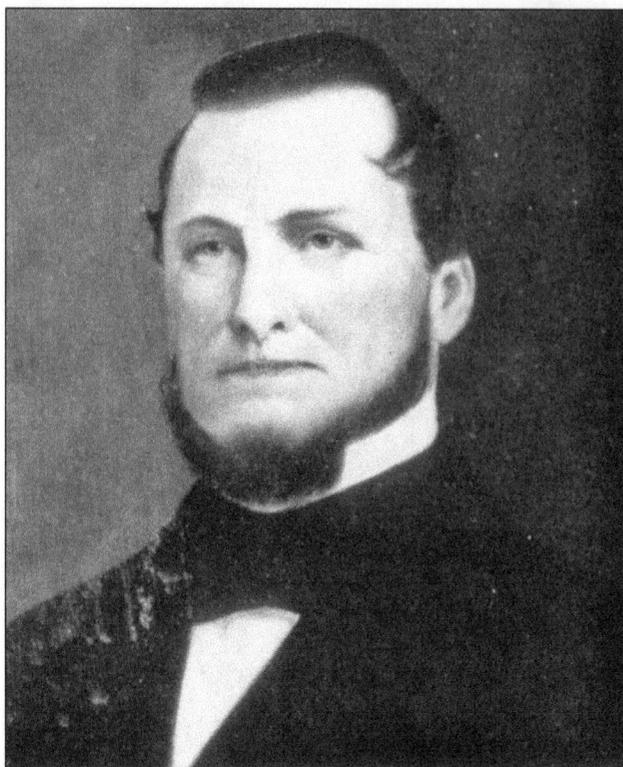

Dr. Pleasant Williams Kittrell (1805–1867) moved with his wife, Mary Frances Goree, and her family to Texas in 1850. A prominent physician and statesmen, Kittrell made numerous contributions to Texas history. He served as Sam Houston's personal doctor, sat on the Austin College Board of Trustees, and played a key role in the formation of the University of Texas. In Huntsville, Kittrell oversaw a large landholding and medical practice. He contracted yellow fever and died in 1867 as he was treating victims of the outbreak. (Courtesy Walker County Historical Commission.)

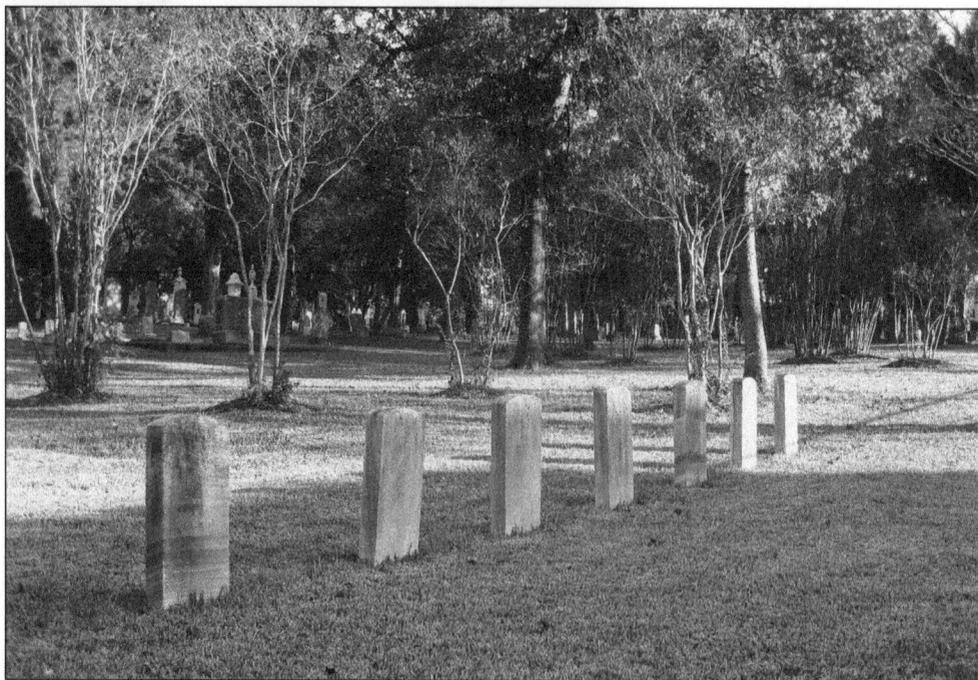

In 1867, a yellow fever epidemic wiped out roughly 10 percent of Huntsville's population. Included in the group were seven Union soldiers stationed in Huntsville after the Civil War. They are buried at Oakwood Cemetery along with dozens of other victims. (Courtesy the author's collection.)

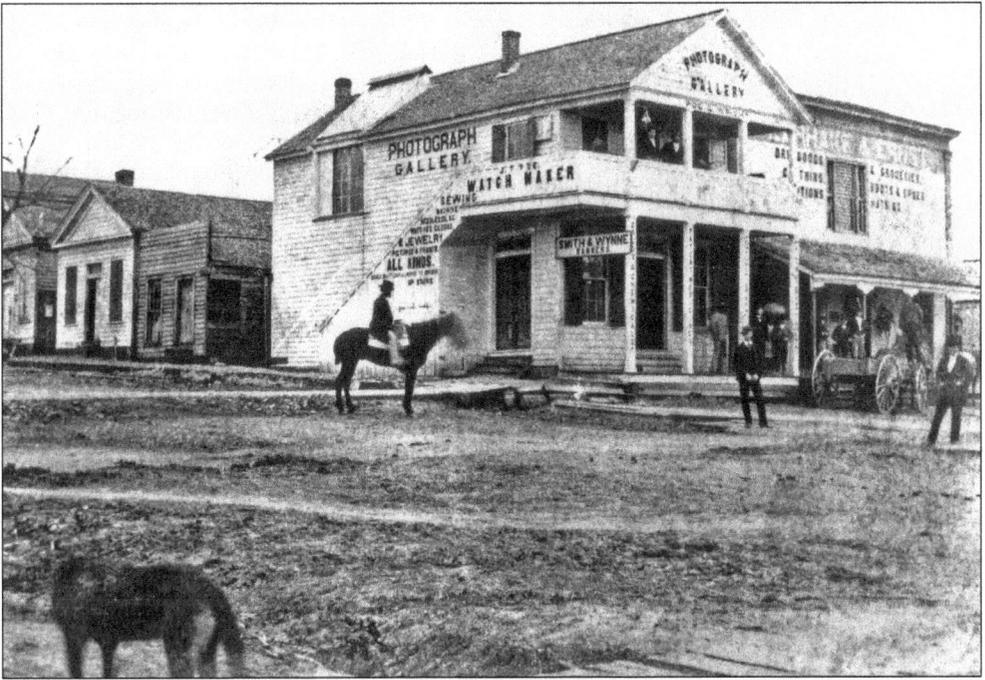

Despite the disastrous yellow fever outbreak of 1867, Huntsville survived and grew. Here is a photograph from the early 1870s showing the businesses that took root at Twelfth Street and University Avenue (the former location of Alexander McDonald's store). Poe and Wright's Photograph Gallery was located on the top floor of the building, with Smith and Wynne, a banking house, located downstairs. (Courtesy Dr. L. E. Bush and the Huntsville Arts Commission.)

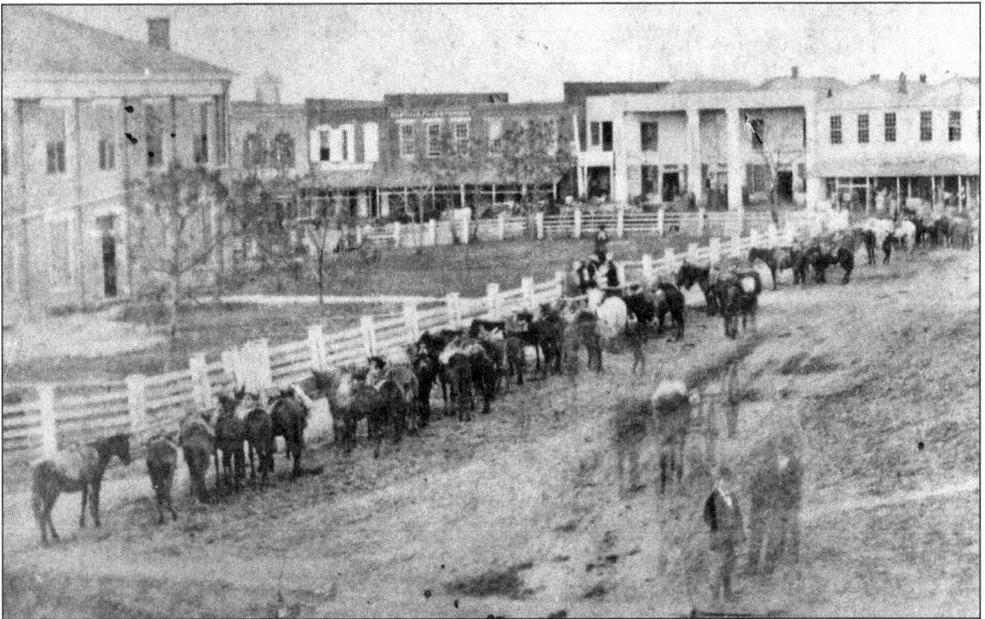

Pictured here is the third Walker County Courthouse on the north side of the square (1873–1875). This was the center of business life in Huntsville at the end of the 19th century. (Courtesy Walker County Historical Commission.)

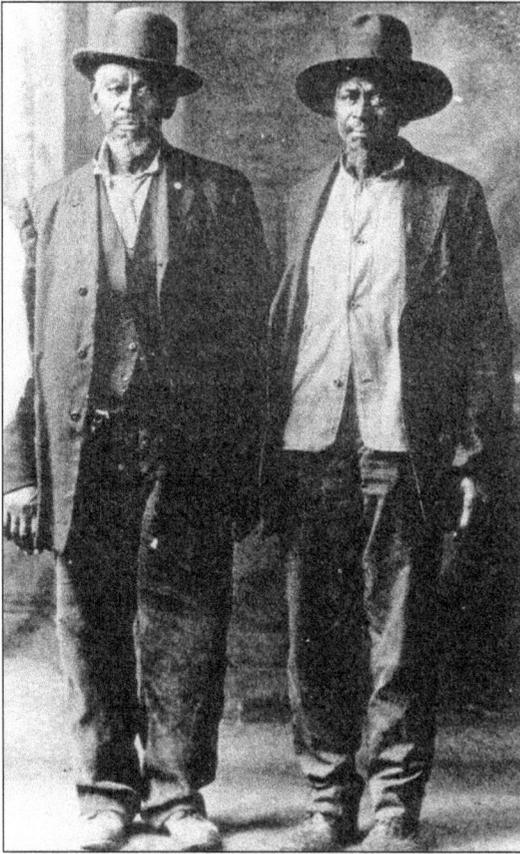

Pictured here are two brothers—Jim and John "Tip" Hightower. Jim Hightower escaped his slave master in Huntsville and went to Oklahoma during the Civil War. Tip stayed behind and won his freedom with the end of the war. This picture was taken around 1875 when Jim returned to Huntsville for a brief visit. (Courtesy Cecil Williams and James D. Patton.)

In 1870, the Houston and Great Northern Railroad bypassed Huntsville, building its line through nearby Phelps. Two years later, however, local businessmen, led by Sandford Gibbs, raised money to support an 8-mile "tap line." The first train from Phelps to Huntsville ran on March 26, 1872. Later known as "Tilley's Tap" for conductor J. Robert Tilley (1864–1929), the new line connected Huntsville to the commercial centers of Texas. The railroad depot—pictured below—sat at the intersection of 1412 Avenue J and the Walls Prison Unit. (Courtesy Walker County Historical Commission.)

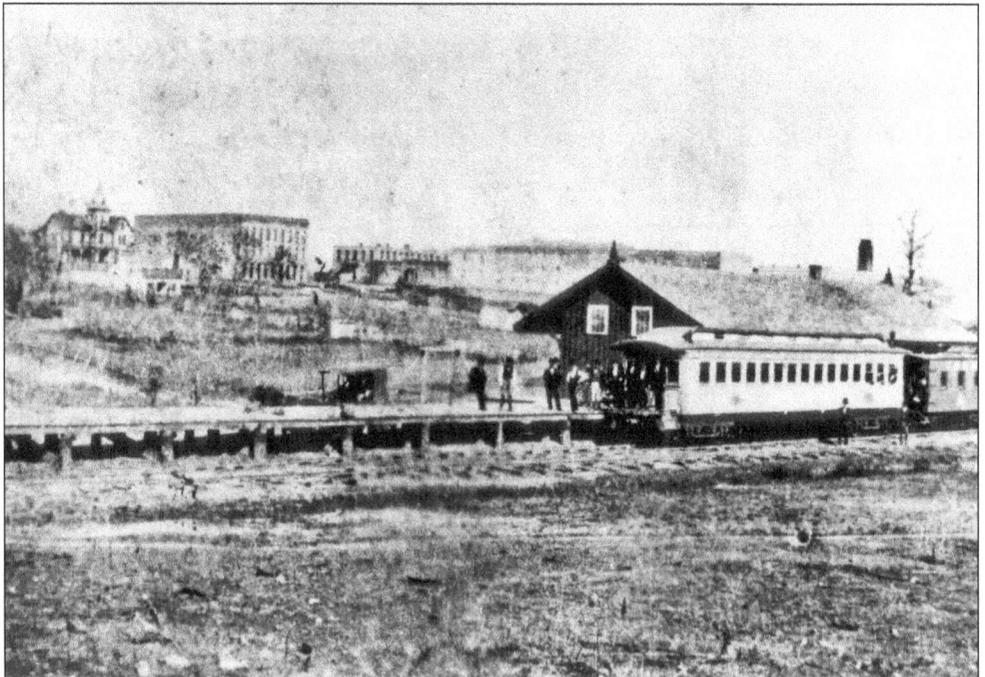

Two

EDUCATIONAL PURSUITS

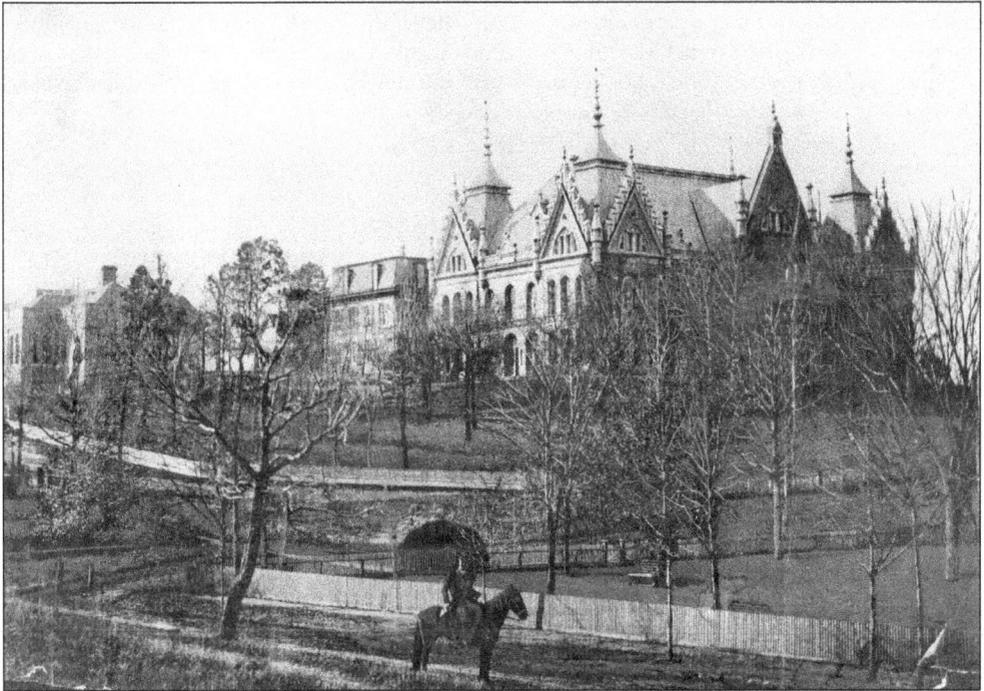

Joseph Lucien Pritchett (1858–1936) was a professor at Sam Houston Normal Institute for more than 40 years. He owned much of the land where Sam Houston Memorial Museum and Pritchett Field are now located. Pictured here is Pritchett with his horse Ginger in front of Old Main, on Sam Houston's campus, around 1908. (Courtesy Walker County Historical Commission.)

Private education began in Huntsville as early as 1845 when local citizens opened Huntsville Academy. The school was known by various names, including the Brick Academy, the Huntsville Male and Female Academy, and finally the Huntsville Female Academy. It was located on 5 acres donated by Pleasant Gray in an area now within the Walls Prison Unit. Prominent members of the faculty included Samuel McKinney, Melinda Rankin, and Rowena Crawford Baker (wife of James Addison Baker). The school closed when Andrew Female College opened in the early 1850s. (Courtesy Huntsville Arts Commission.)

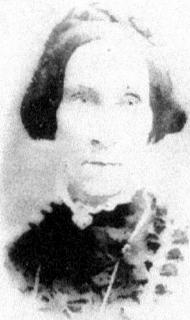

About 1840, Gen. David Rankin having lost his property, Melinda and her two sisters determined to go West and earn money by school teaching to rebuild his family fortunes. This they successfully accomplished, purchasing a farm, and making his last days full of rest and peace so befitting to old age. The other sisters were in due time favorably and happily married, while Melinda continued the work of teaching. When the Mexican war closed, she was in Mississippi. Such accounts of the benighted condition of Mexico came to her through returning officers and soldiers that she thought it her duty, single-handed and alone, to go to that country as a missionary. She was not a demonstrative woman, but a woman of great determination and force of character. In her early days of girlhood she used to say to the wife of her cousin, Rev. Andrew Rankin—my own honored and sainted mother—that she wished she had been a man so she could preach the gospel as he did. And now it seemed to her prayerful and teachable spirit that perhaps God would open the way. She first made several unsuccessful appeals to missionary societies to see if they would send her. Then, without any detailed plan, she determined to go herself.

MELINDA RANKIN.

Melinda Rankin (1811–1888) was a Presbyterian missionary and teacher who came to Texas in 1847. She taught at Huntsville Male and Female Academy and opened a school with Rev. W. Adair at Cincinnati, Texas, in 1848. While in Walker County, she wrote a famous book entitled *Texas in 1850*. She then moved to Brownsville and later to Mexico, where she continued missionary work for the remainder of her life. (Courtesy the author's collection.)

ANDREW FEMALE

COLLEGE

MAY PARTY.

A MAY PARTY will be given at ANDREW FEMALE COLLEGE, by the young ladies, on Thursday May first, at 4 o'clock P. M, to which the pleasure of your company is respectfully solicited.

COMMITTEE.

KALETA HARDIN.	ALICE J. KEENAN.
MARY C. HIGHTOWER.	MARY E. SIMS.
ANN E. WOODALL.	ELIZA BESSER.
SARAH J. SMITH.	MATILDA WYNNE.
MARY C. DAVENPORT.	MARTHA ROAN.
MARGARET MURRAY.	JOSEPHINE OLIPHANT.
IDA HARDING.	SHELA HOUSE.
MARTHA HOGAN.	AMANDA HOUSE.
HARRIET J. WYNNE.	MARY T. MASON.

Huntsville, Texas, April 21st., 1856.

Andrew Female College was founded by the Methodist church in 1852. Named for Bishop James Osgood Andrew, the college sat at the present site of Mance Park Middle School. Many prominent Huntsville residents were trustees of the college, including Henderson Yoakum, Daniel Baker, and Thomas H. Ball. The school provided young ladies with a classical education focusing on literature, art, and music. The school closed in 1879–1880 when Sam Houston State Teachers College opened. (Courtesy Huntsville Arts Commission.)

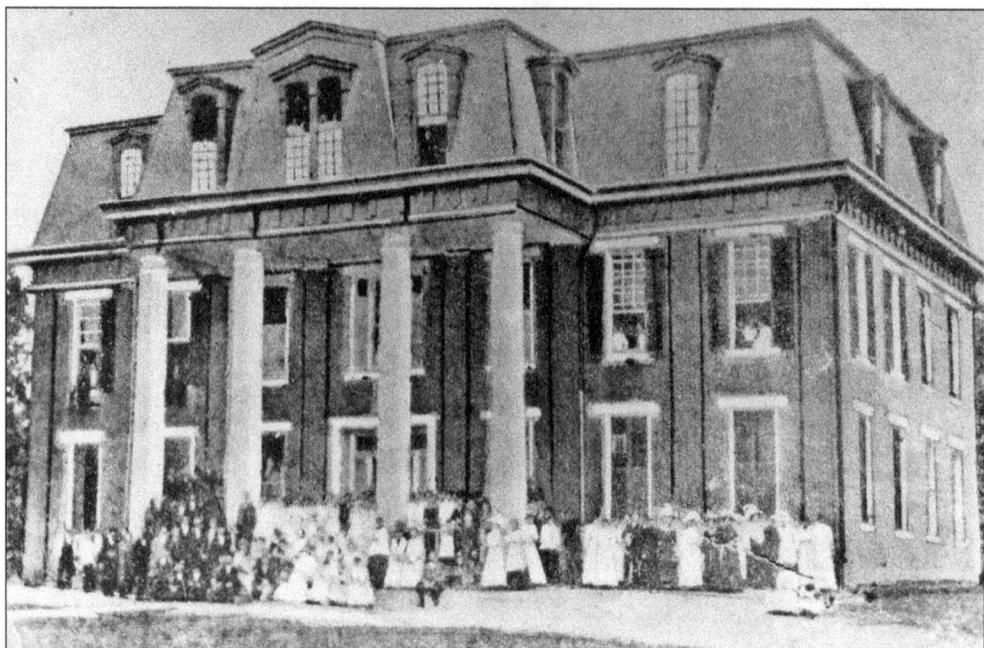

In the mid-1840s, the Presbyterian church asked missionary Daniel Baker to find an appropriate location for a men's college in East Texas. When Baker broached the topic with local figures in Huntsville, town leaders quickly reacted. They set aside 5 acres for the building project and raised $10,000 to secure the school. In 1850, their work paid off when Austin College opened for its first semester of classes. Samuel McKinney and Daniel Baker served as early presidents of the school, which struggled through the Civil War and Reconstruction. In 1876, the Presbyterian church moved the college to Sherman, Texas. (Courtesy Sam Houston State University Archives.)

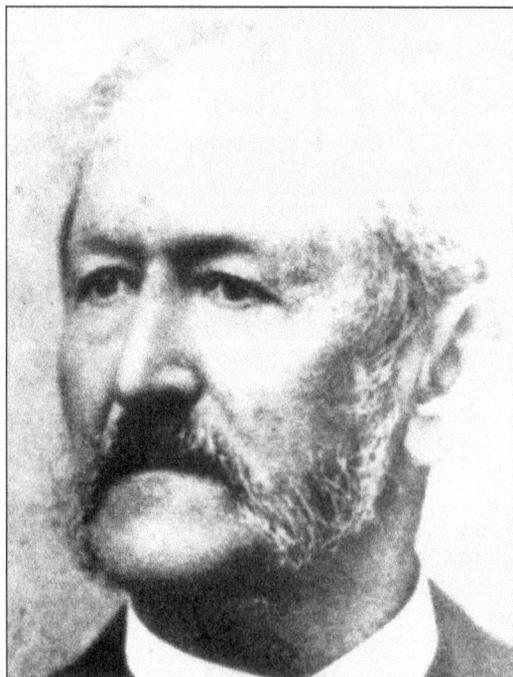

Born in Madison County, Alabama, James Addison Baker (1821–1897) trained in the law before moving to Huntsville in 1852. After a brief marriage to Caroline Hightower—ending with her tragic death—Baker married Rowena Crawford, principal of the Huntsville Female Academy. In time, Baker became a prominent lawyer in East Texas and was selected as a state legislator and judge. In 1855, he helped establish the first law school in Texas at Huntsville's Austin College. Although the school was short-lived, Baker went on to serve as an attorney and cofounder of the firm now known as Baker-Botts in Houston. Baker was the father of Capt. James A. Baker— associated with Rice University—and the great-grandfather of James A. Baker III, a cabinet member under Ronald Reagan and George Bush. (Courtesy Walker County Historical Commission.)

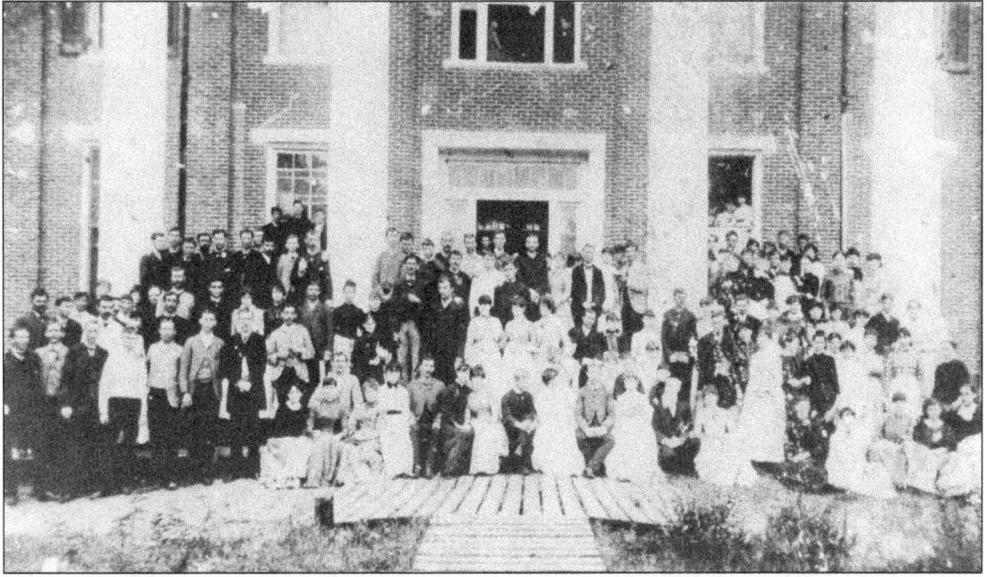

In 1879, Sam Houston Normal Institute (later Sam Houston State University) opened in Huntsville. The school was located on the site formerly occupied by Austin College. It was the first public-supported teacher-training institution in Texas, and it soon became the standard for future teaching institutes across the state. Pictured here are the first students and faculty members at the school in 1879–1880. (Courtesy Sam Houston State University Archives.)

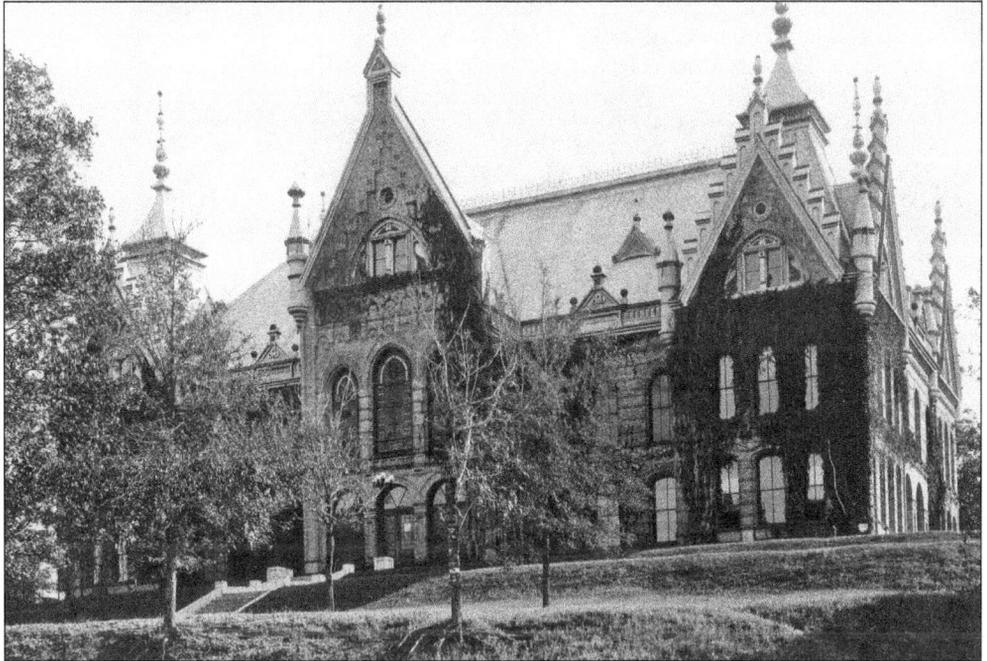

Old Main was a landmark in Huntsville until 1982, when it burned down in a tragic fire. The building was initially constructed in 1889–1890, and it emerged as the centerpiece of the Sam Houston's collegiate campus. Built in the Victorian Gothic Revival style, Old Main served as the first permanent building constructed by the State of Texas for teacher training. (Courtesy Sam Houston State University Archives.)

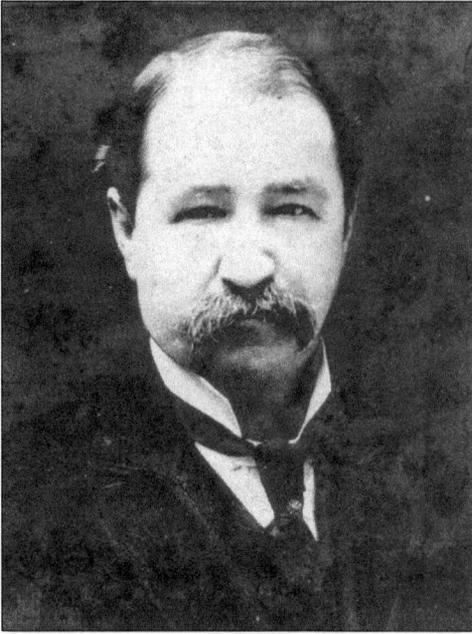

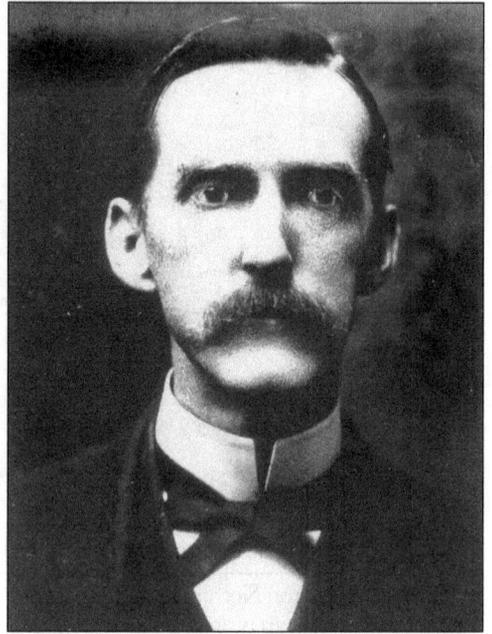

Pictured here are Henry C. Pritchett (1852–1908) and Harry F. Estill (1861–1942), two pioneering educators in early Huntsville. Pritchett arrived in 1881 to teach mathematics at Sam Houston Normal Institute, and a decade later, he became president of the school. Upon Pritchett's death in 1908, H. F. Estill was appointed to the presidency. Estill was a graduate of Sam Houston and had served as vice president of the school for 16 years. During his administration (1908–1937), a four-year curriculum was introduced and the name of the school was changed to Sam Houston State Teachers College. (Courtesy Sam Houston State University Archives.)

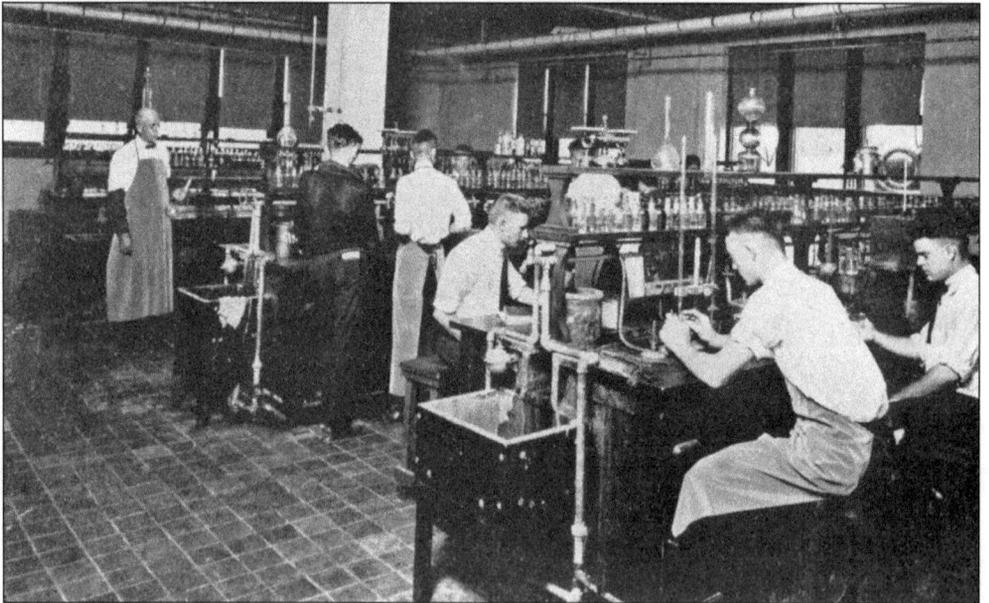

Students and faculty members at Sam Houston Normal Institute explored all areas of academic work. Here is a picture from the 1922 annual—the *Alcalde*—showing a class in one of the school's scientific laboratories. (Courtesy Sam Houston State University Archives.)

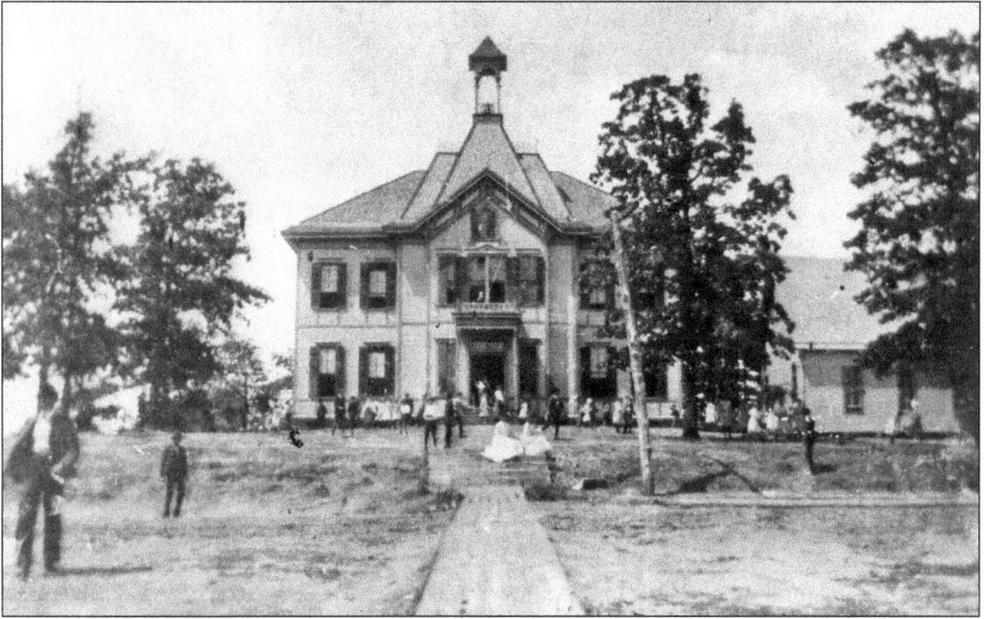

Huntsville Public School was the first building constructed by the City of Huntsville for use as a public school. It sat on the former site of Andrew Female College at Eighth Street and Avenue J (the current site of Mance Park Middle School). This wood-frame building was built around 1889 and was destroyed by fire in 1906. (Courtesy Huntsville Arts Commission.)

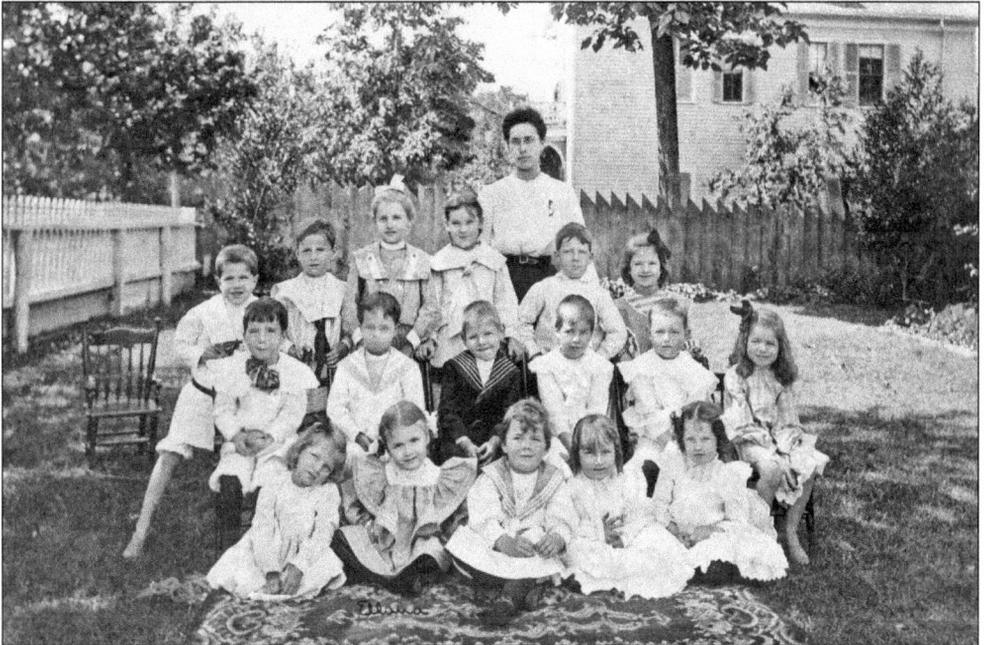

Agnes Junkin's 1902–1903 kindergarten class included, from left to right, (first row) Nan Ashford, Ellana Eastham, Hubert Coleman, Sarah Irving, and Mary Alice Parish; (second row) Jack Josey, Donald Josey, James Thomason, Lawrence Otey, Wilbourn Robinson, and Claire Ashford; (third row) Hamlin Hill, Charles Brahan, Sue Thomason, Eunice Tilley, Philip Johnson, and Kate Barr. (Courtesy Walker County Historical Commission.)

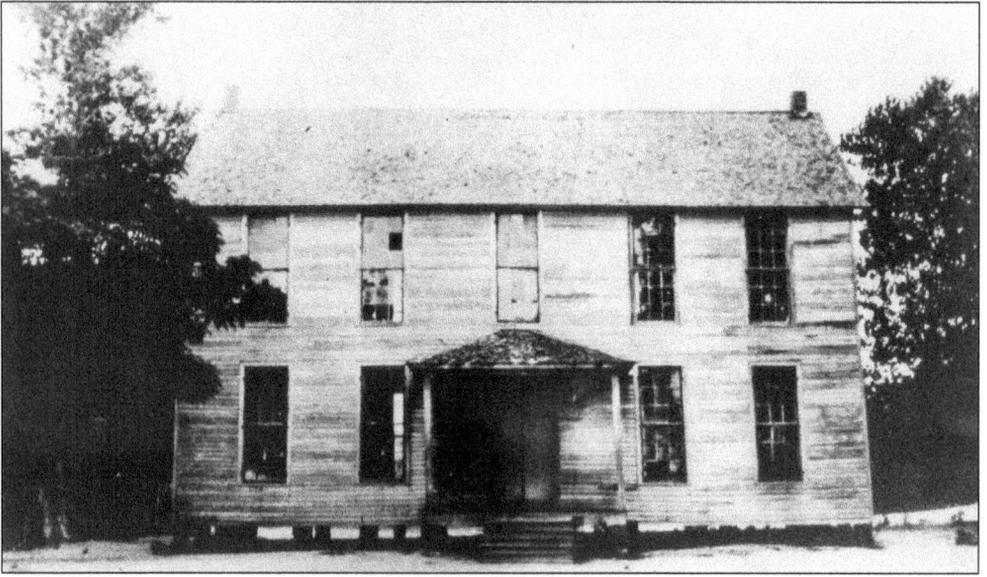

In 1888, the Methodist church deeded Andrew Female College to the City of Huntsville for a public school. The following year, the city moved the building to the corner of Tenth Street and Avenue P (at the current site of Samuel Walker Houston Elementary School). In this neighborhood, known as "Rogersville," the city opened its first public school for African American children in January 1890. (Courtesy Samuel Walker Houston Museum and Cultural Center.)

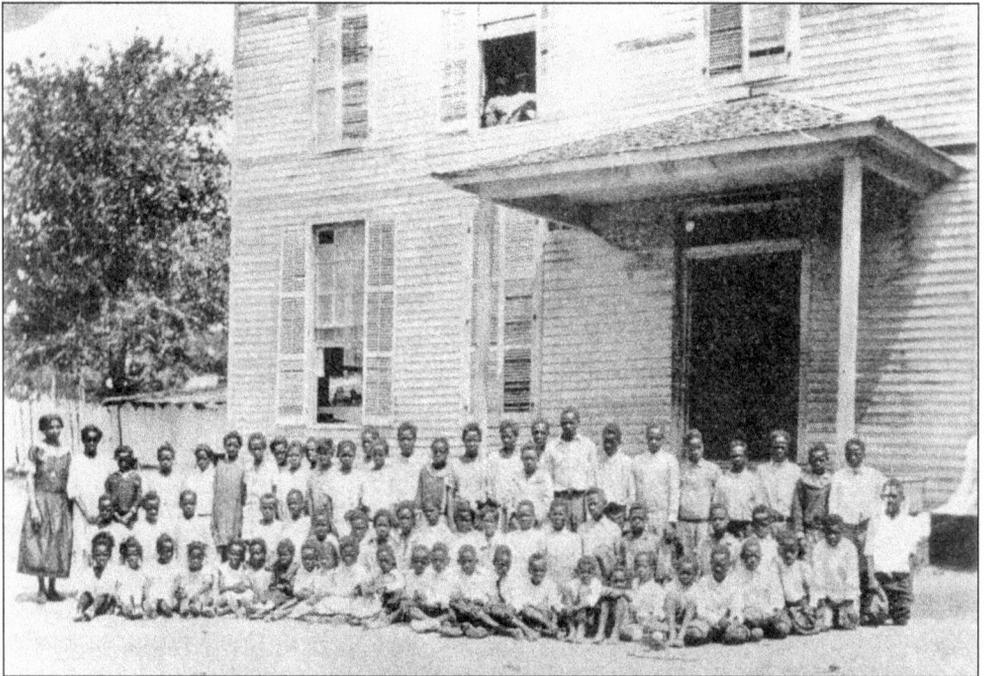

Pictured here are dozens of the students at the Rogersville public school in Huntsville. (Courtesy Samuel Walker Houston Museum and Cultural Center.)

Memphis Allen was a prominent member of Huntsville's African American community. He was an outspoken proponent of education and sat on the board of trustees for the Bishop Ward Normal and Collegiate Institute for Negroes. This coeducational school was founded by the Methodist church in 1883, and it operated for seven years. It was the fifth college established for African Americans in Texas, and it represented a significant step forward for Huntsville's black community. (Courtesy Samuel Walker Houston Museum and Cultural Center.)

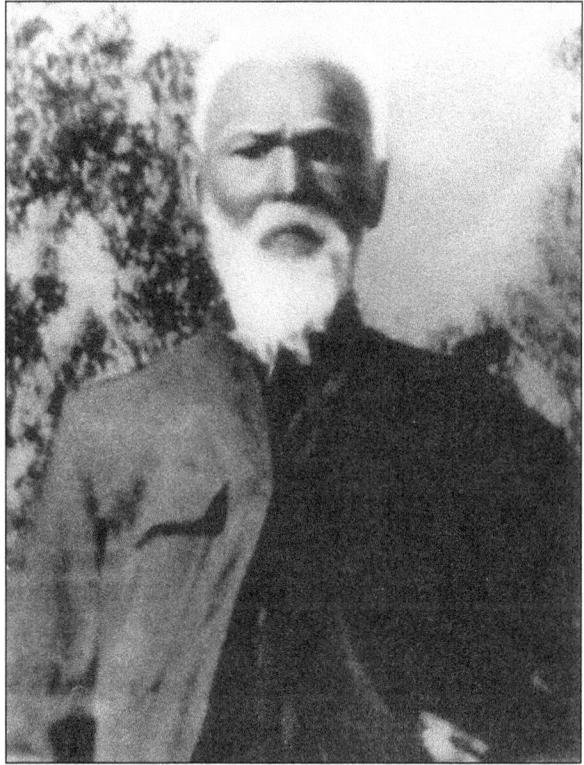

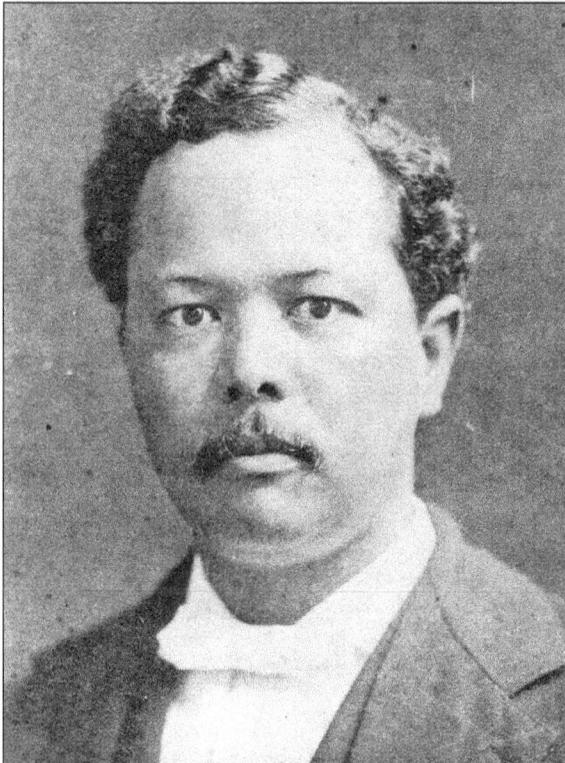

Prof. Charles W. Luckie graduated from Atlanta University in the class of 1883. He then moved to Huntsville, where he taught at Bishop Ward Normal Institute before becoming principal of the city's new African American high school. Luckie spent four years as principal and was also on the city school board. One of his students was Samuel Walker Houston. Luckie moved to Prairie View A&M in the late 1880s and taught there until his death in 1909. (Courtesy Mickey Phoenix.)

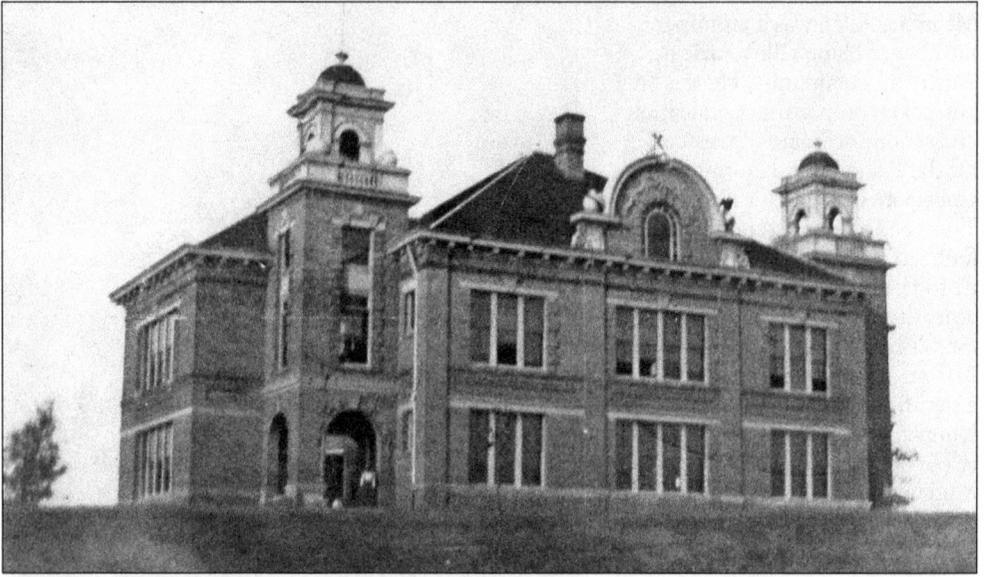

After the first public school in Huntsville burned down in 1906, the city constructed a beautiful two-story brick building that opened the following year. This school served white students in all grades and was located at the corner of Eighth Street and Avenue K—on the site of the current Mance Park Middle School. This building was torn down in 1963. (Courtesy Huntsville Arts Commission.)

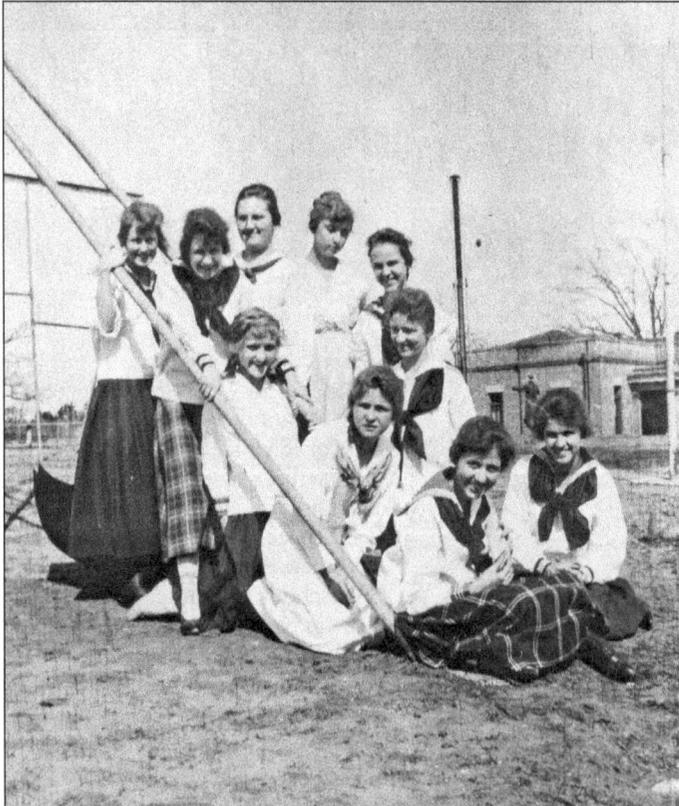

Pictured here is a group of girls on the playground at Huntsville Public School around 1915. (Courtesy Huntsville Arts Commission.)

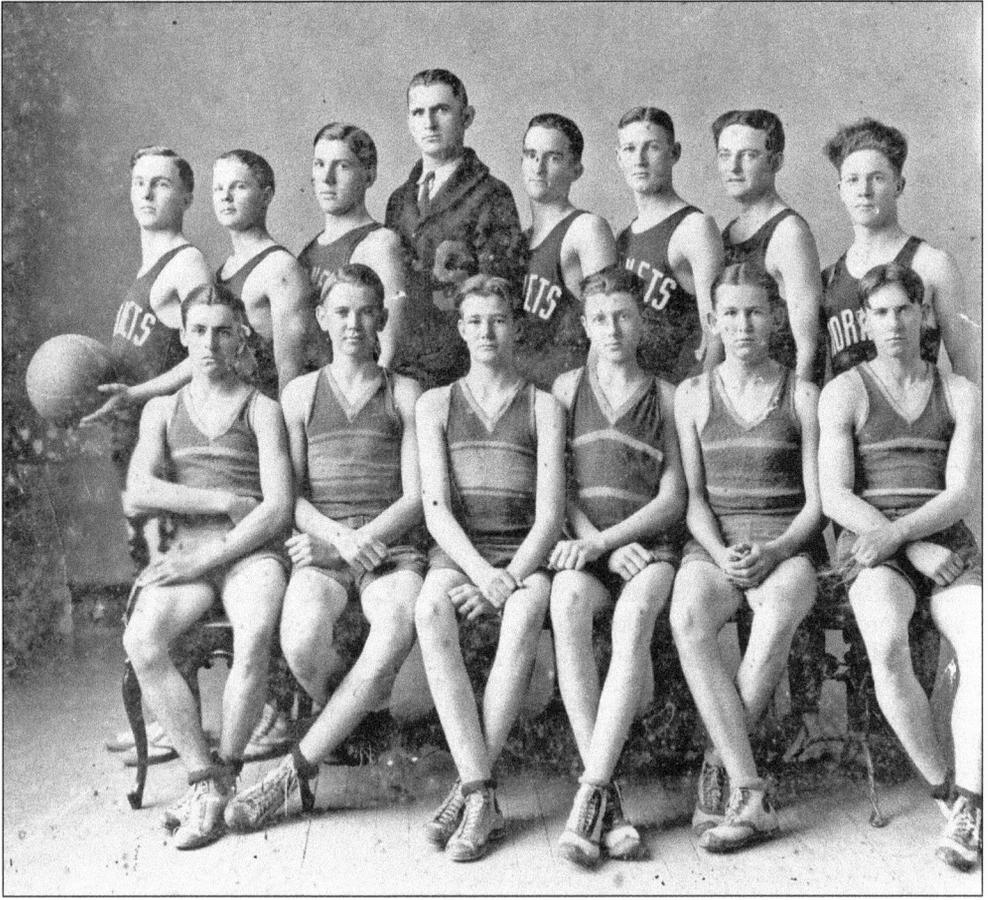

Here is coach R. M. Hawkins with the Huntsville Hornets basketball team in the early days of the 20th century. (Courtesy Huntsville Arts Commission.)

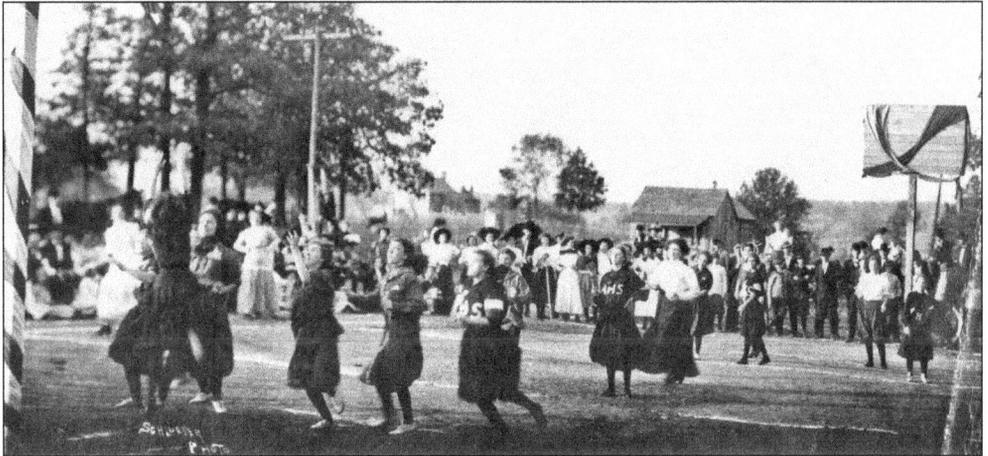

Pictured here is a girl's basketball game taking place on Thanksgiving in 1909. (Courtesy Huntsville Arts Commission.)

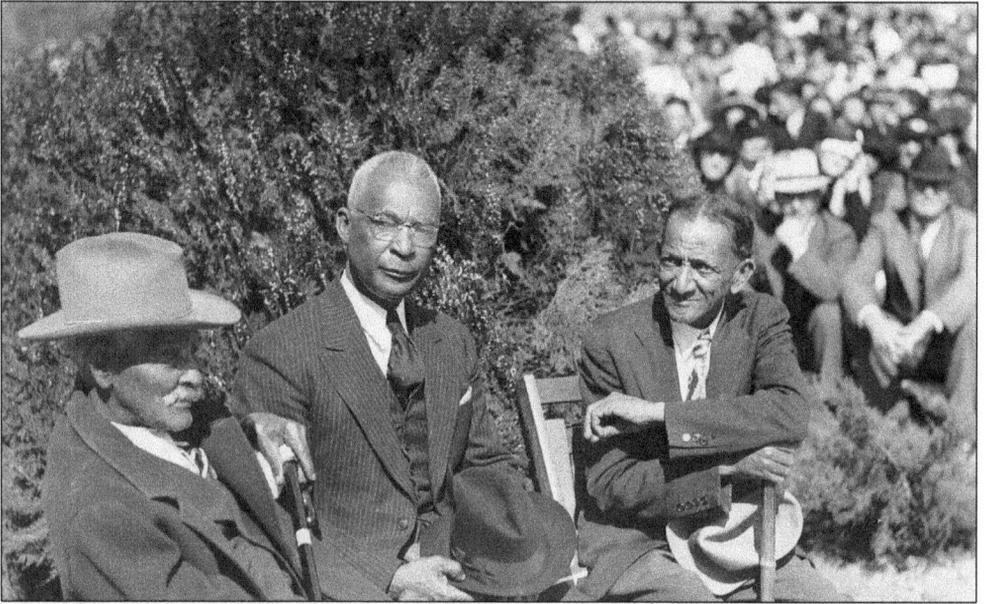

This picture highlights two of the leading African American figures in Huntsville's history. The first, Jeff Hamilton (left), was a former slave of Sam Houston. He wrote a memoir of his time in slavery, entitled *Sam Houston, My Master*. The second, Samuel Walker Houston (center), was the son of Joshua Houston. He established a school for African American students in Galilee in 1906 and later became principal of Sam Houston High School in Huntsville. (Courtesy Samuel Walker Houston Museum and Cultural Center.)

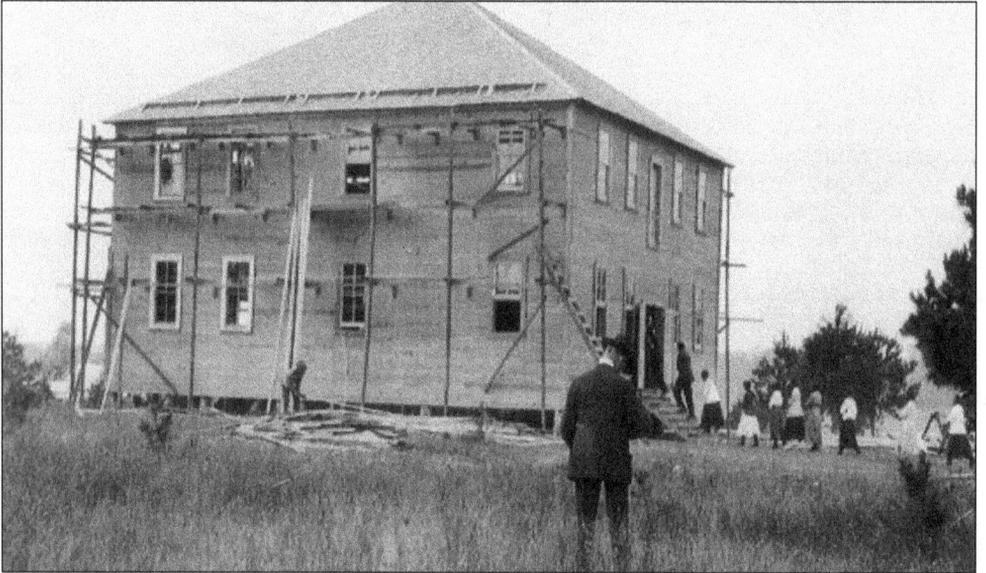

Pictured here is construction work at Samuel Walker Houston Training School in Galilee, a small settlement west of Huntsville. The school was founded by Samuel Walker Houston in 1906. Houston had received educational training at Hampton Institute, Atlanta University, and Howard University before inaugurating his own school in Walker County. (Courtesy Jackson Davis Collection of African American Educational Photographs, Special Collections, University of Virginia Library.)

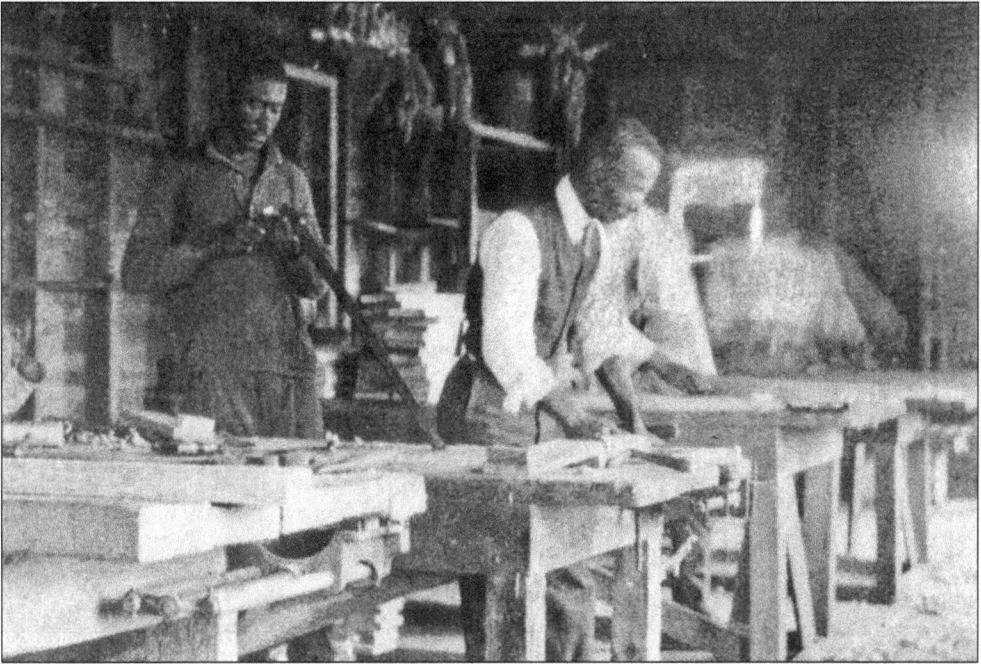

The Samuel Walker Houston Training School taught students craft skills, such as masonry and building construction. In addition, Houston also emphasized a classical education in literature and music. Students who graduated from the school received a well-rounded education in one of the only black high schools in the state. (Courtesy Jackson Davis Collection of African American Educational Photographs, Special Collections, University of Virginia Library.)

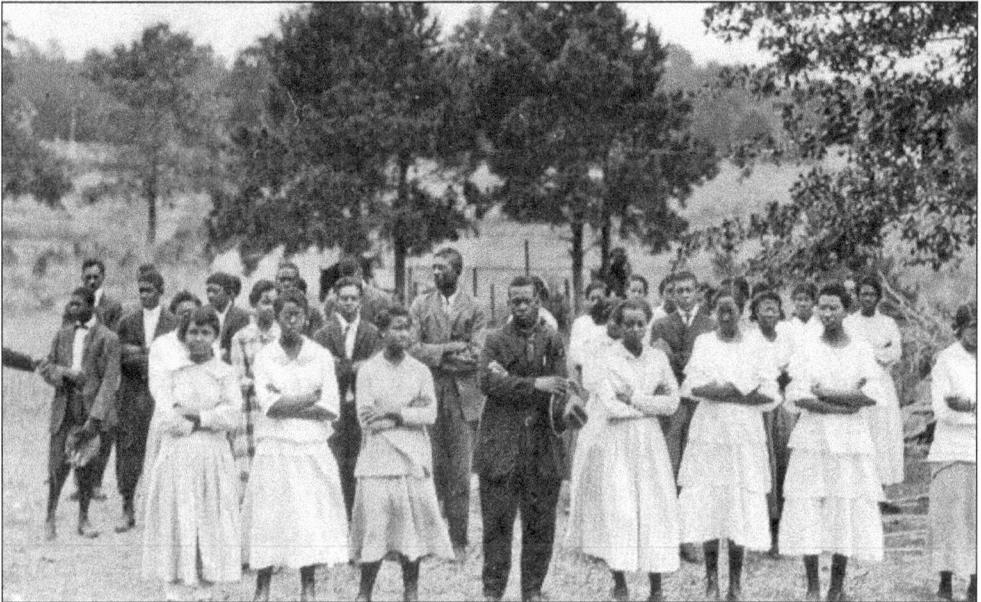

Pictured here is a group of students from the Samuel Walker Houston Training School at Galilee. Note their professional dress and determined look. These young men and women had a new future before them. (Courtesy Jackson Davis Collection of African American Educational Photographs, Special Collections, University of Virginia Library.)

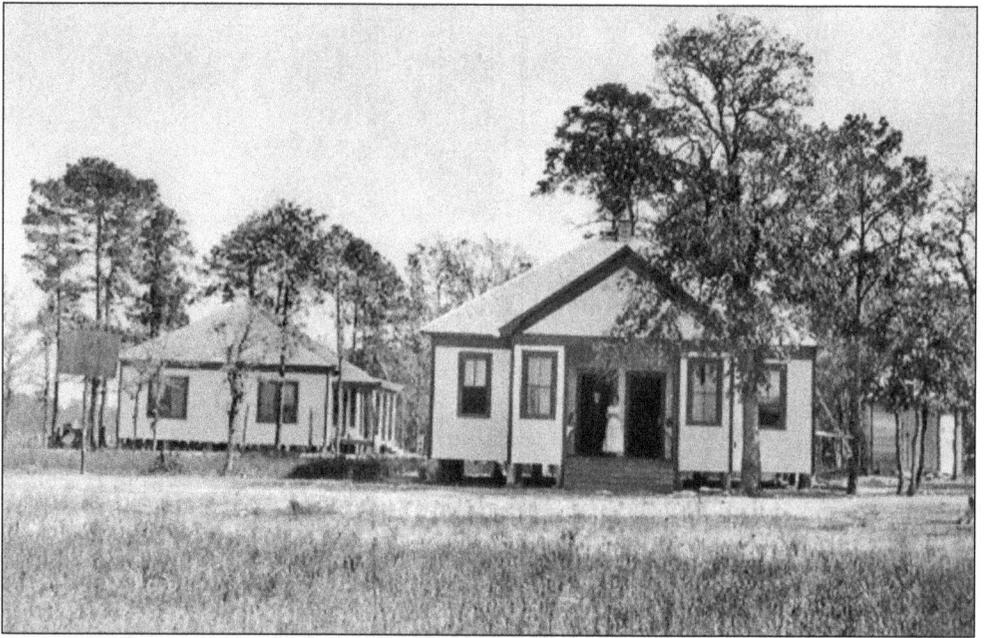

Many of the students in Walker County attended small rural schools during the early years of the 20th century. Here is one such institution, the Cline's Prairie Consolidated School. At the door stands Principal J. L. Lexter. (Courtesy Jackson Davis Collection of African American Educational Photographs, Special Collections, University of Virginia Library.)

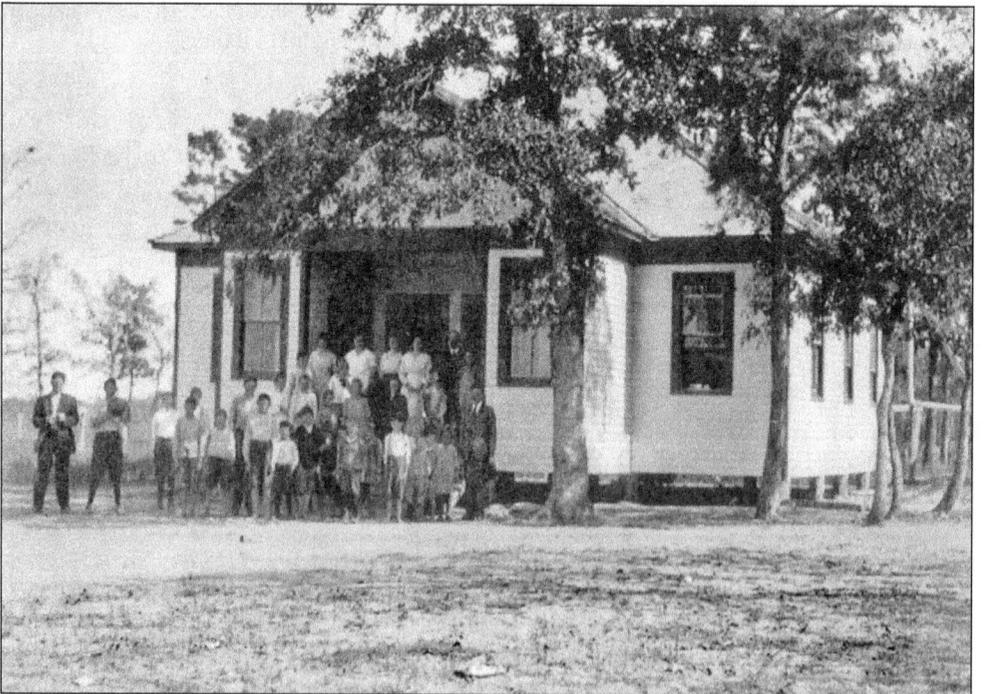

Pictured here is a small white school in Walker County around 1916. (Courtesy Jackson Davis Collection of African American Educational Photographs, Special Collections, University of Virginia Library.)

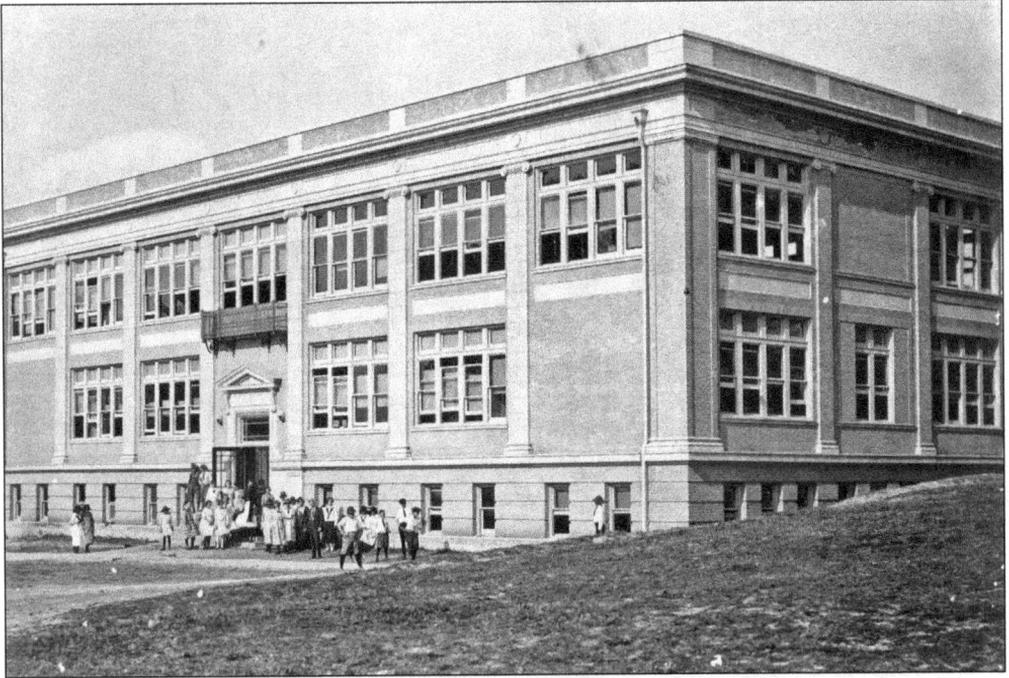

For many years, Sam Houston Teachers College operated a "demonstration school" for college students who were preparing for careers in public education. This school allowed college students to hone their skills while providing learning opportunities for hundreds of local children. (Courtesy Sam Houston State University Archives.)

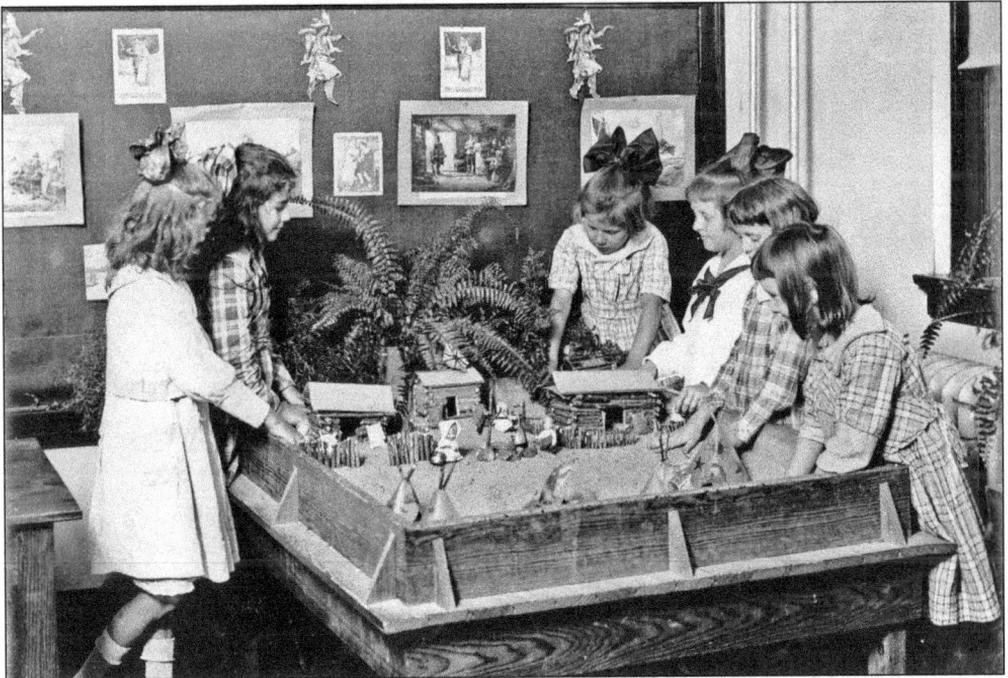

The facilities at the demonstration school were excellent, and young students enjoyed the wide range of activities teachers presented. (Courtesy Sam Houston State University Archives.)

Huntsville!
AGAIN MOVES FORWARD
Back to School
In New Modernly Equipped Buildings

All Huntsville Is Proud of this New High School Building.

This Building Stands as a mark of progress on the part of the Citizenship of Huntsville.

Quitters Never Win---
Winners Never Quit

The boys and girls in this area of school age were never offered as great an opportunity to get as complete an education as now. Let's urge each and every one to take advantage of this opportunity and go on to school.

We Wish to Take This Opportunity to Extend Congratulations and Thanks to the Citizens of Huntsville—The School Board—The Faculty and All Others Instrumental in Helping Our Progress.

FROM THE UNDERSIGNED HUNTSVILLE BOOSTERS

GIBBS BROTHERS & COMPANY	HUNTSVILLE BANK & TRUST COMPANY	FORTNER & GRESHAM
SMITHER GROCERY COMPANY	HUNTSVILLE-WALKER CO. CHAMBER OF COMMERCE	JOINERS SHOE STORE
FIRST NATIONAL BANK	HUNTSVILLE OIL MILL COMPANY	MALLERY & SMITHER

In 1931, the City of Huntsville opened a new high school to make space for the surging population of white school-age children in the area. The new school was located across the street from the existing building, which was now renamed Huntsville Elementary School. (Courtesy Sam Houston State University Archives.)

In 1938, Huntsville constructed a new school for its African American students, which was known as Samuel Walker Houston High School. (Courtesy Samuel Walker Houston Museum and Cultural Center.)

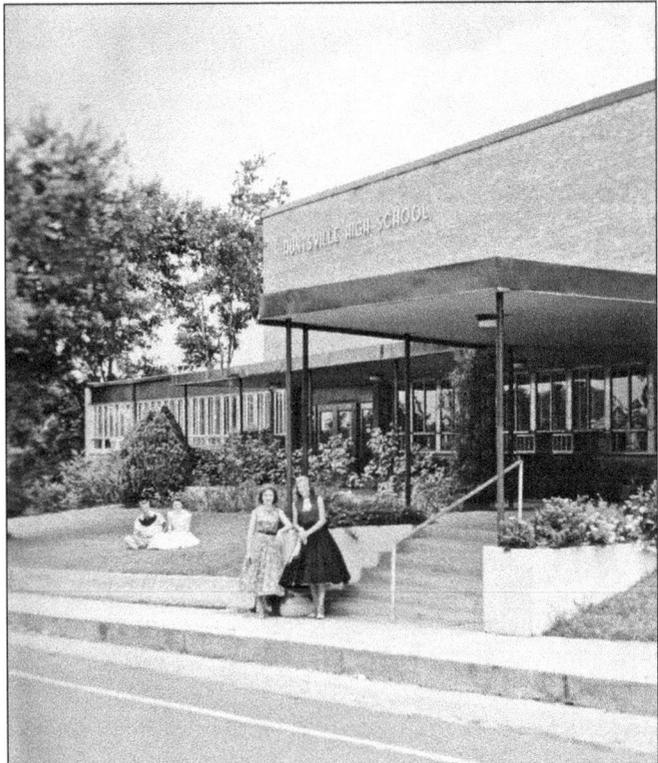

In 1950, the Huntsville school system outgrew its existing facilities, and a new high school was built. It is now known as Mance Park Junior High. (Courtesy Cheryl Spencer.)

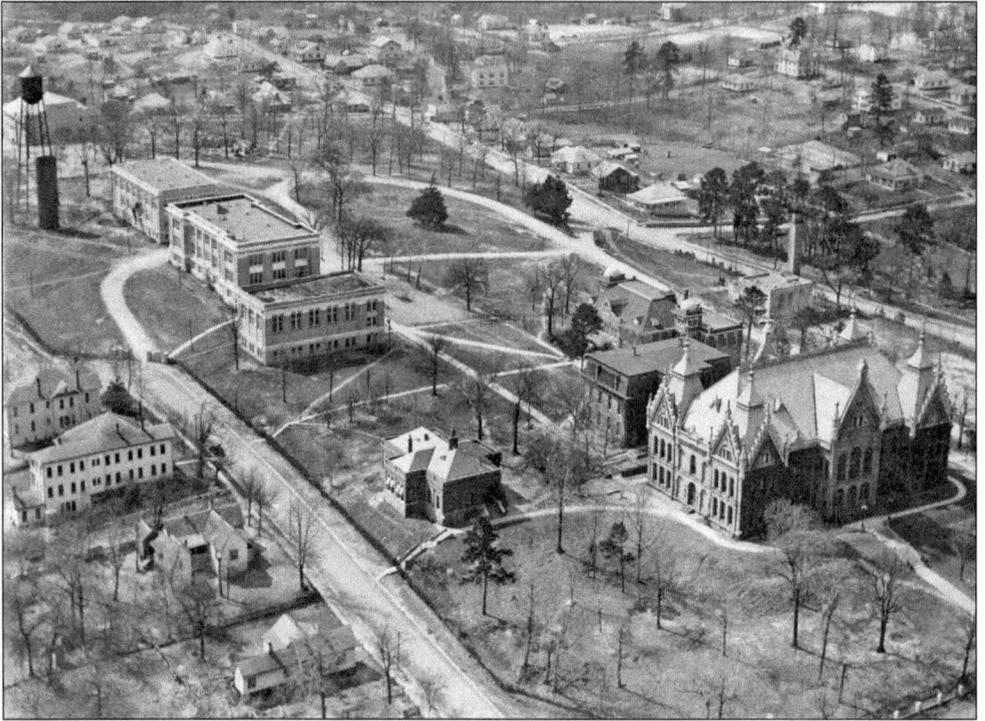

This is a c. 1930 aerial view of Sam Houston State Teachers College. (Courtesy Sam Houston State University Archives.)

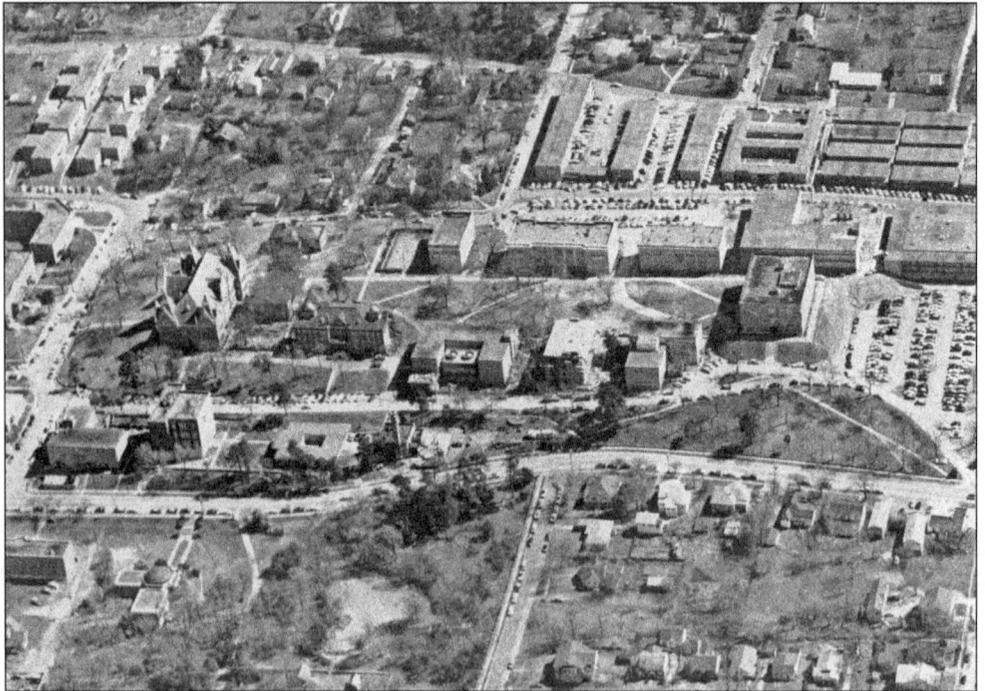

And here is a later aerial view of Sam Houston State University from around 1960. (Courtesy Sam Houston State University Archives.)

Three

RELIGIOUS OBSERVANCES

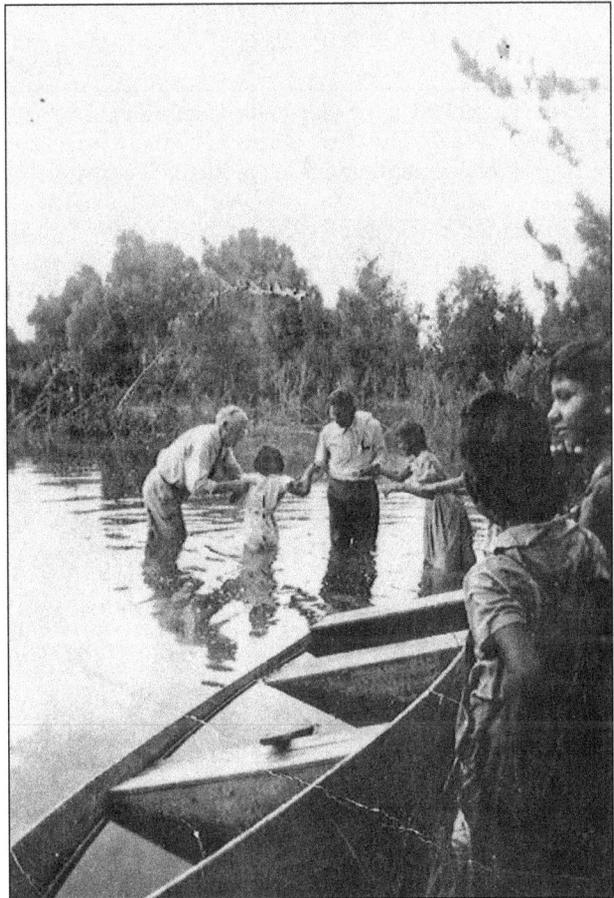

In the mid-20th century, the First Mexican Baptist Church in Huntsville conducted baptism ceremonies in the Trinity River. (Courtesy Boettcher Mill Oral History Project.)

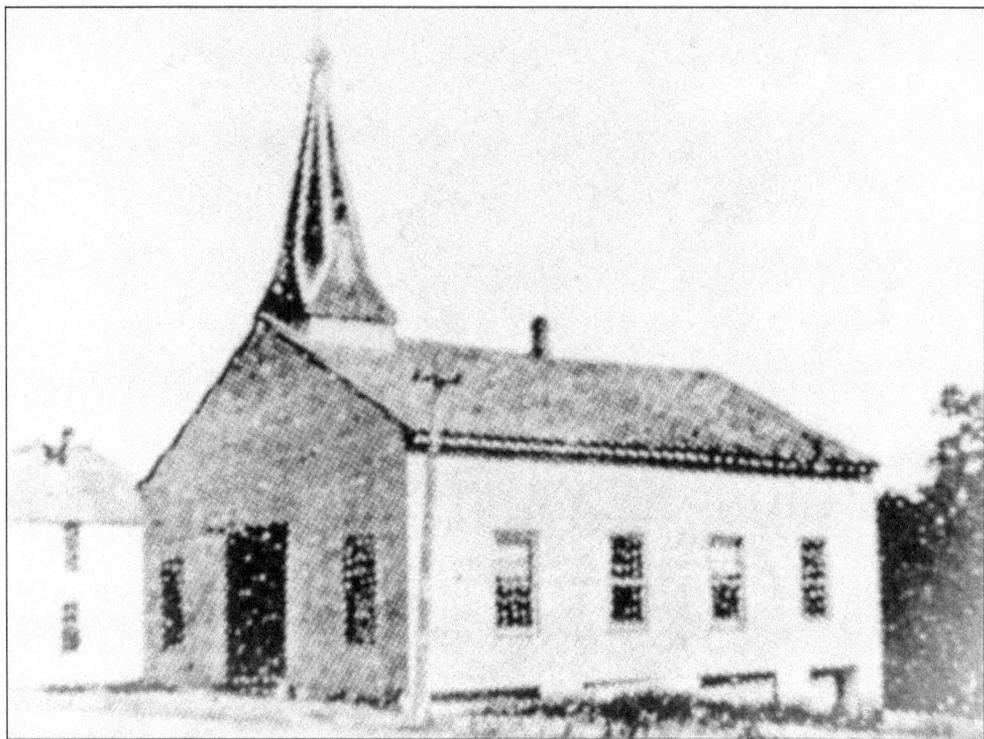

Originally organized in the early 1840s, Cumberland Presbyterian erected the first church building in Huntsville in 1848. It sat at the corner of Eleventh Street and Avenue J, and was subsequently used by several other congregations in the city. (Courtesy Walker County Historical Commission.)

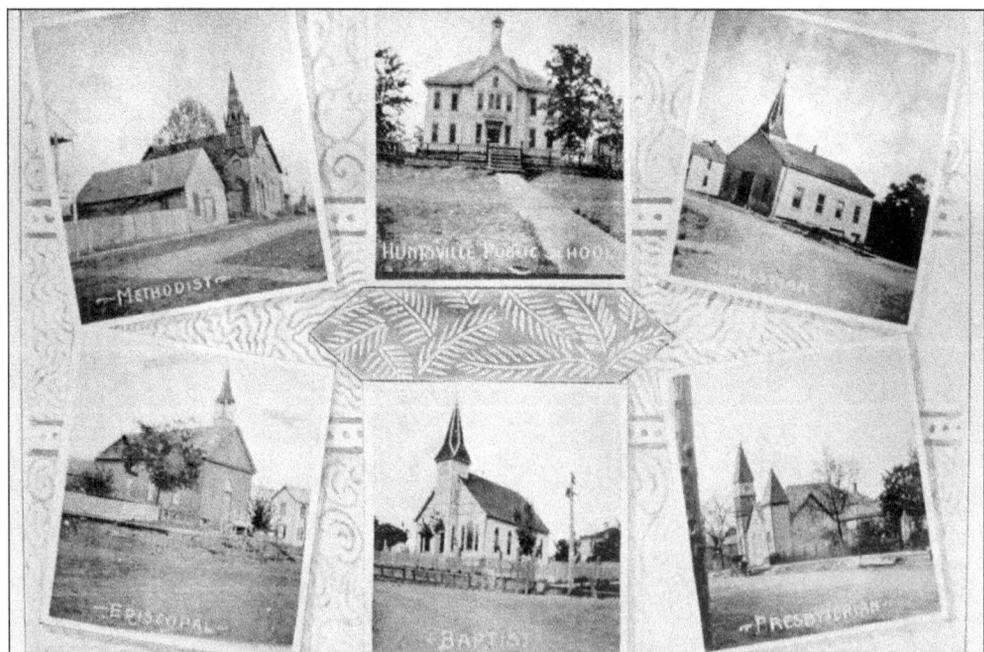

Pictured here are the early churches of Huntsville. (Courtesy Walker County Historical Commission.)

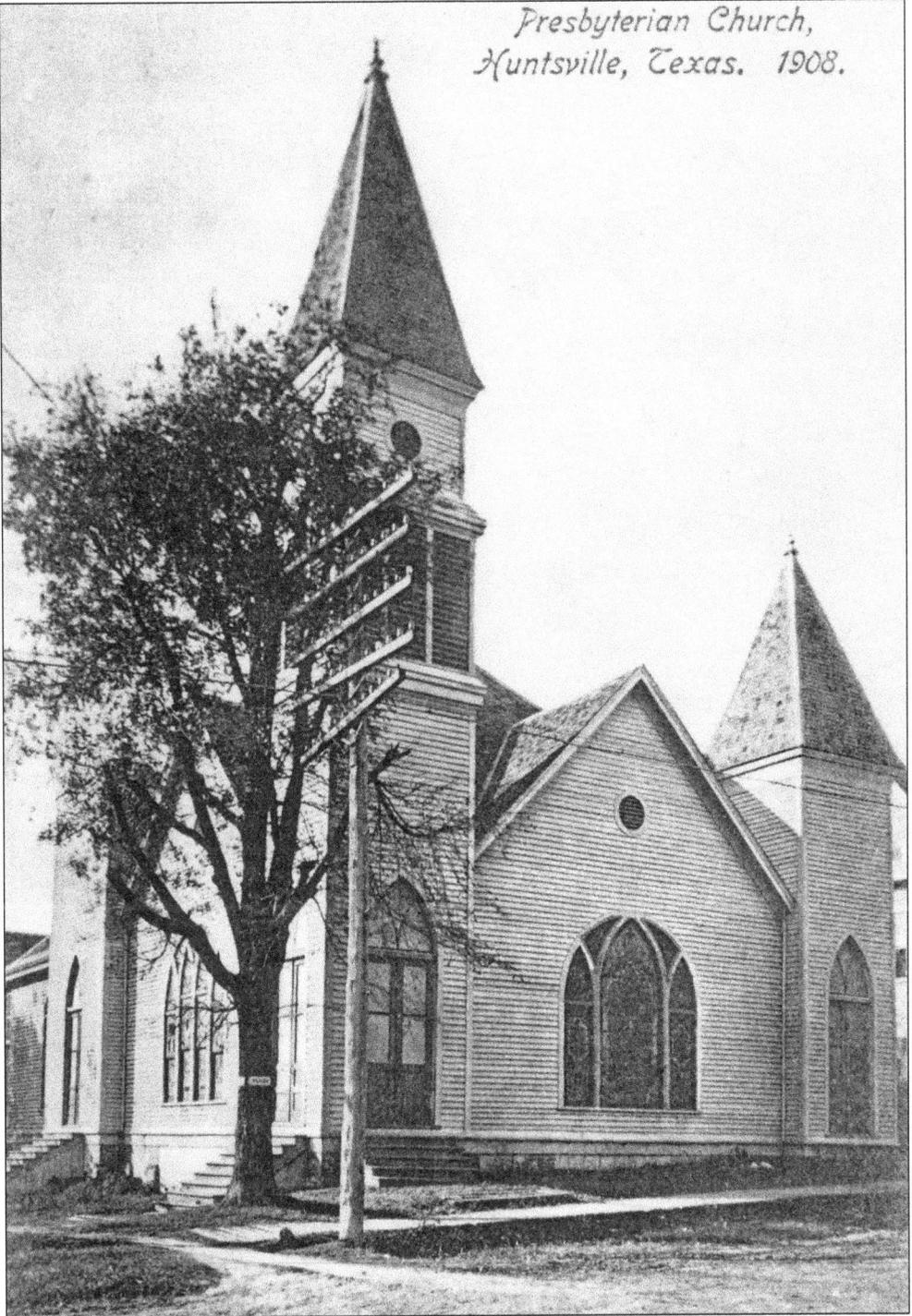

The First Presbyterian Church in Huntsville was organized early in the city's history. The congregation built its first building in 1855 at the corner of Thirteenth Street and University Avenue. The initial structure was torn down in 1898 and was replaced with the building pictured here. (Courtesy Walker County Historical Commission.)

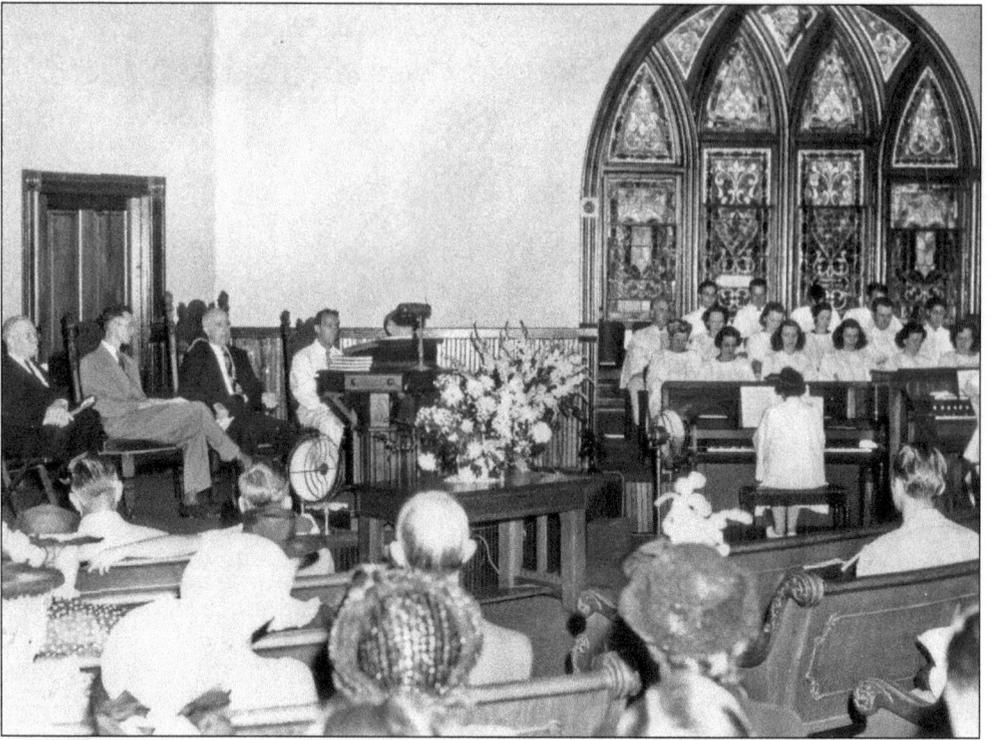

Pictured here is the interior of the First Presbyterian Church during its centennial celebration in 1948. (Courtesy Huntsville Arts Commission.)

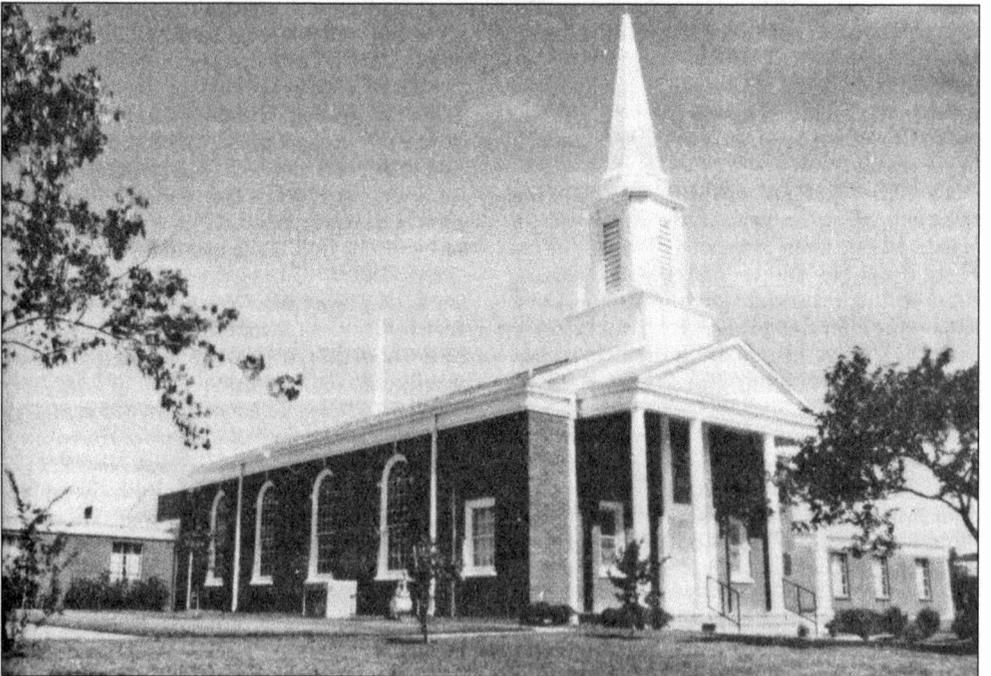

In September 1956, the First Presbyterian Church opened its current building on the corner of Nineteenth Street and Avenue R. (Courtesy Walker County Historical Commission.)

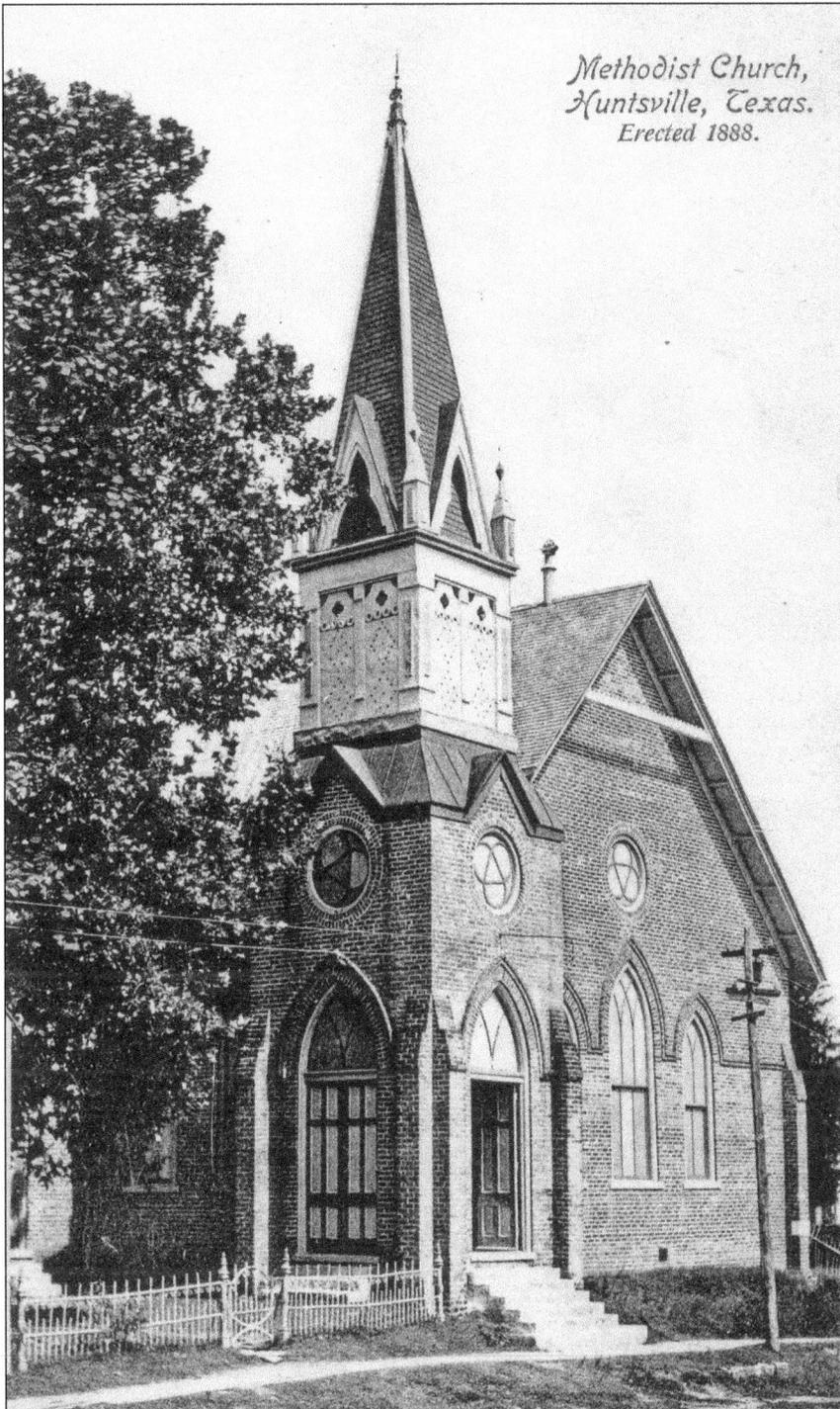

The First United Methodist Church in Huntsville was constructed in 1857, and it stood until 1888. Pictured here is the second Methodist church building, which was erected in 1888. This structure stood through one fire in 1910 but was torn down and replaced by the present building in 1913. (Courtesy Walker County Historical Commission.)

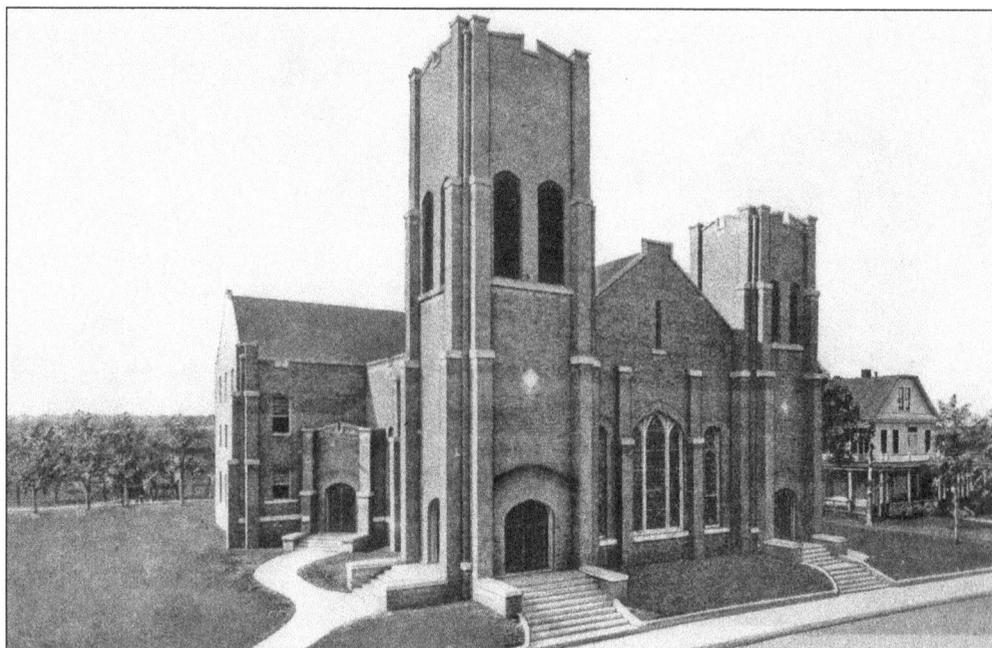

Between 1913 and 1919, the United Methodist Church completed a new building that remains at the corner of Sam Houston Avenue and Eleventh Street. (Courtesy Walker County Historical Commission.)

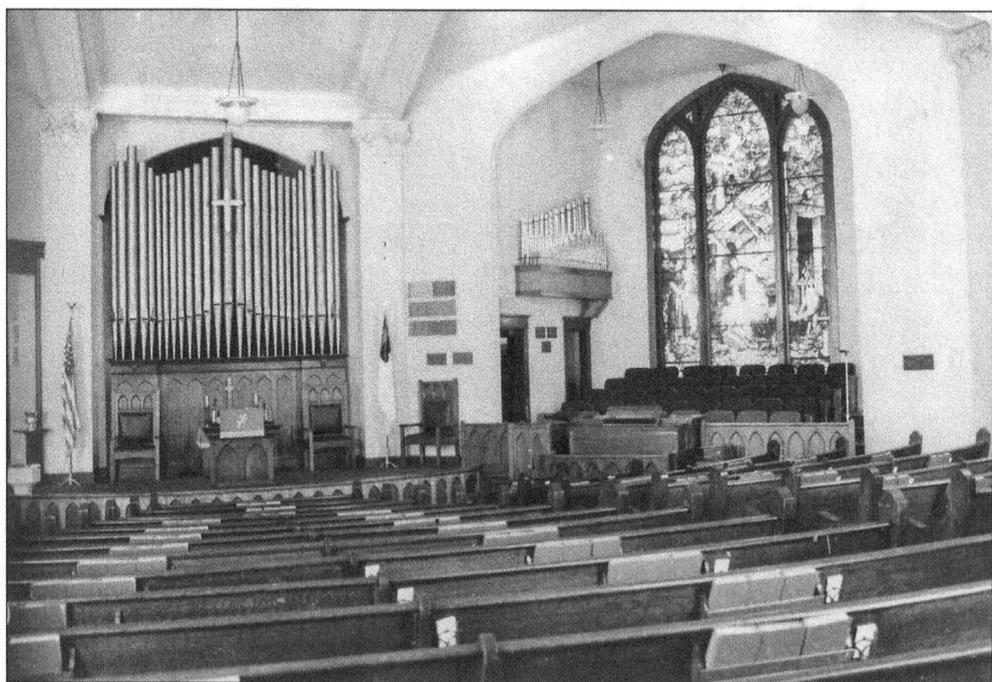

Pictured here is the interior of the United Methodist Church. (Courtesy United Methodist Church.)

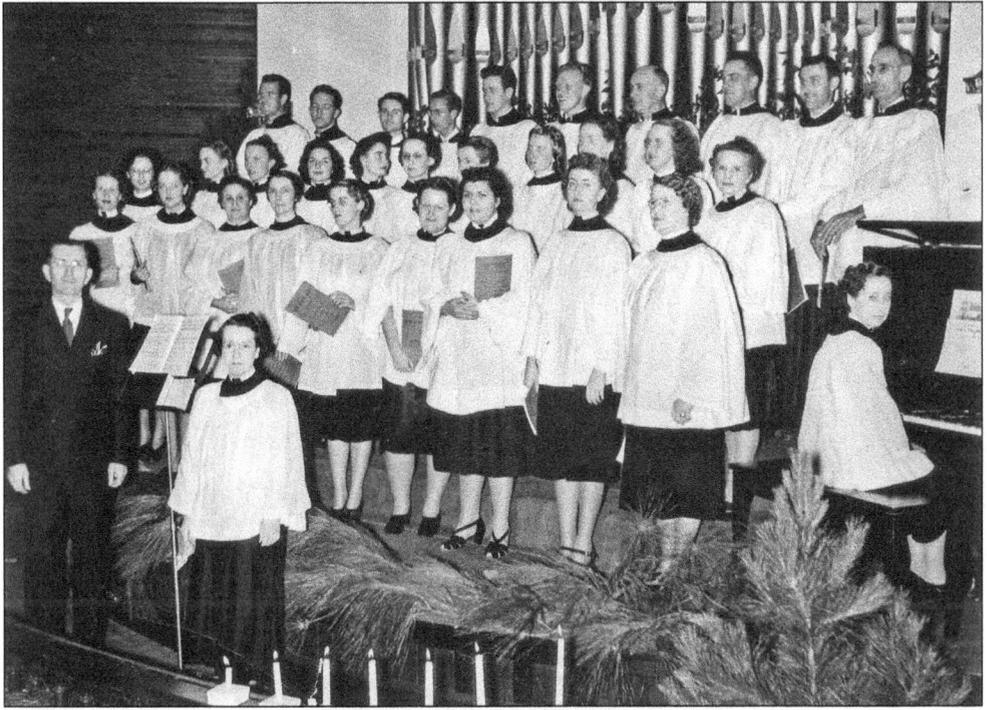

The choir director and local members are shown at the United Methodist Church. (Courtesy United Methodist Church.)

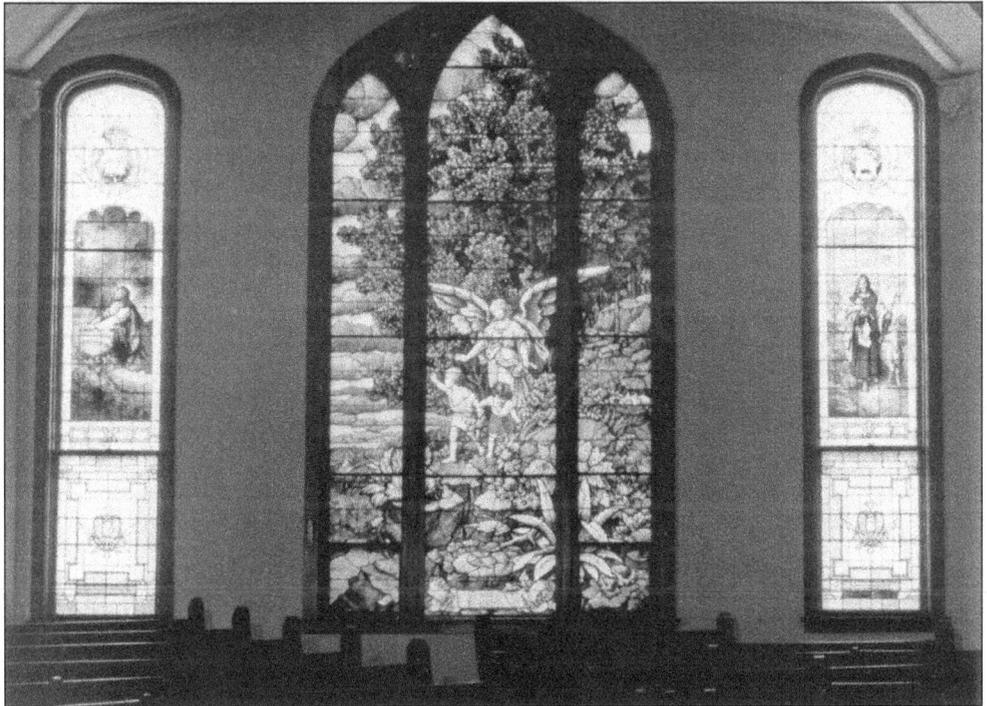

Beautiful stained-glass windows adorn the sanctuary at the United Methodist Church. (Courtesy United Methodist Church.)

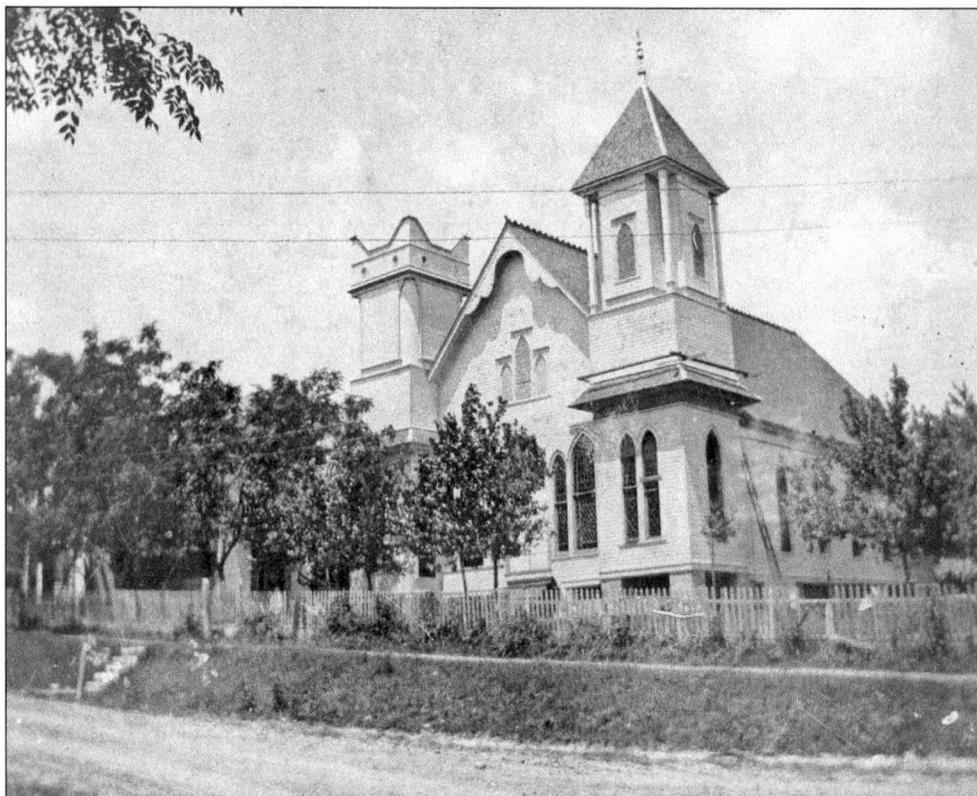

Early Baptists in Huntsville bought two plots of land for their first church in November 1852. Although the date of the initial building is unknown, First Baptist Church erected its sanctuary sometime in the mid-1850s. As the congregation grew, it needed additional space for services. In 1891, the church built its second building, which is pictured here. This frame wooden structure served the congregation until 1924, when it was torn down and replaced with a three-story brick building. (Courtesy Walker County Historical Commission.)

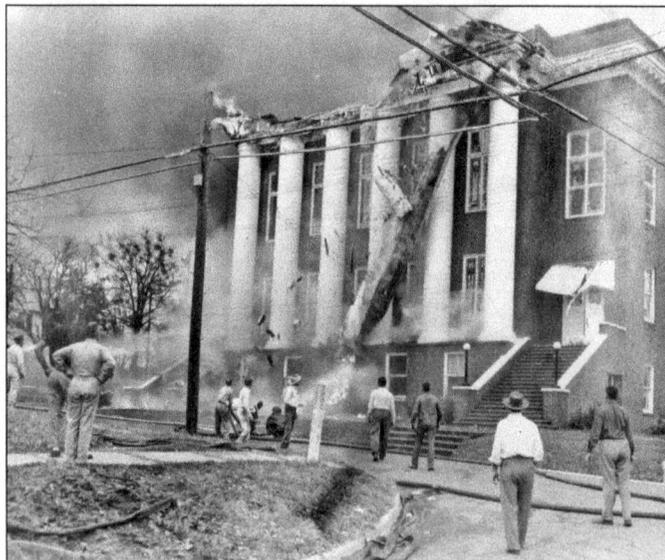

On a cold Sunday in January 1954, First Baptist Church caught on fire shortly after morning worship. Although fire departments from the area tried to fight the blaze, the fire raged out of control and destroyed most of the building. (Courtesy Walker County Historical Commission.)

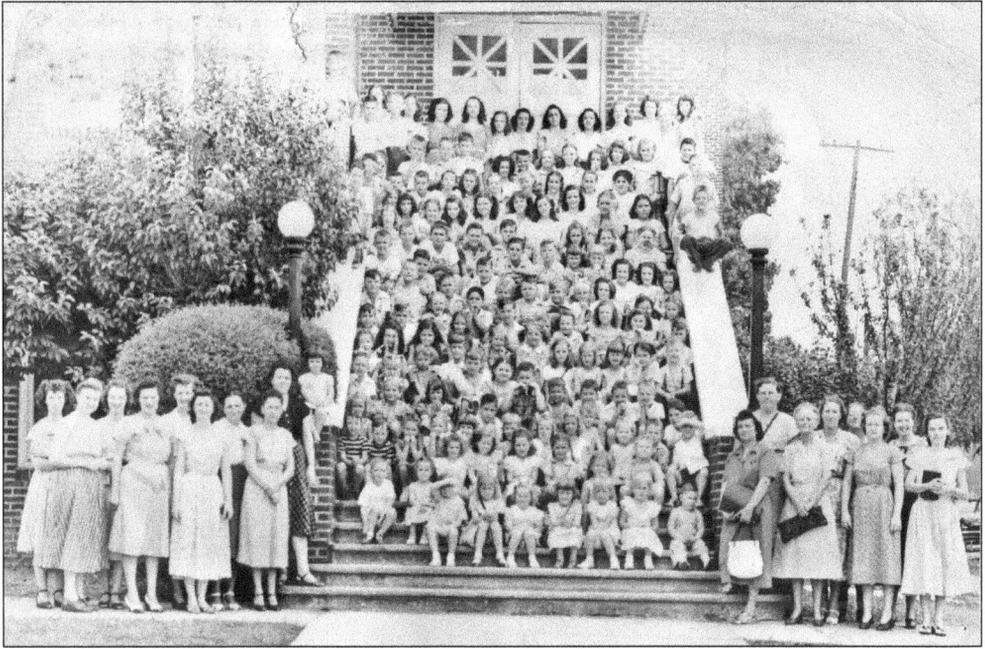

Local congregation members and children pose on the steps of First Baptist Church. (Courtesy First Baptist Church.)

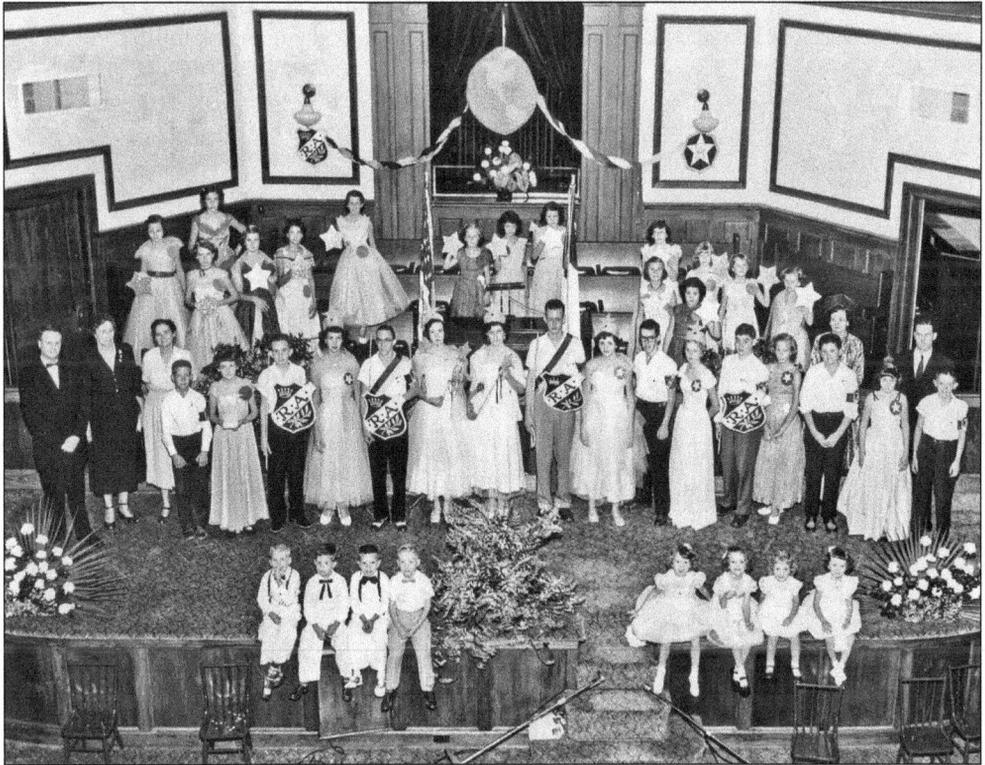

A missions celebration for First Baptist highlights the achievement of Royal Ambassadors (RAs) and Girls in Action (GAs). (Courtesy First Baptist Church.)

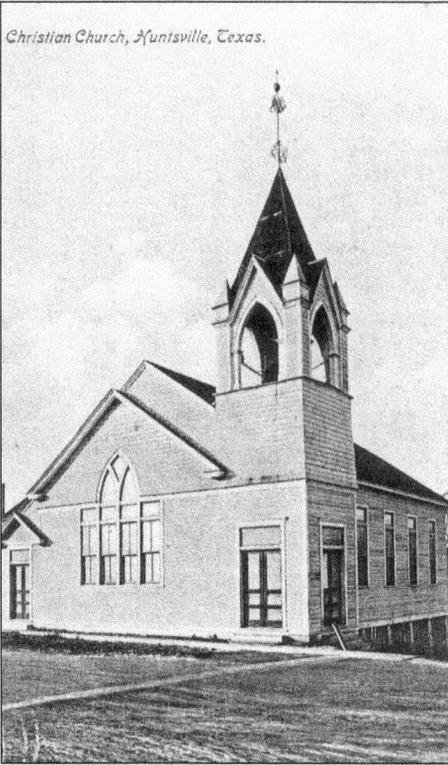

Christian Church, Huntsville, Texas.

The initial meetings of Huntsville's First Christian Church date back to 1854, when the congregation met in local houses. The church bought the former Cumberland Presbyterian Church in 1871. Later this structure was removed, and in 1901, the congregation erected the building pictured here. (Courtesy Walker County Historical Commission.)

In the mid-20th century, the First Christian Church bricked the facade of its classic building. (Courtesy Walker County Historical Commission.)

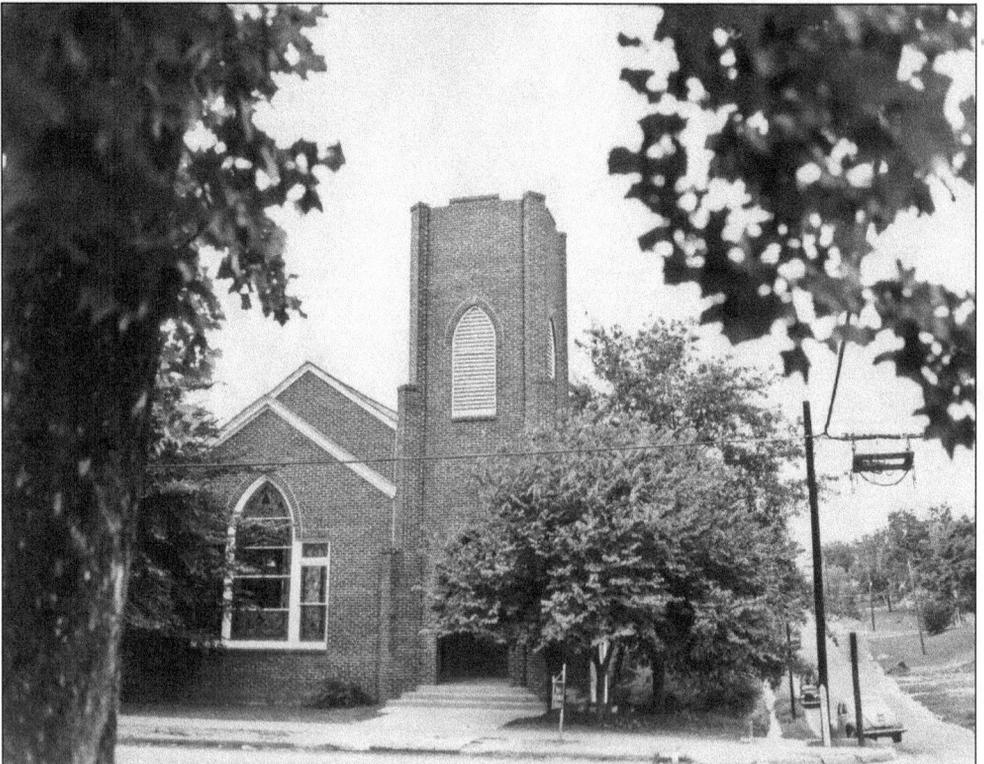

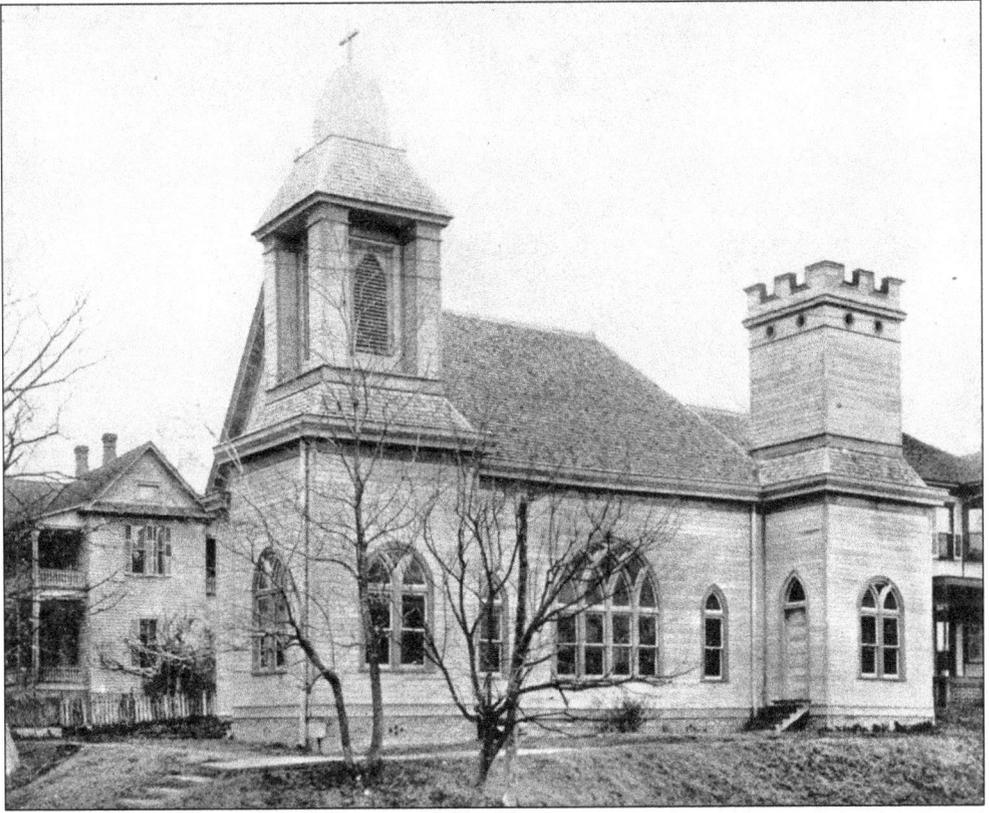

St. Stephen Episcopal Church traces its roots to the 1840s and 1850s. Lay people initially led the church, but in 1871, Rev. Jeremiah Ward became rector. Two years later, the congregation consecrated its first church building. Although attendance remained small throughout the remainder of the 19th century, the church constructed a beautiful new building—pictured here at Avenue L and Thirteenth Street—in 1904. (Courtesy Huntsville Arts Commission.)

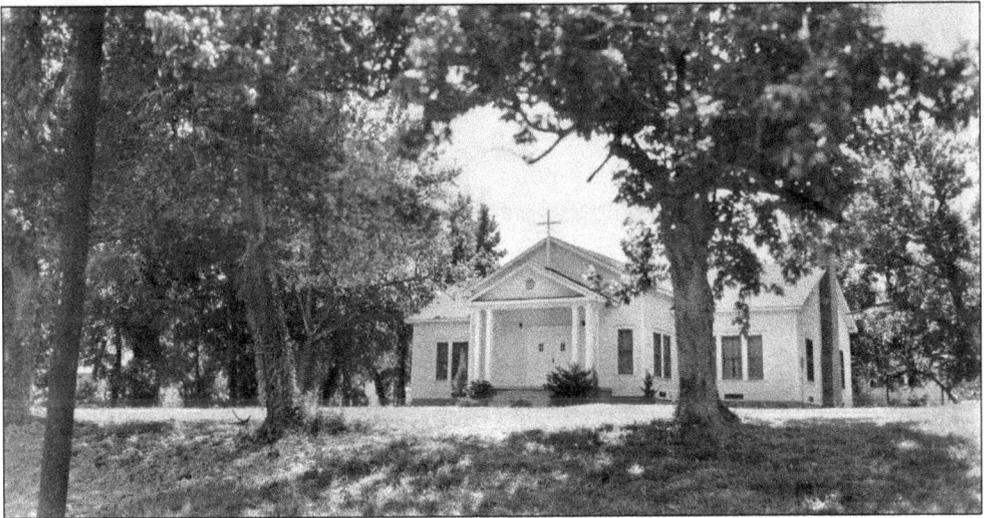

Pictured here is St. Stephen Episcopal Church at Fifth Street and Avenue M in September 1950. (Courtesy Huntsville Arts Commission.)

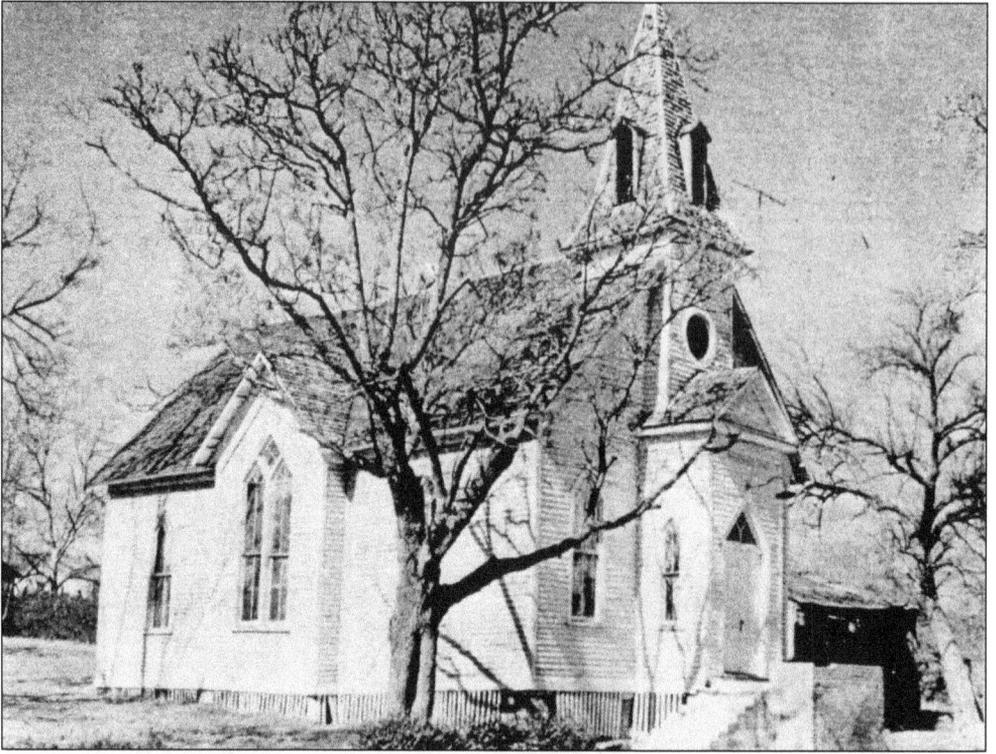

After emancipation in 1865, the free black community in Huntsville formed a "Union Church," where Methodist and Baptist adherents worshipped together. The church split into three separate groups in 1869. The Methodist Episcopal congregation remained at the "Union" site at Fourteenth Street and Avenue M, founding St. James Methodist Episcopal Church (pictured here). (Courtesy Huntsville Arts Commission.)

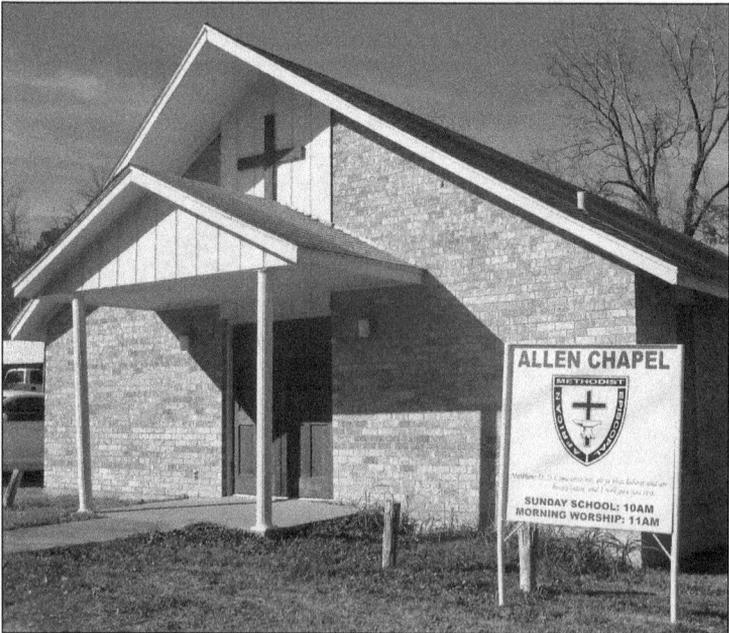

When the black Union Church split apart in 1869, members of the African Methodist Episcopal faith founded Allen Chapel AME church on Avenue I and Eleventh Street in 1872. Later the church was moved to its current location at 215 Highway 30 East in Huntsville. (Courtesy the author's collection.)

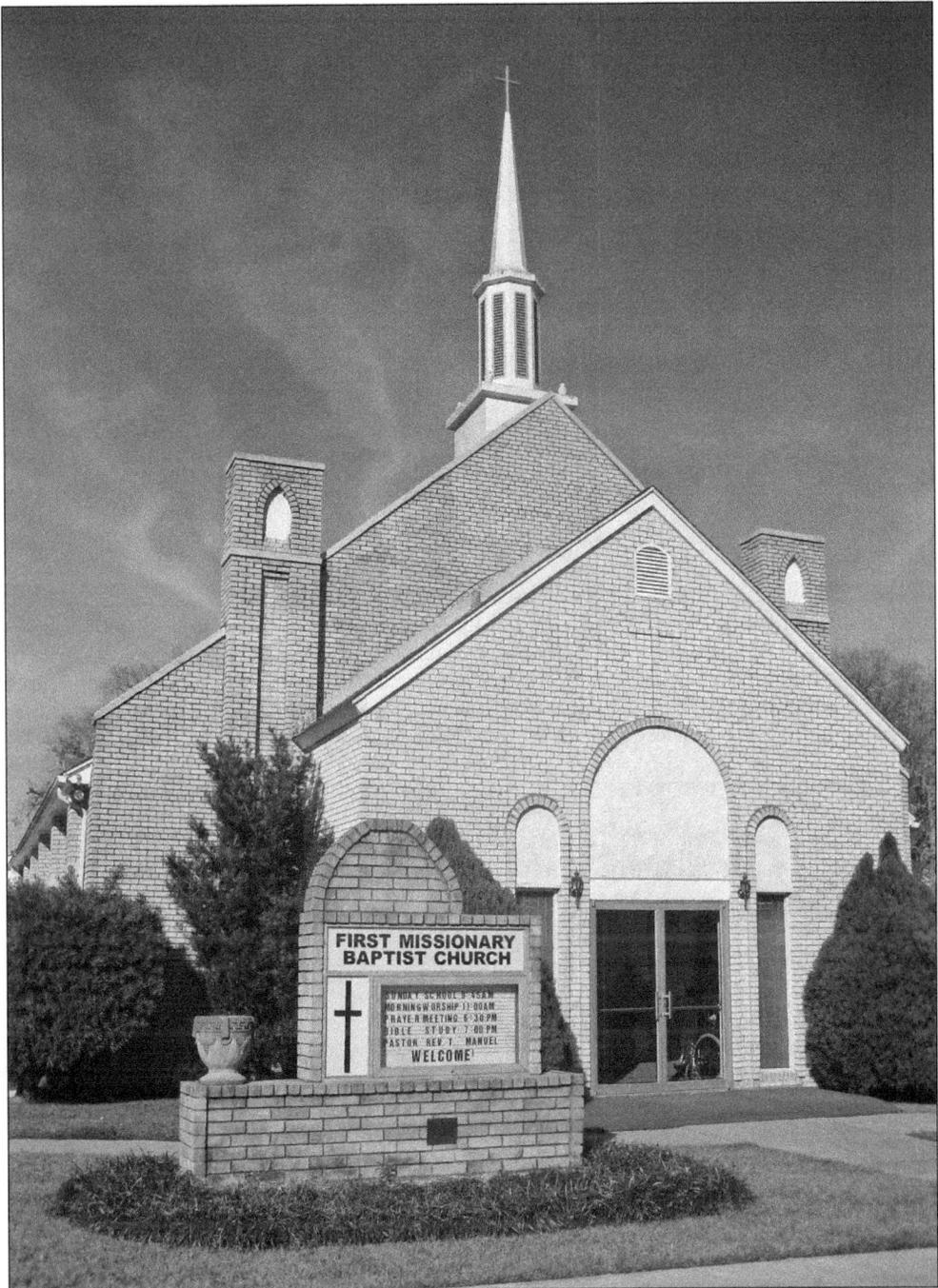

At the same time Allen Chapel AME was founded, Baptist congregants from the old Union Church established First Missionary Baptist on Tenth Street and Avenue P near the present site pictured here. (Courtesy the author's collection.)

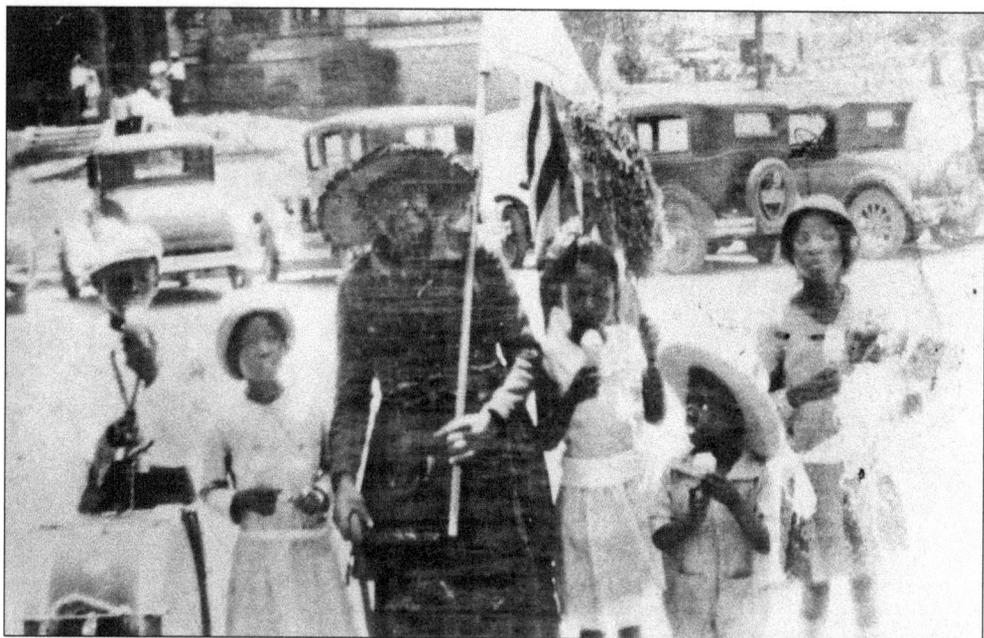

Immediately following emancipation, annual Juneteenth celebrations were held at the Union Church. Following the split of the congregation, however, Jane Ward played a crucial role in keeping the yearly festivities alive. A local hotel operator and community activist, Ward organized children's parades—like the one pictured here—and gala events at Sims Grove (now known as Emancipation Park). (Courtesy Samuel Walker Houston Museum and Cultural Center.)

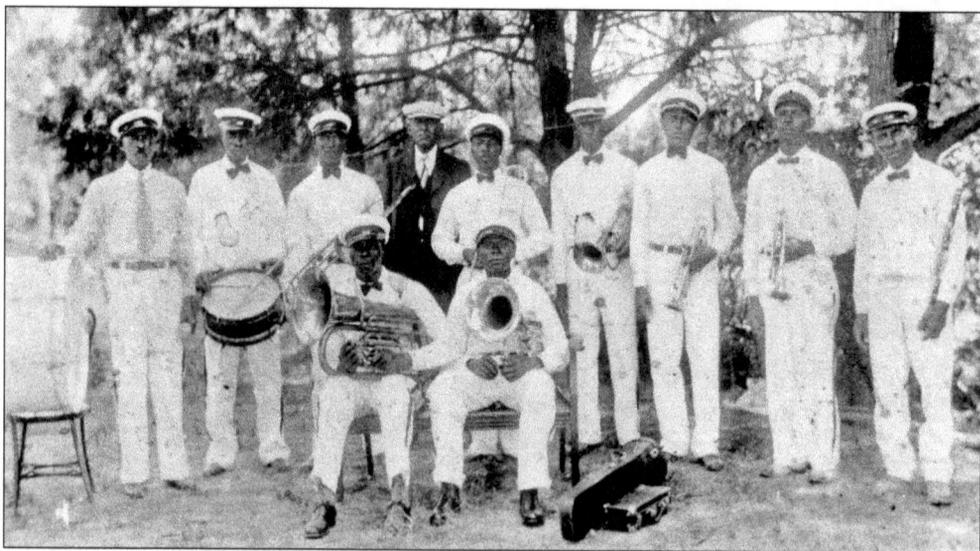

David Williams (dark suit), a prominent African American musician and teacher, led the Band and Park Association of Huntsville in the early 1930s. The organization was established to raise funds for the purchase of Sims Grove, where the African American community had celebrated Juneteenth since 1914. With help from Robert A. Josey of Houston—a Huntsville native who had made money in the oil and newspaper business—the association secured Sims Grove in 1933, renaming the spot Emancipation Park. (Courtesy Samuel Walker Houston Museum and Cultural Center.)

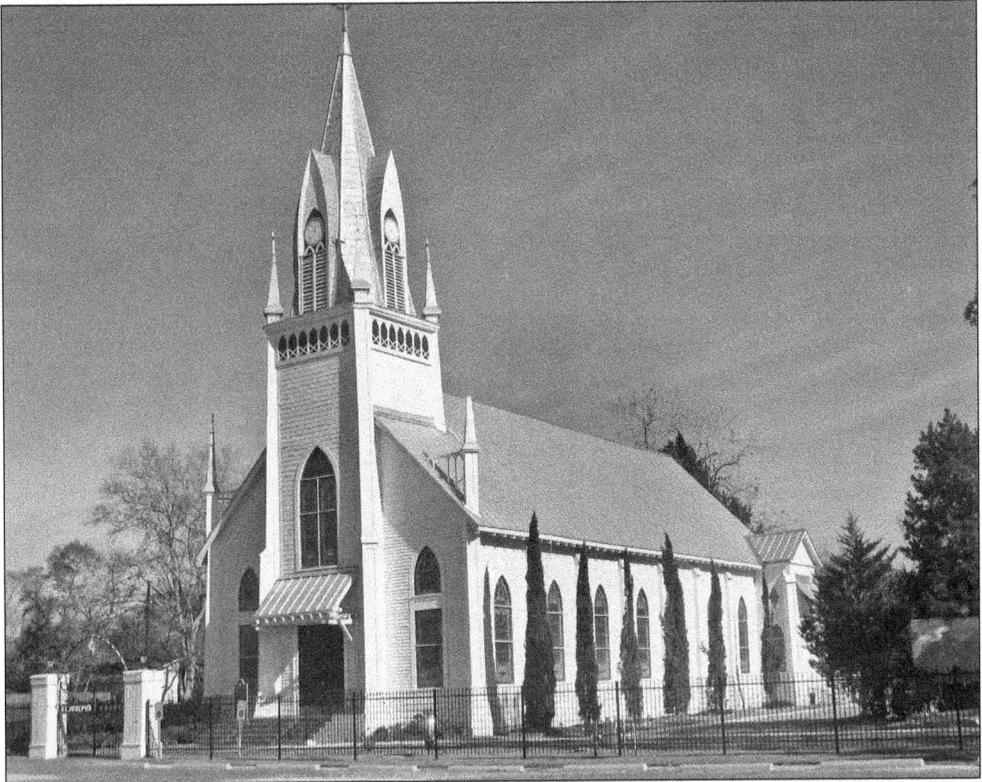

Rev. Felix Orzechowski organized St. Joseph's Parish in 1869. Soon thereafter, the first Catholic church in Walker County was built in New Waverly. The beautiful Gothic structure that stands today was completed between 1905 and 1908. It continues to serve the Catholic community in the area. (Courtesy the author's collection.)

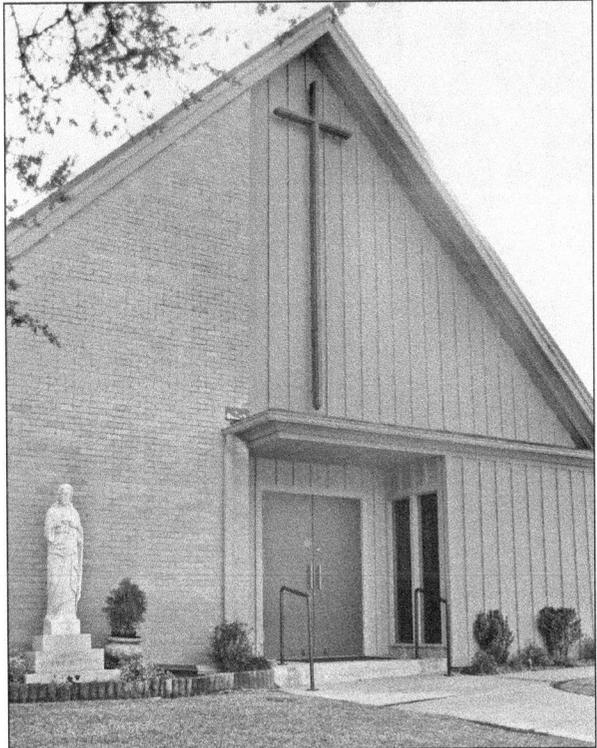

It appears that few Roman Catholics lived in Huntsville at the start of the 20th century. Those who did worshipped together without a formal church building until the early 1960s, when St. Thomas the Apostle Catholic Church was completed under parish priest Fr. Jack B. Jones. Since that time, the church has grown and prospered. (Courtesy the author's collection.)

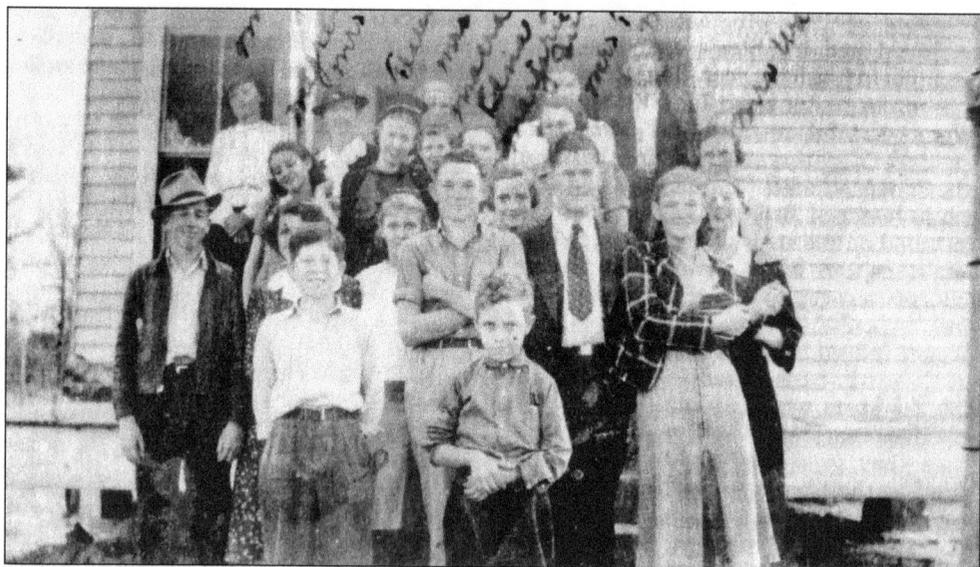

Wesley United Methodist Church traces its origins to Sterling Chapel in the mid-1920s. Pictured here are members of an early Sterling Chapel Sunday school class. (Courtesy Walker County Historical Commission.)

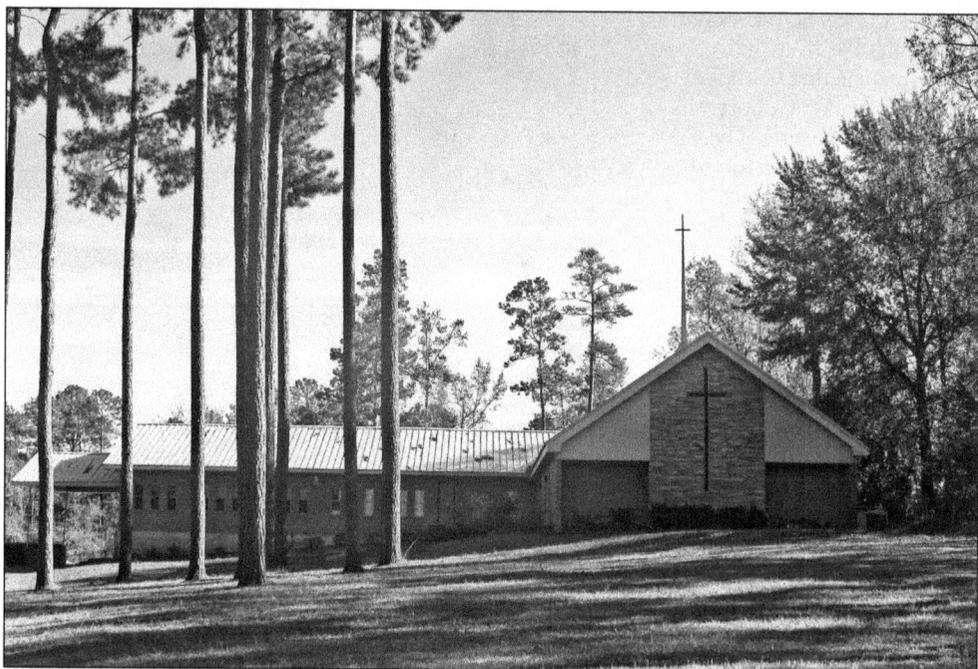

In 1938, the Sterling Chapel congregation completed work on a new church, which was named Wesley United Methodist. Pictured here is the current church sanctuary, completed in 1968. (Courtesy the author's collection.)

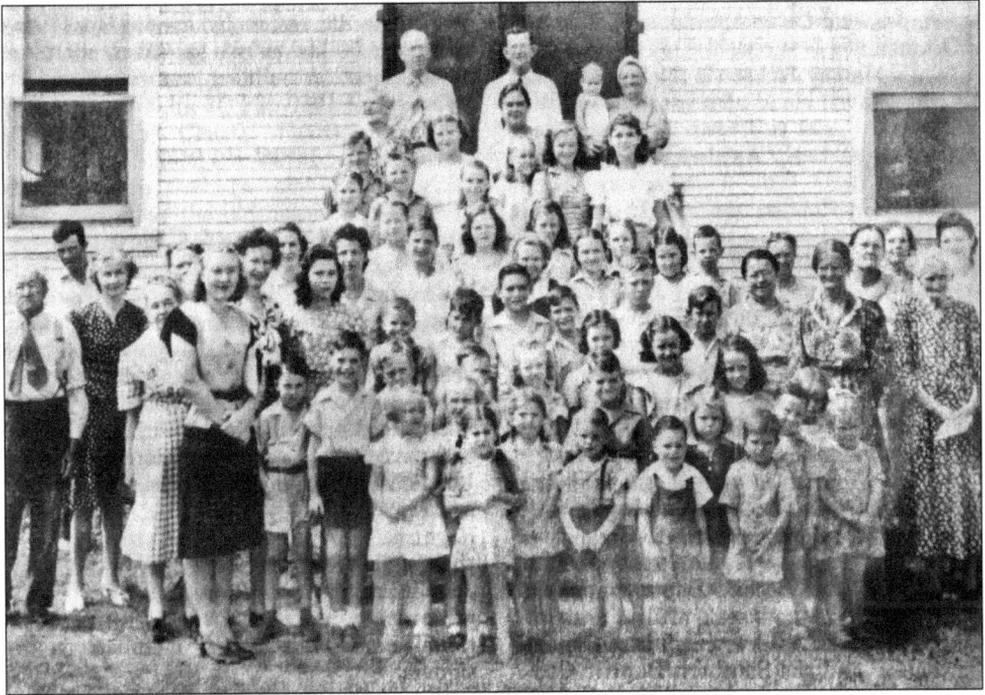

University Heights Baptist Church traces its history to East Huntsville Baptist Church, which was established in the early 1930s. Pictured here is a Bible School class from East Huntsville Baptist in 1947–1948. (Courtesy Walker County Historical Commission.)

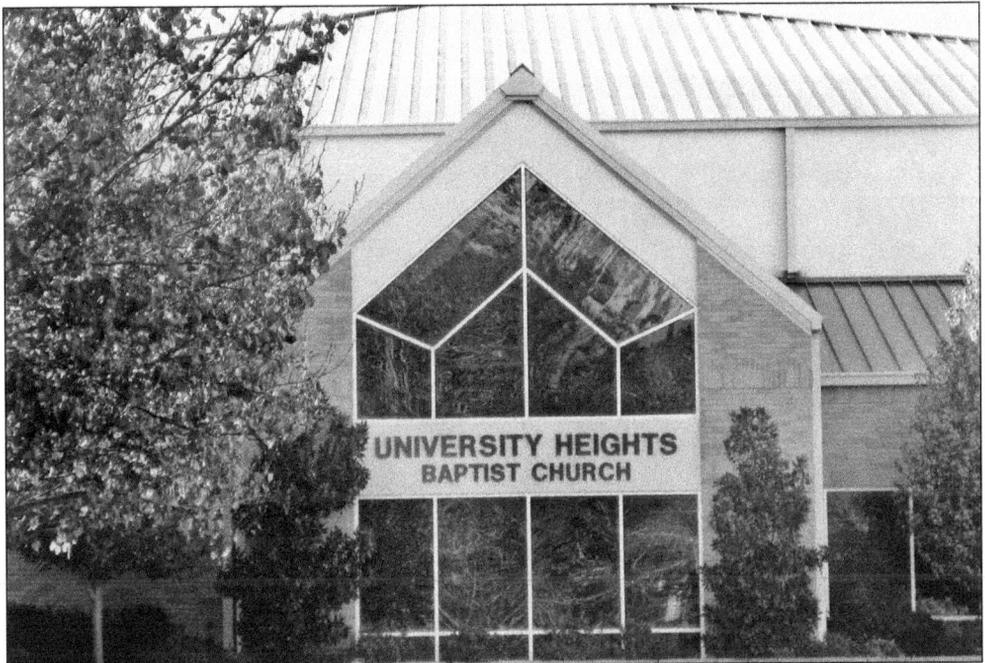

In 1970, East Huntsville Baptist Church changed its name to University Heights. Since that time, the congregation has opened a beautiful new series of buildings near Sam Houston State University on Sycamore Avenue. (Courtesy the author's collection.)

Huntsville's First Assembly of God was organized in 1935. The congregation established its first permanent building on University Avenue but later moved to Phelps Drive. Today the church has a wonderful new building near I-45 on Montgomery Road. (Courtesy the author's collection.)

Calvary Baptist Church had its origins at a revival meeting held in June 1938. Since that time, the church has grown and the congregation has expanded. The current church is located at the corner of Highway 190 and Calvary Road. (Courtesy Walker County Historical Commission.)

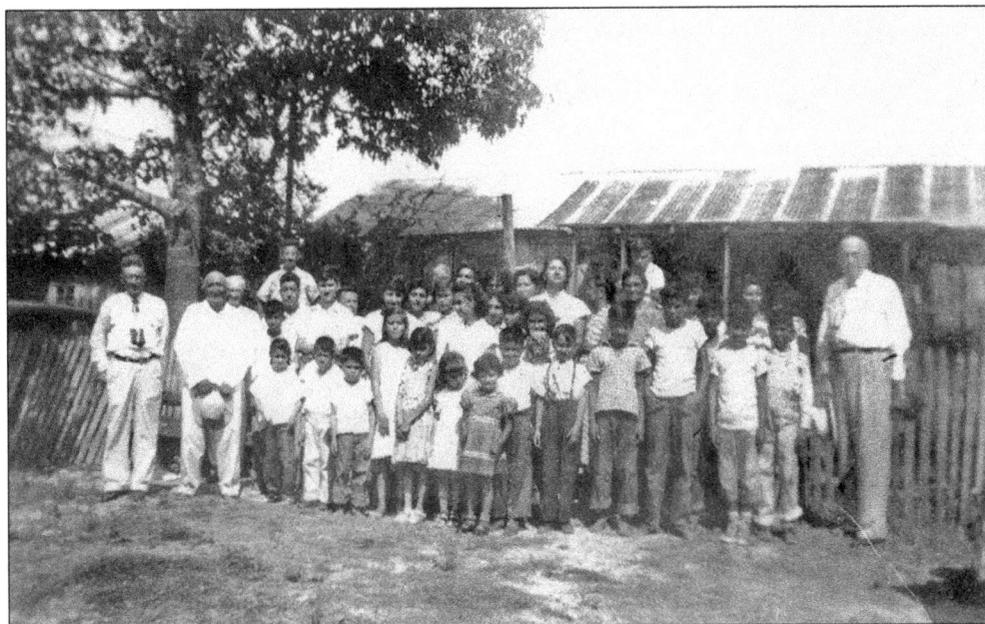

Pictured here are Rev. D. P. Cagle (far right), Austin Martinez (second from left), and members of the First Mexican Baptist Church at Boettcher's Mill. This photograph was taken on mill property in the 1950s. (Courtesy Boettcher Mill Oral History Project.)

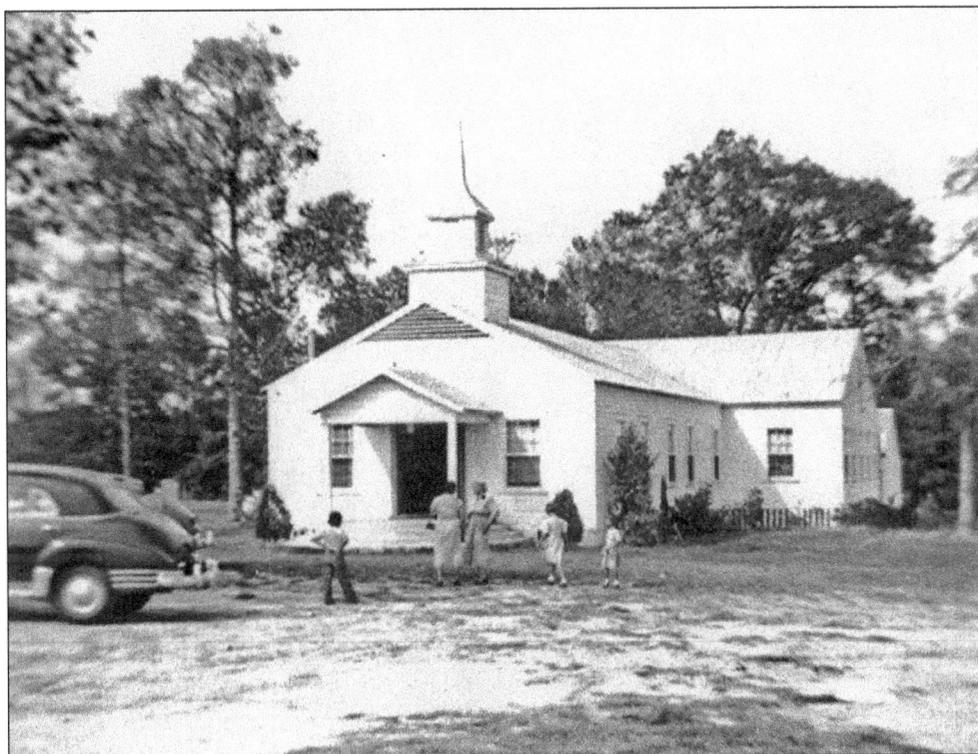

The First Mexican Baptist Church (now known as Faith Memorial Baptist Church) is pictured here in April 1955. (Courtesy Boettcher Mill Oral History Project.)

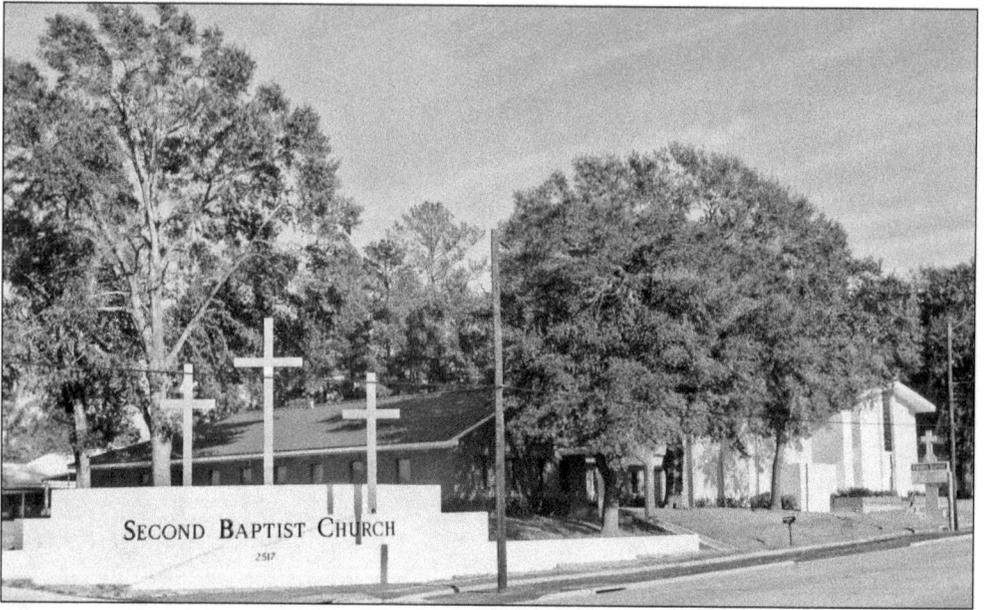

Huntsville's Second Baptist Church was founded in February 1957. The congregation opened its first building the following year, and since that time, the church has blossomed on Sam Houston Avenue. (Courtesy the author's collection.)

Faith Lutheran Church was organized in January 1957. The congregation initially met in a small building at 1629 Avenue J at the edge of Sam Houston State University. Today the church is located at 111 Sumac Road off Highway 30. (Courtesy the author's collection.)

Elkins Lake Baptist Church was established in the southwestern section of Huntsville in 1970–1971. It has grown and relocated several times in its 40-year history. Pictured here is the current church at 206 Highway 19. (Courtesy the author's collection.)

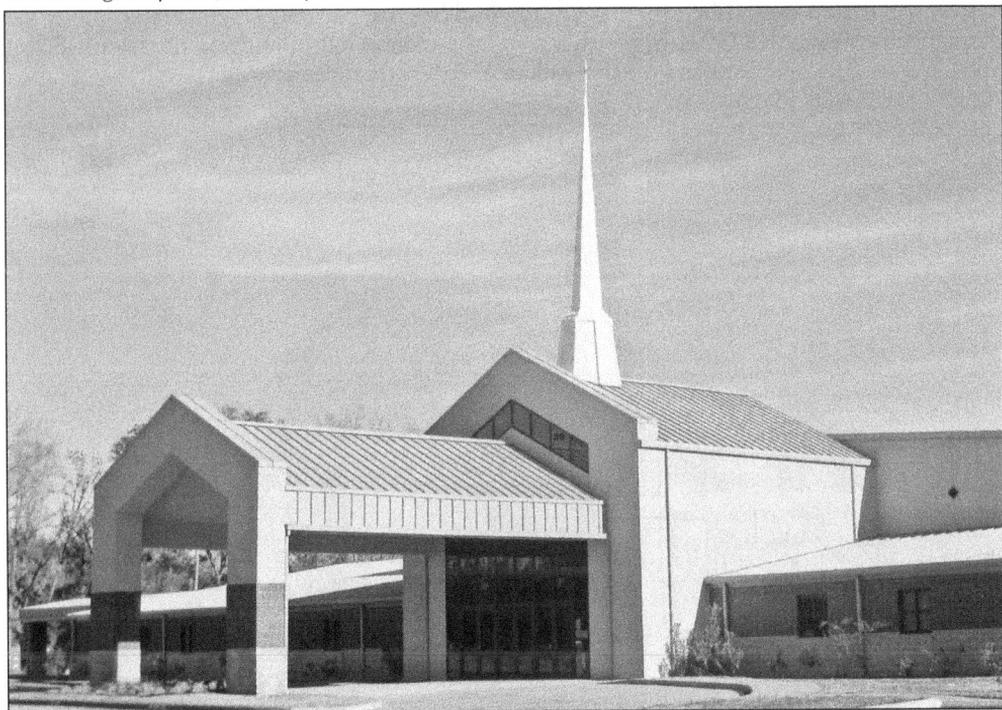

The first Church of Christ in Huntsville was founded in 1860. Members joined in large numbers initially, but by the turn of the 20th century, the church had all but disappeared. It resurfaced in the 1920s, however, and since then, the congregation has grown dramatically. Pictured here is the current church on Highway 30 West. (Courtesy the author's collection.)

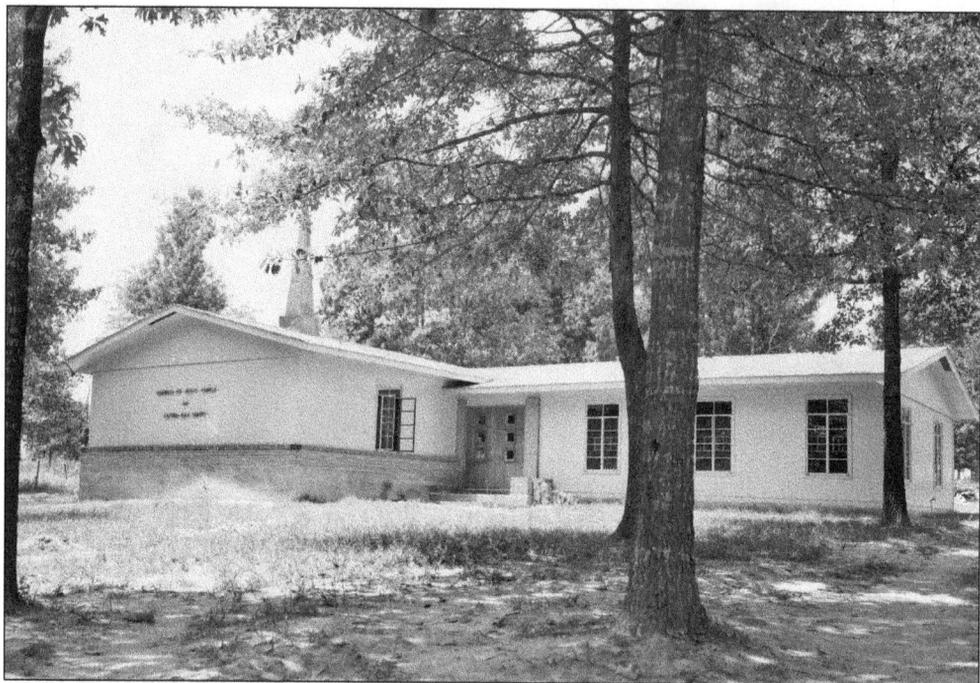

The Church of Jesus Christ of Latter-day Saints began meeting in Huntsville as early as 1949. The congregation established its first church building in 1955, and membership increased dramatically during the 1970s. Since that time, the church has moved to Nineteenth Street and Avenue S, where it offers a kind welcome to visitors every week. (Courtesy Walker County Historical Commission.)

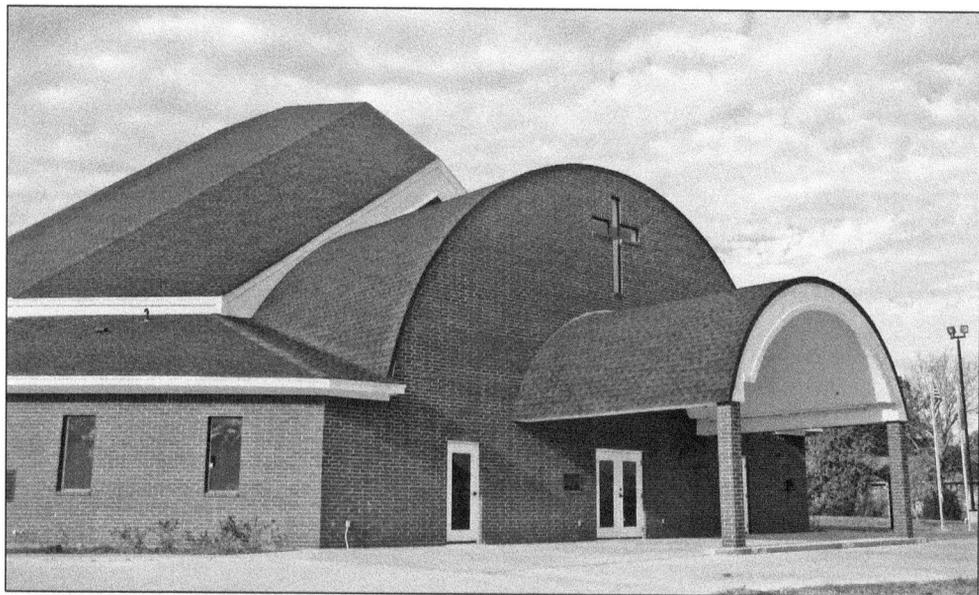

Little Zion Baptist Church was founded in 1900. After years of growth and development, the congregation voted to change its name to Greater Zion Baptist. Pictured here is the current sanctuary building, which sets atop a small hill on Highway 190 East in Huntsville. (Courtesy the author's collection.)

Four

BUSINESS INTERESTS

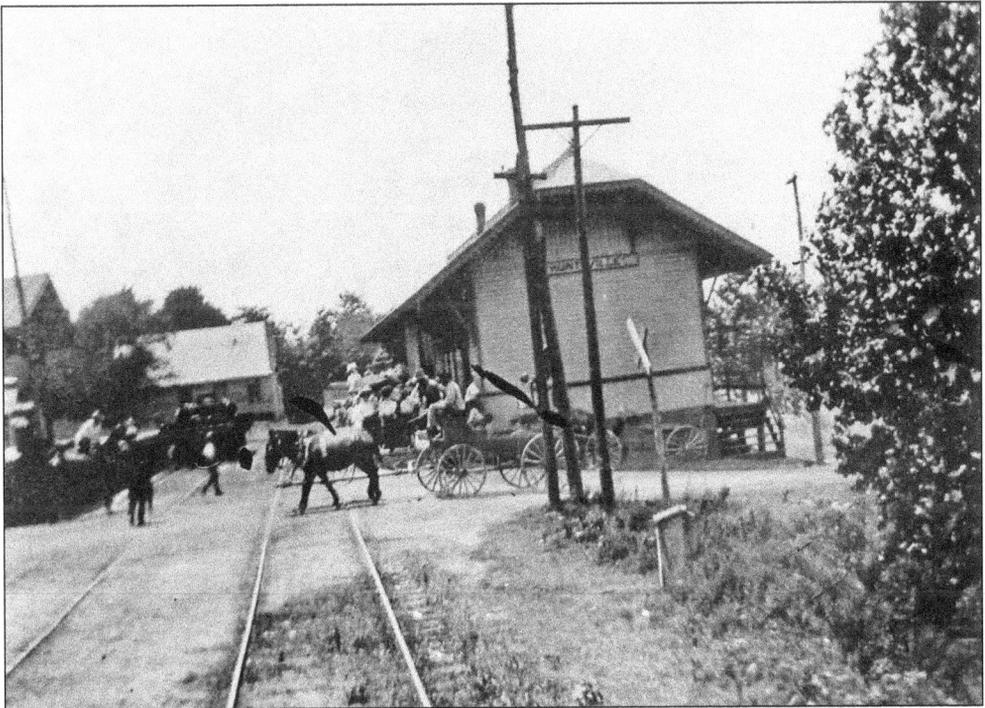

Shown here is the Huntsville Train Depot around 1880. (Courtesy Walker County Historical Commission.)

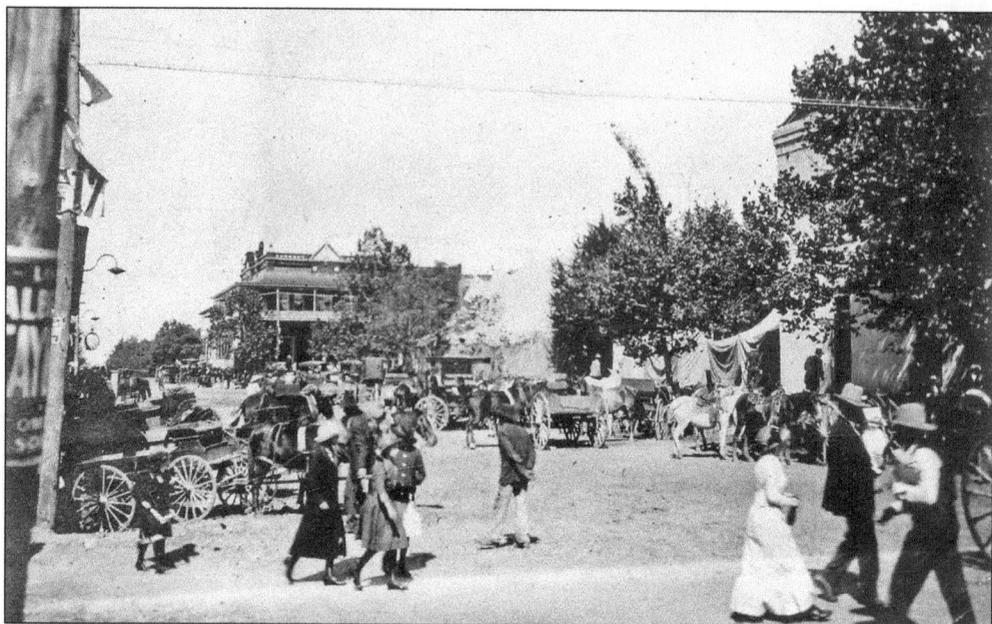

The square in Huntsville was a public meeting spot and an excellent site for business at the end of the 19th century. In the background, the oldest store on the square—Gibbs Brothers—is visible. (Courtesy Walker County Historical Commission.)

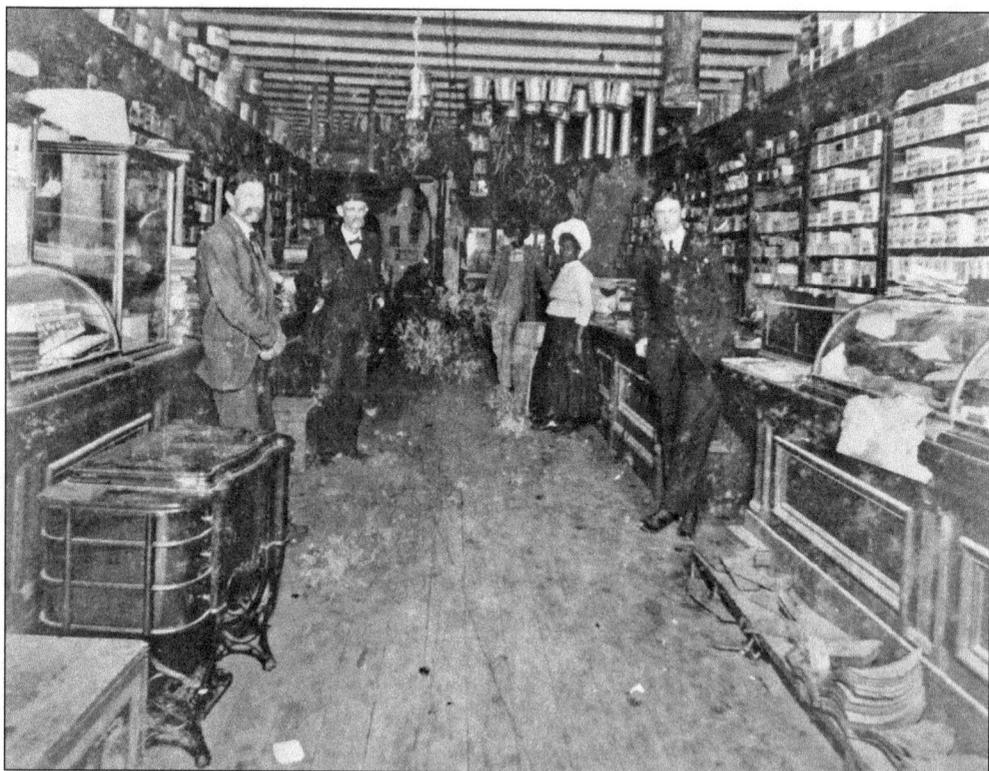

This photograph provides a rare glimpse inside the Gibbs Brothers store around 1880. (Courtesy Walker County Historical Commission.)

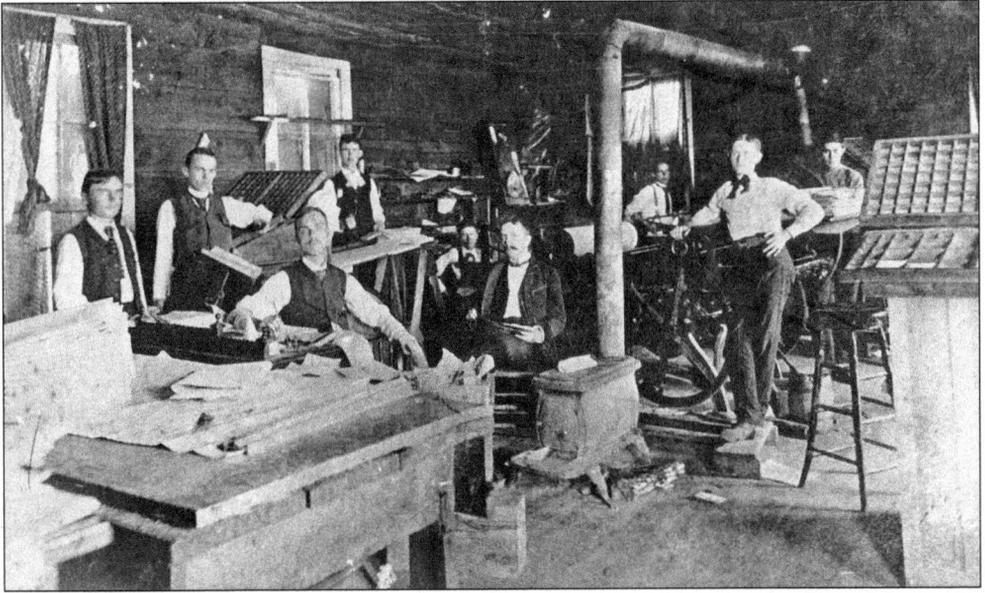

Pictured here is the interior of the *Huntsville Item* on a c. 1885 publication day. From left to right are (seated) Fred B. Robinson and W. Y. Barr; (standing) John Ernst, Hunter Ward, ? Farris, Hugh Bob Davis, M. E. Foster (founder of *Houston Chronicle*), Henry Raines, and Gus Ernst. (Courtesy Huntsville Arts Commission.)

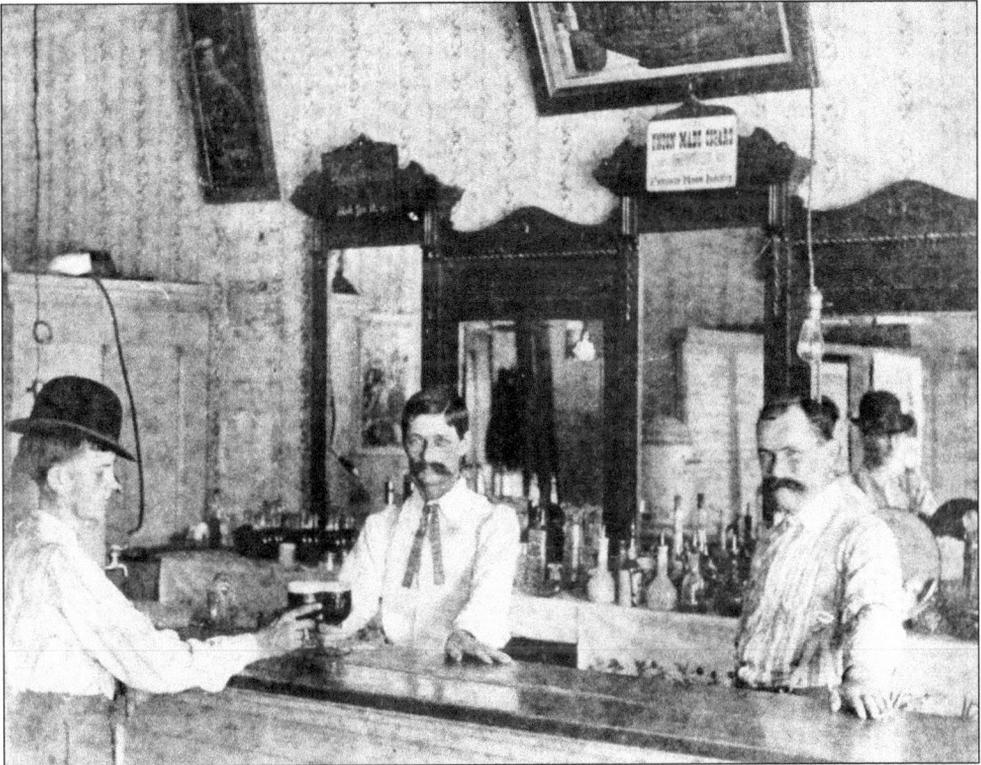

Doorman's Saloon was a popular watering hole on the south side of the square in the 1890s. (Courtesy Huntsville Arts Commission.)

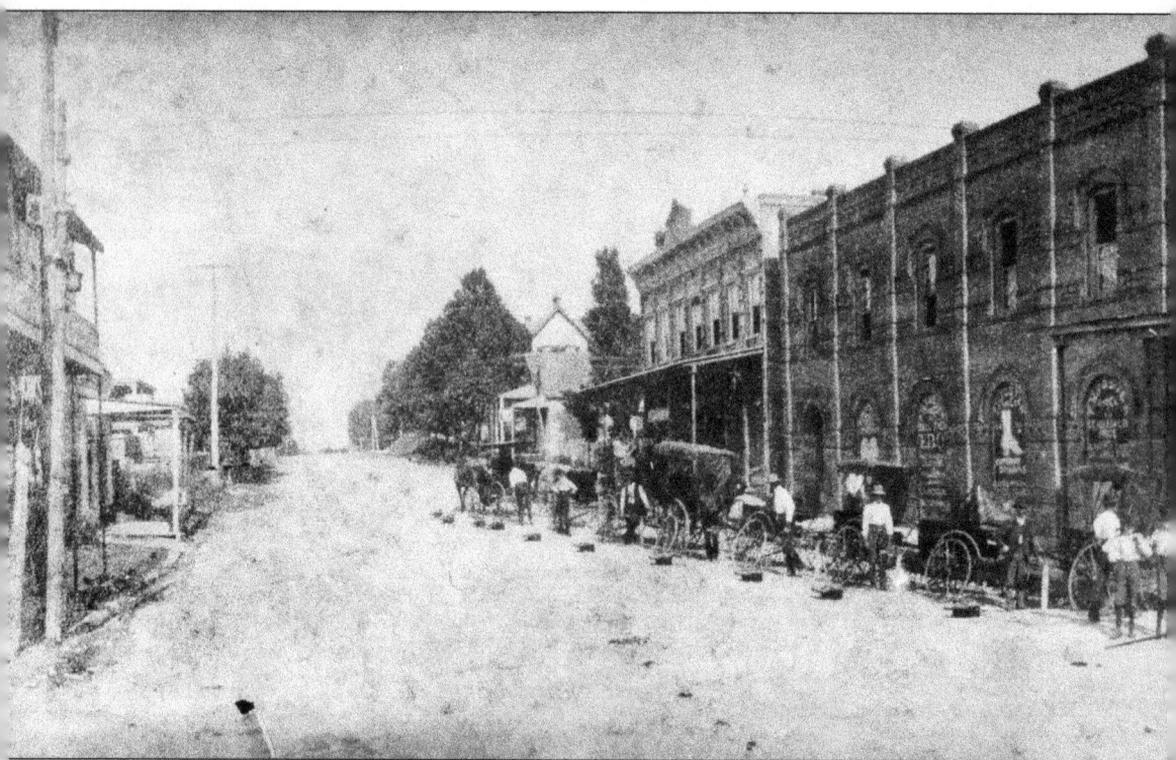

In 1893, Fitz Hugh Foster established a mercantile store at University Avenue and Twelfth Street. He was the brother of M. E. Foster (the founder of the *Houston Chronicle*) and the grandson of George Fitzhugh, the author of *Sociology for the South*. Fitz Hugh Foster's business

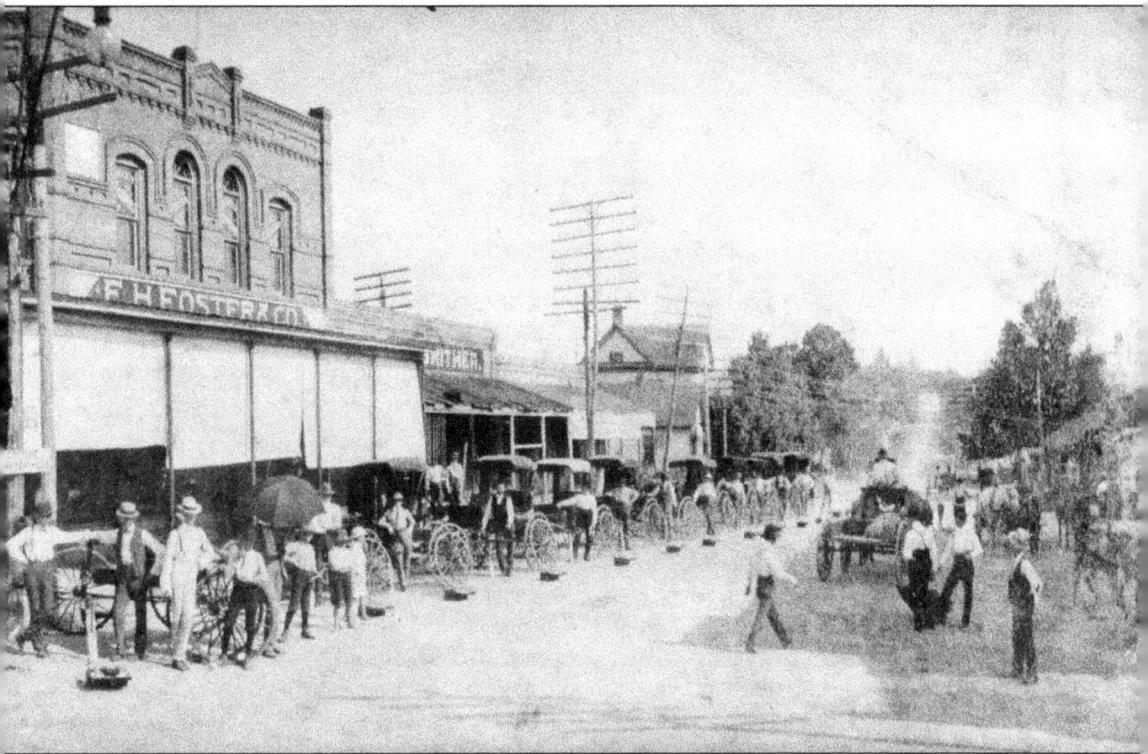

flourished in the 1890s, and he briefly sat on the school board of Huntsville. In 1902, Foster died suddenly, and his younger brother A. B. Foster took over the business. (Courtesy Walker County Historical Commission.)

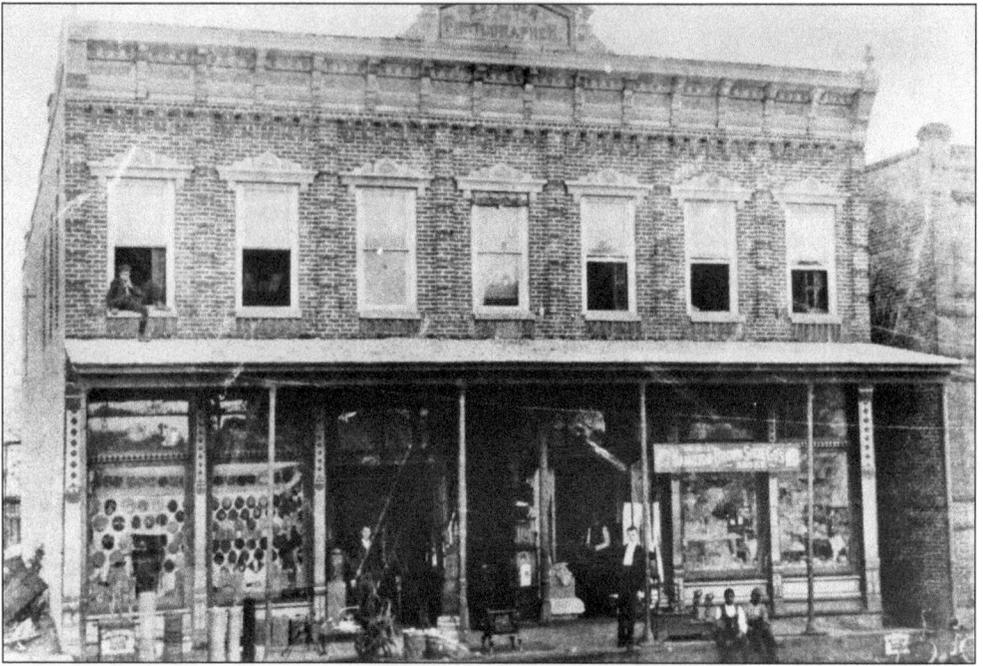

Following a successful run in the Galveston shipping business, Spurgeon Sheridan Felder arrived in Huntsville in 1882. He quickly set up a photographic studio and went into the real estate business. His building on Twelfth Street—initially rented to a local merchant—was a family dry-goods store by the time this photograph was taken in 1895. (Courtesy Walker County Historical Commission.)

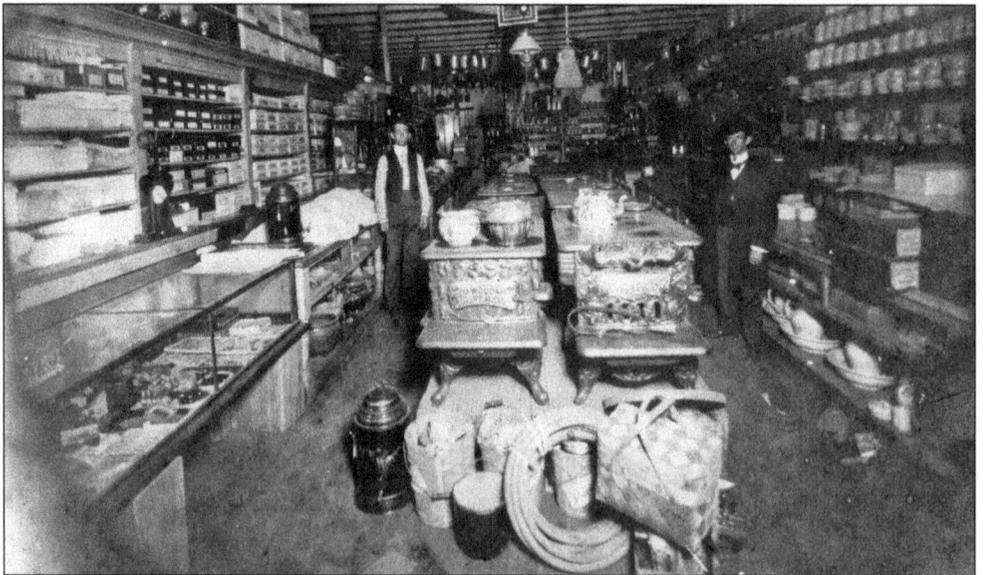

William Hamby Randolph was the grandson of Samuel McKinney, one of Huntsville's early pioneers. Born in 1875, Randolph became a contractor and construction expert. He operated a Hardware Store (pictured here), sawmill, and lumber company. In addition, he even purchased the old Cumberland Presbyterian Church building to make a skating rink. (Courtesy Walker County Historical Commission.)

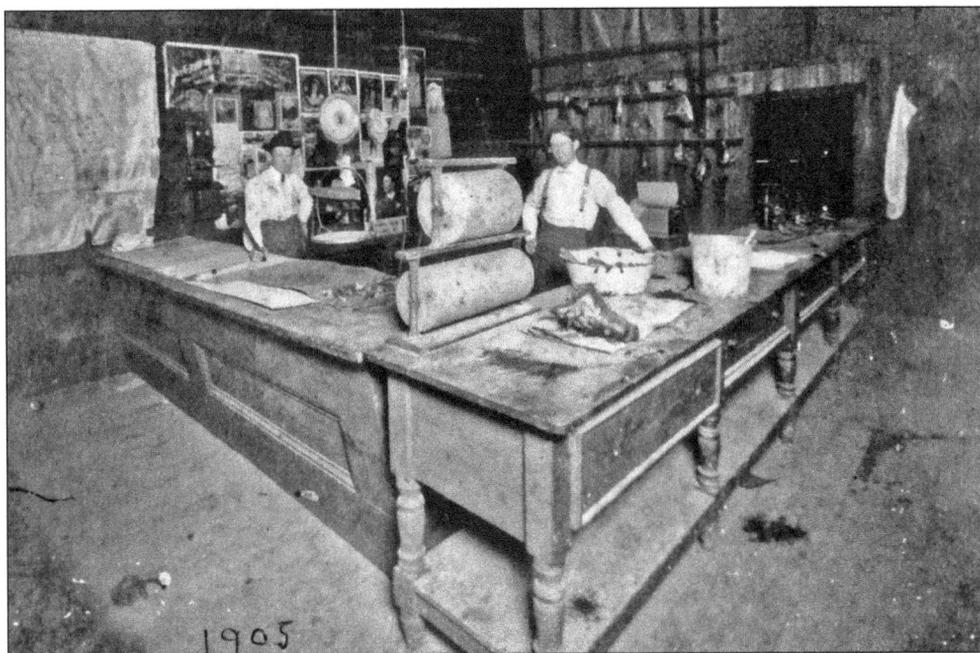

James Marcus Smith was born in Walker County in 1883. He went into business with his older brother J. Wince Smith, and they had ranches in nearby Pearsall and Pearland. Pictured here is the Smith Meat Market on Eleventh Street near the former post office around 1905. (Courtesy Huntsville Arts Commission.)

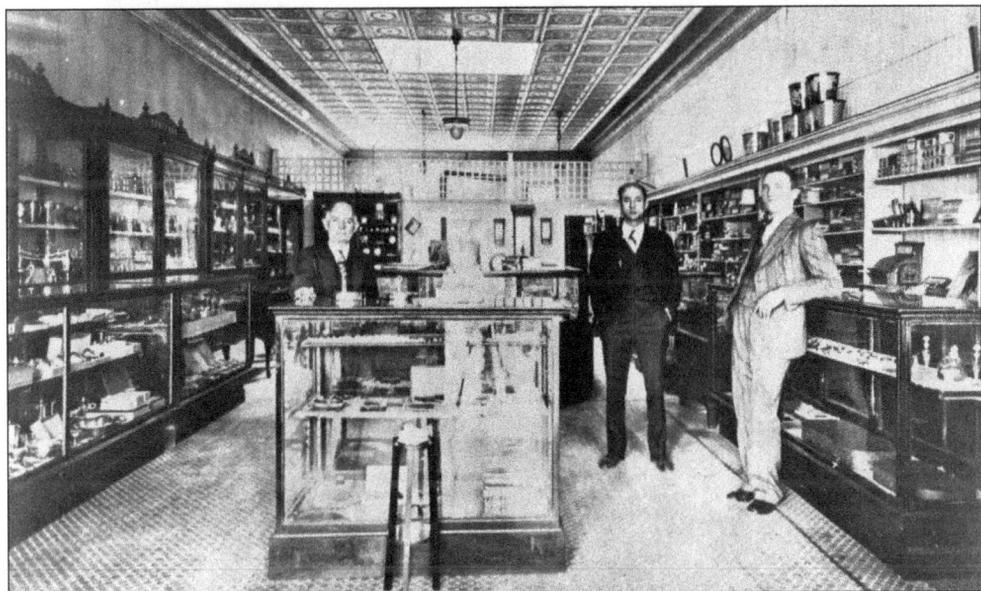

Edward Ernst immigrated to Huntsville from Switzerland in 1852. He was a partner of James A. Baker and did well in the mercantile business that grew up in the early city. Following Edward's death in 1861, his brother Augustus emerged as the head of the family. Augustus married Edward's widow, Rebecca, and the couple had four sons. Robert Ernst, one of these young men, became a prominent jewelry retailer during the first half of the 20th century. (Courtesy Huntsville Arts Commission.)

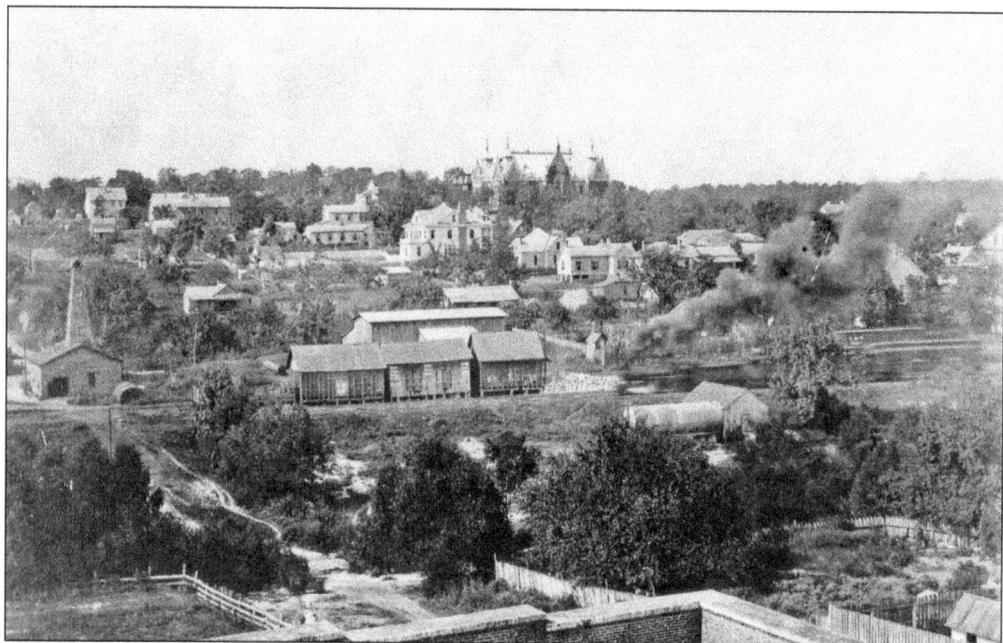

This photograph provides a view from the Huntsville Penitentiary toward Sam Houston State University. It highlights the growth of Huntsville by the early 20th century and shows the "Tilley" train line, named after its conductor, J. Robert Tilley. (Courtesy Huntsville Arts Commission.)

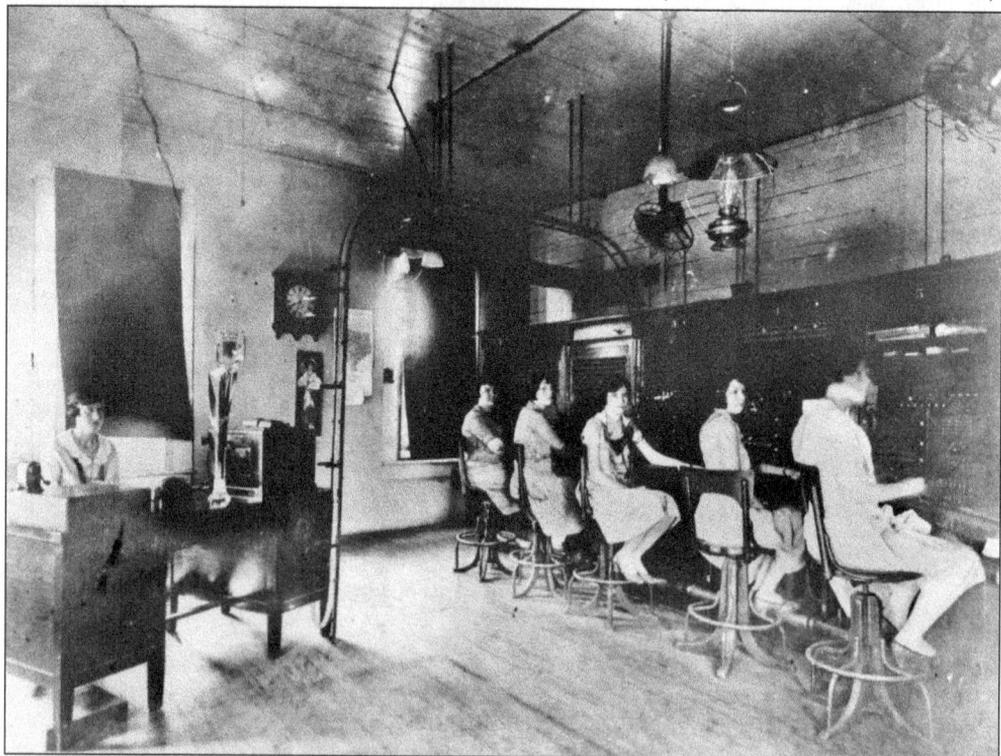

Pictured here are the operators at the early telephone switchboard established by Huntsville Telephone Company around 1920. (Courtesy Huntsville Arts Commission.)

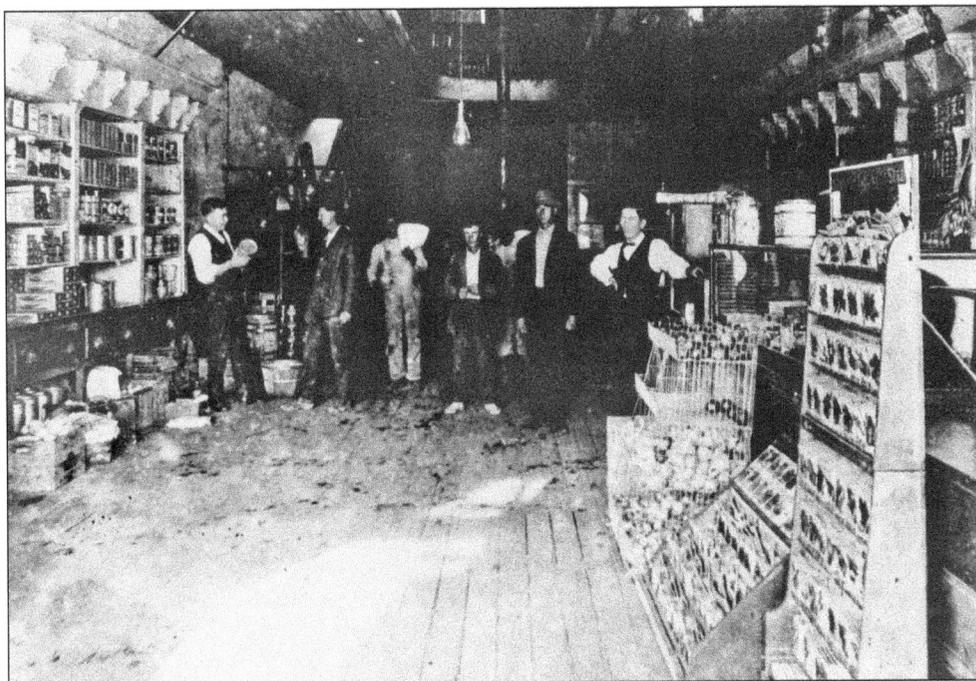

George Mercer received one league of land from the Mexican government in 1835. His wife, Elizabeth Linfoot Mercer, inherited the land when he died of yellow fever. She then married John William Oliphint around 1840. The Oliphints had several children and grandchildren. One of the most prominent was Thomas Leclair Oliphint (1888–1947), who operated a grocery store on the north side of the Huntsville square with Murray Lamkin, one of his cousins. Thomas Oliphint later became manager of Huntsville Coca-Cola Bottling Company. (Courtesy Huntsville Arts Commission.)

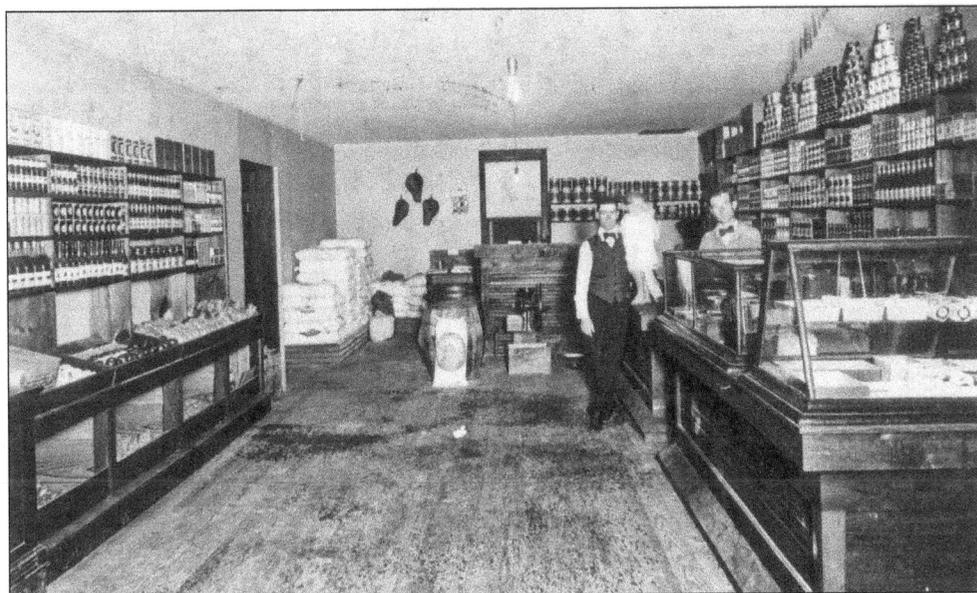

Pictured here are John Baldwin (left) and James Baldwin (right), the owners of Baldwin Brothers Grocery and Hardware Store on the north side of the square. (Courtesy Huntsville Arts Commission.)

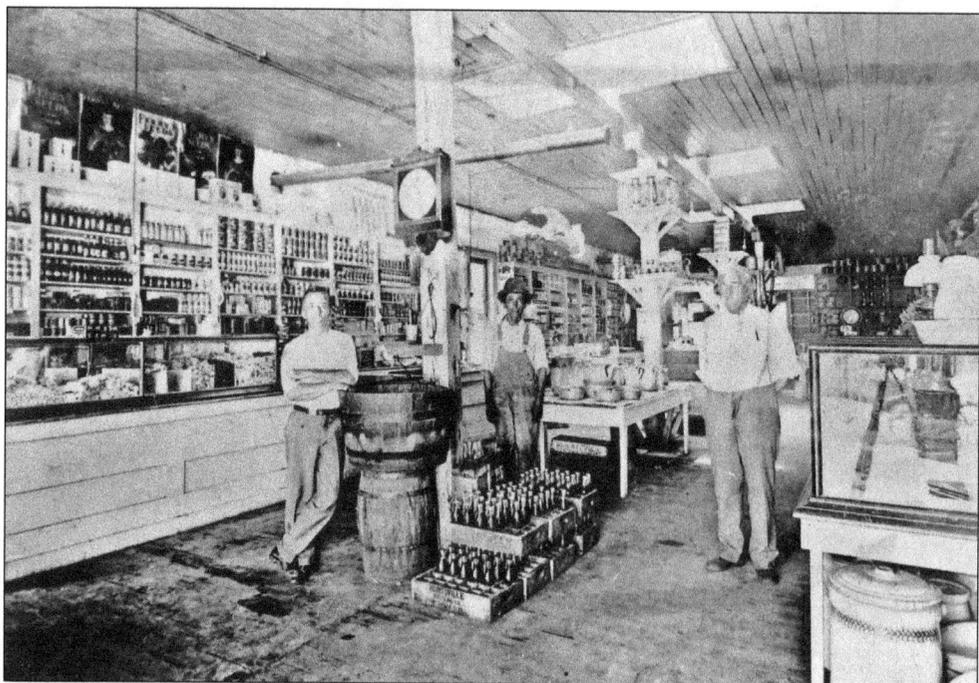

Braxton Alston Eastham (1868–1936) was born in Huntsville to Byrd and Delha Eastham. His parents had extensive farm and cattle holdings in the area and owned a plantation home near the square. When Braxton's father died in 1883, the young man helped his mother run the family's properties. Pictured here around 1920 is the family store located on the north side of the square. (Courtesy Huntsville Arts Commission.)

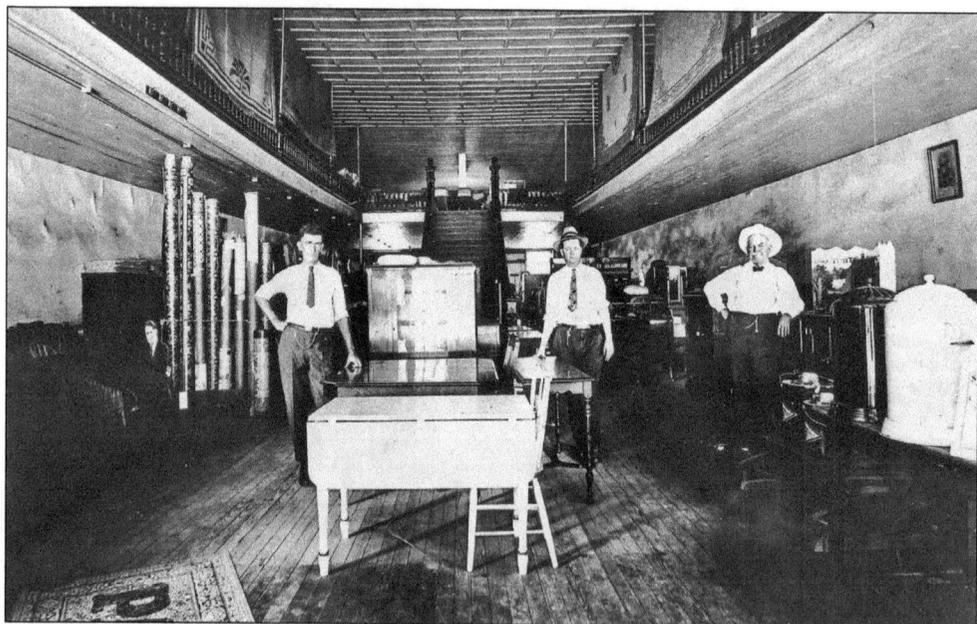

Here is a rare c. 1924 interior photograph of Ashford Furniture and Undertaking. Pictured from left to right are Wilber Rittenhouse, Goree Ashford, and J. G. Ashford. (Courtesy Huntsville Arts Commission.)

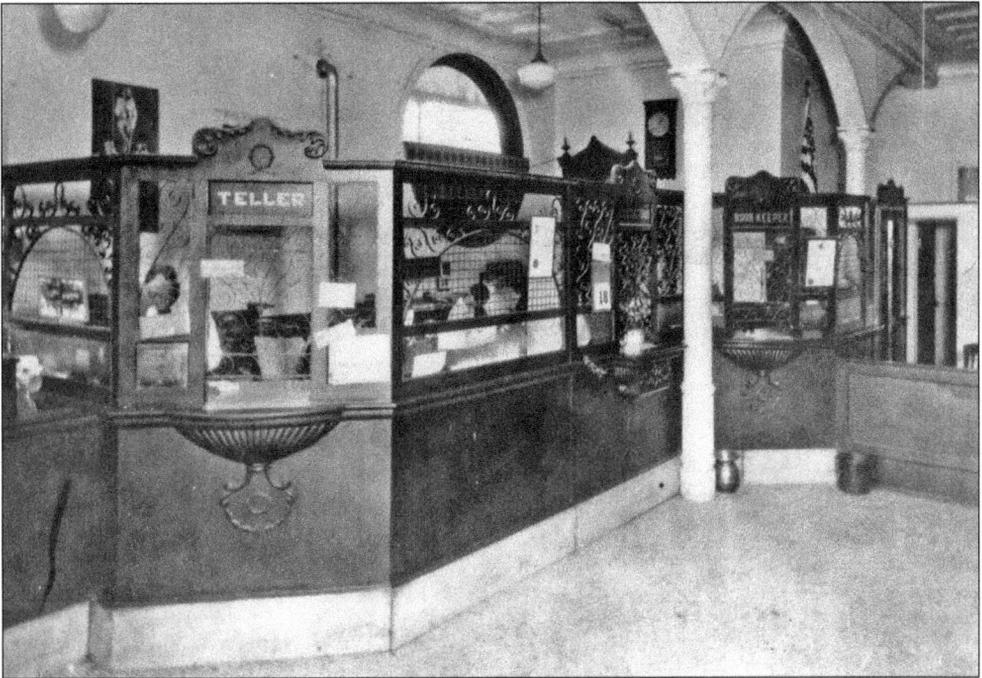

Gibbs National Bank was established in 1890 after customers repeatedly requested to use the local firm's safe. In 1922, this institution became the First National Bank in Huntsville. (Courtesy Huntsville Arts Commission.)

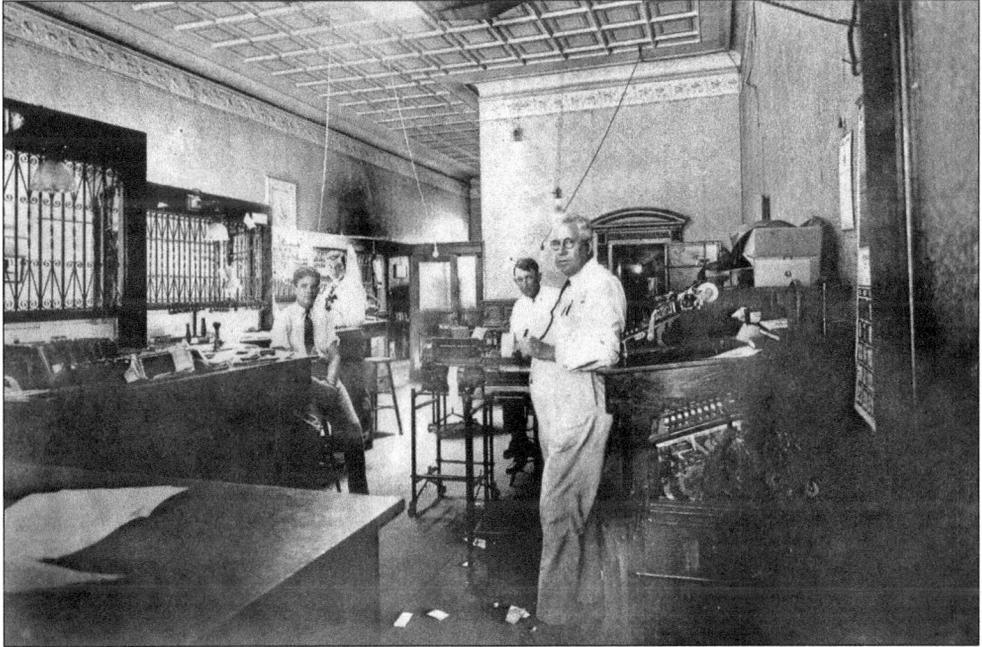

Pictured here is a 1933 interior photograph of Huntsville State Bank (later Huntsville National Bank), with Raymond Davis, H. Q. Webster, Rufus Miller, and A. T. Randolph. Huntsville State Bank was founded in 1907 as a local alternative to the Gibbs National Bank. (Courtesy Huntsville Arts Commission.)

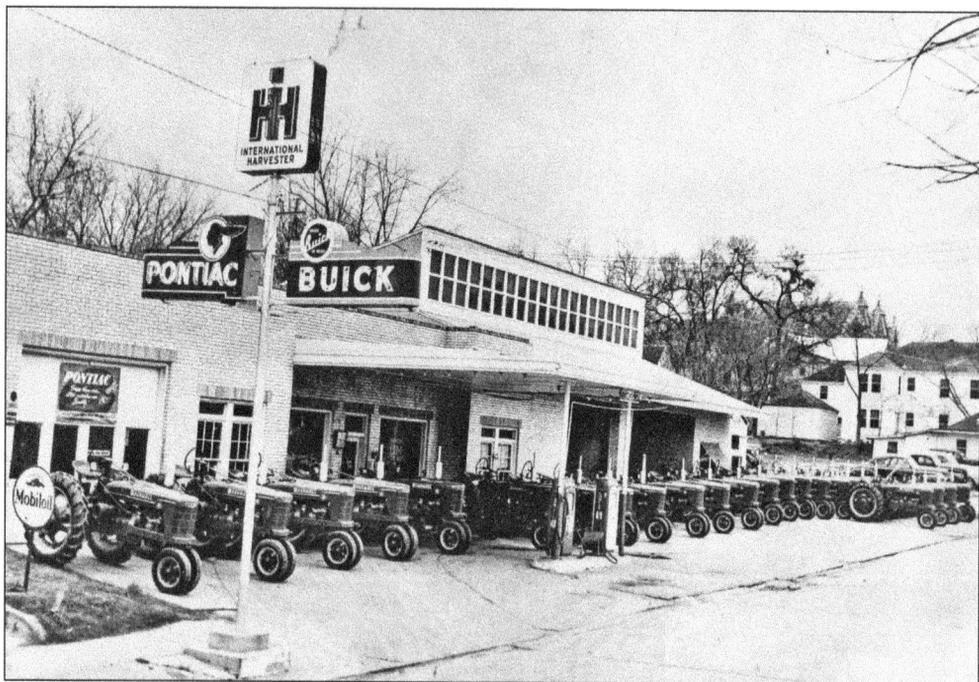

This *c.* 1946 photograph shows more than 20 tractors assembled on the lot at Charles and Sam Motor Company on Sam Houston Avenue and Fifteenth Street. (Courtesy Huntsville Arts Commission.)

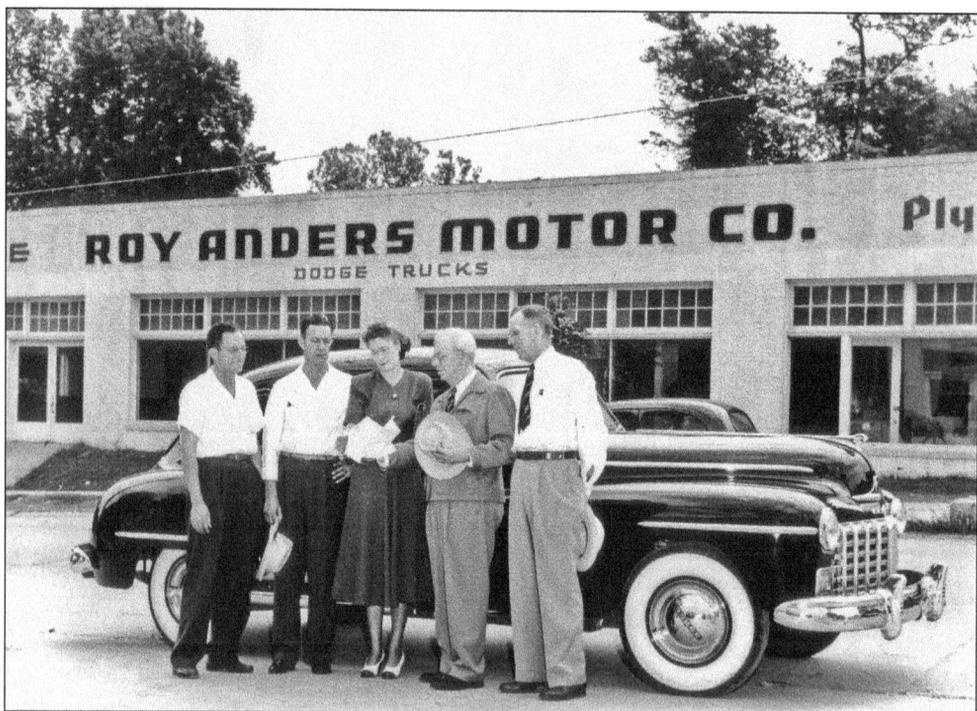

Here is a promotional photograph from Roy Anders Motor Company and Car Sales, which gave away this classic Dodge in May 1948. (Courtesy Huntsville Arts Commission.)

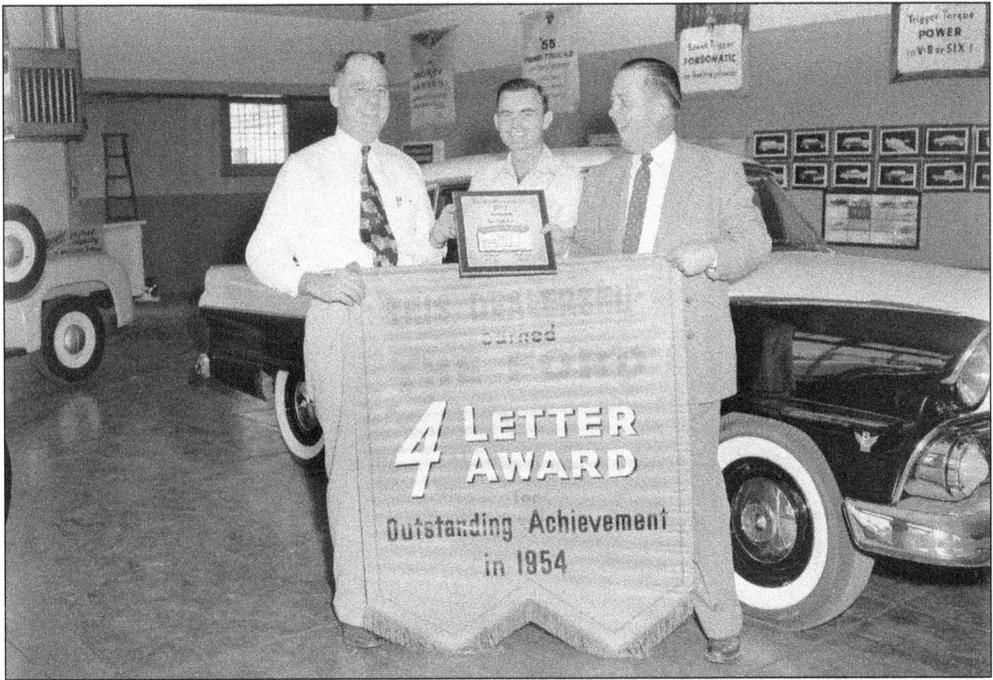

In 1954, Wood Motors received a Four Letter Award for Outstanding Achievement. Pictured here from left to right are Frank Moore, Jerry Heartfield, and John Apple on March 25, 1955. (Courtesy Huntsville Arts Commission.)

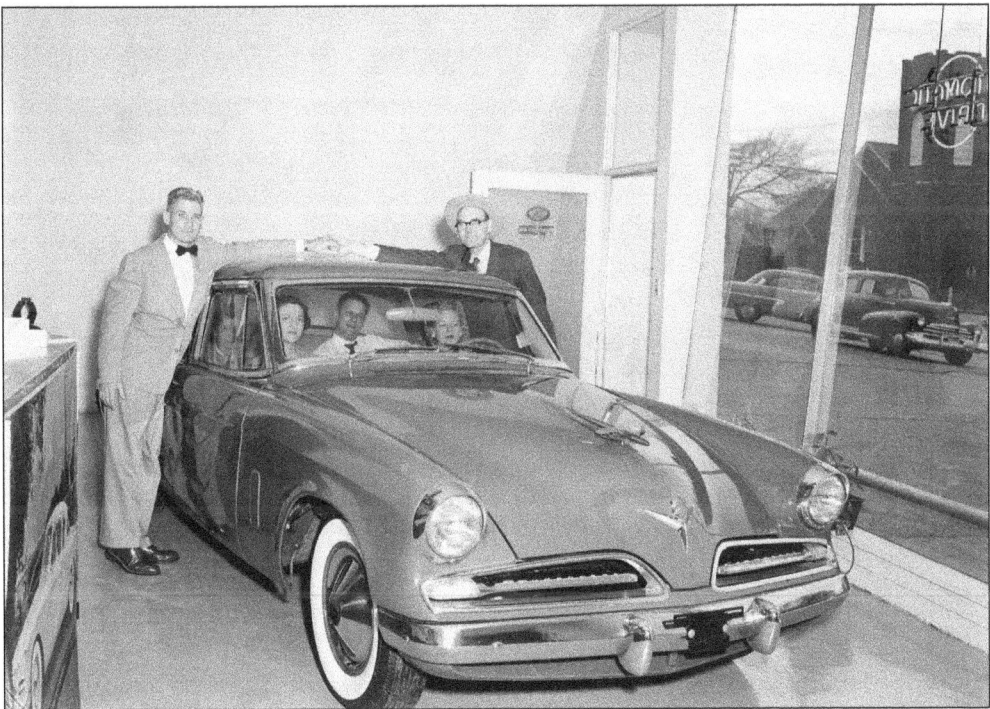

Joseph Griggs (left) and Q. C. Robbins shake hands over the top of a new Sport Studebaker on March 3, 1953. (Courtesy Huntsville Arts Commission.)

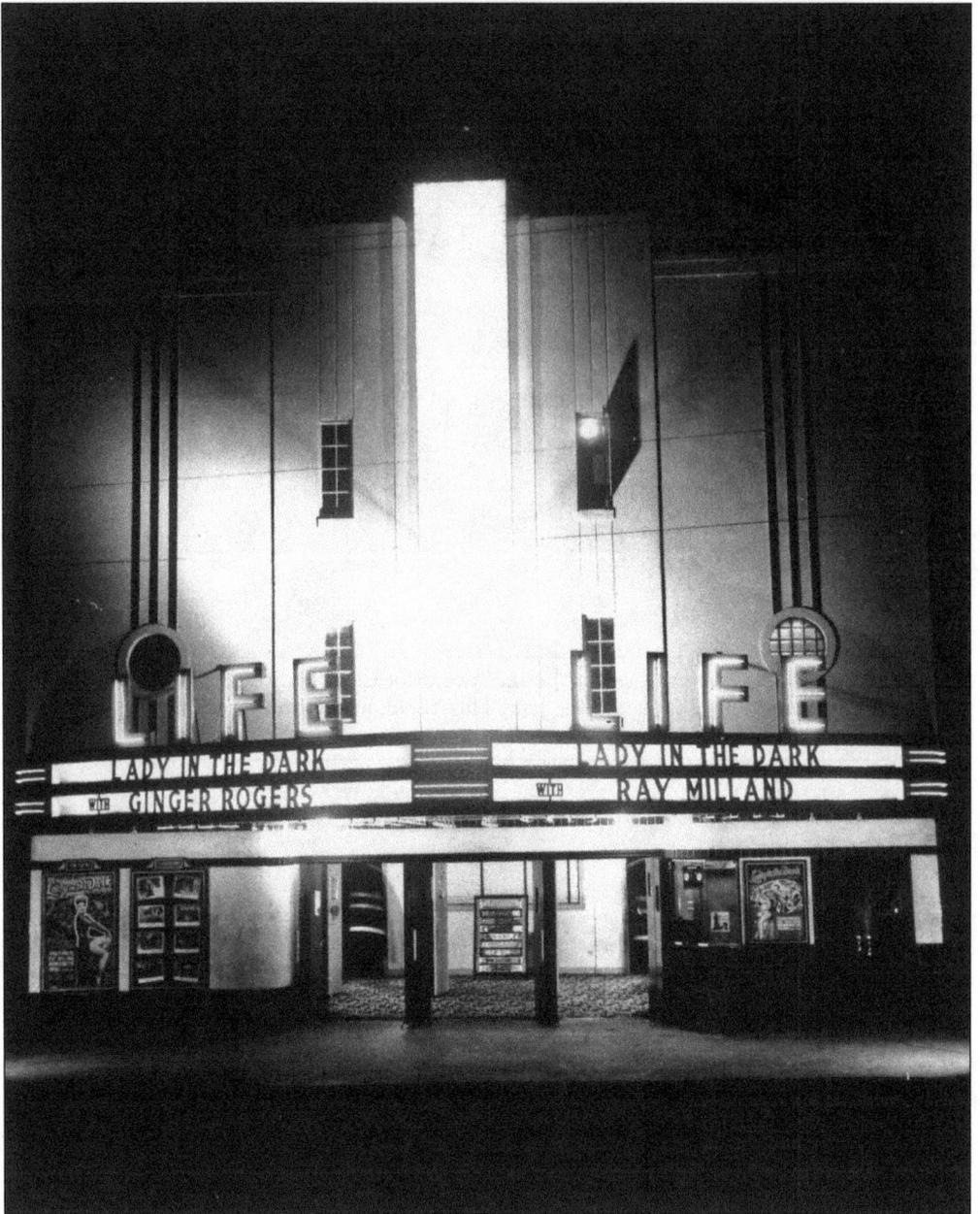

Pictured here is Life Theatre (1941–1980), a Huntsville hot spot that was located on Sam Houston Avenue. (Courtesy Huntsville Arts Commission.)

The Avon Theater offered moviegoers another option for entertainment in Huntsville. (Courtesy Huntsville Arts Commission.)

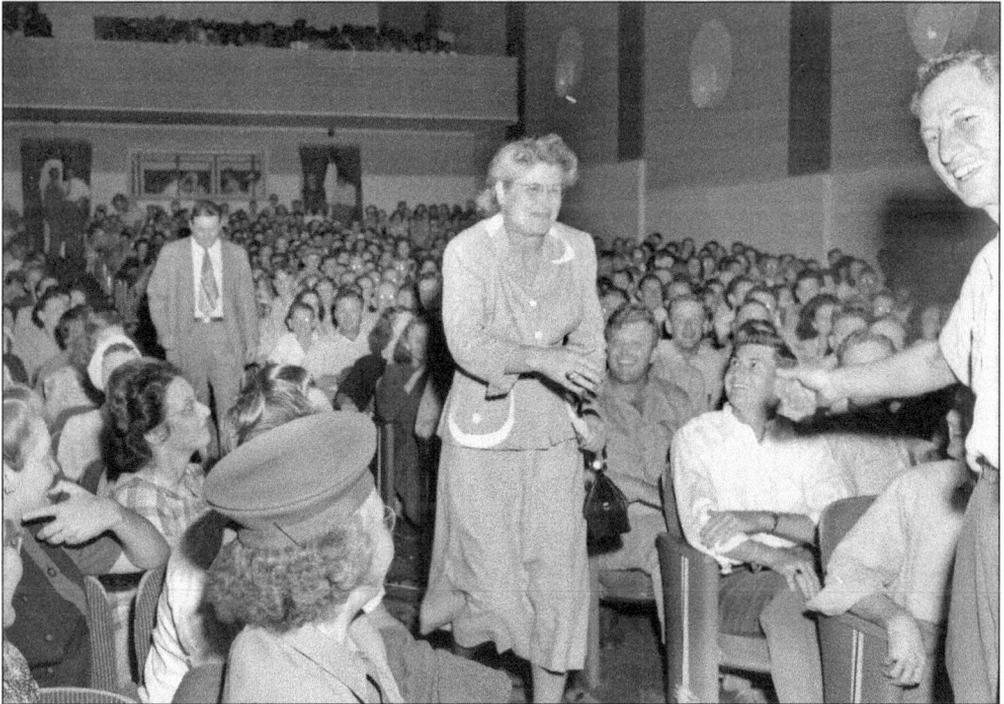

On May 12, 1948, Roy Anders Dodge gave away a car at the Life Theater. Note the segregated seating arrangements of the late 1940s. (Courtesy Huntsville Arts Commission.)

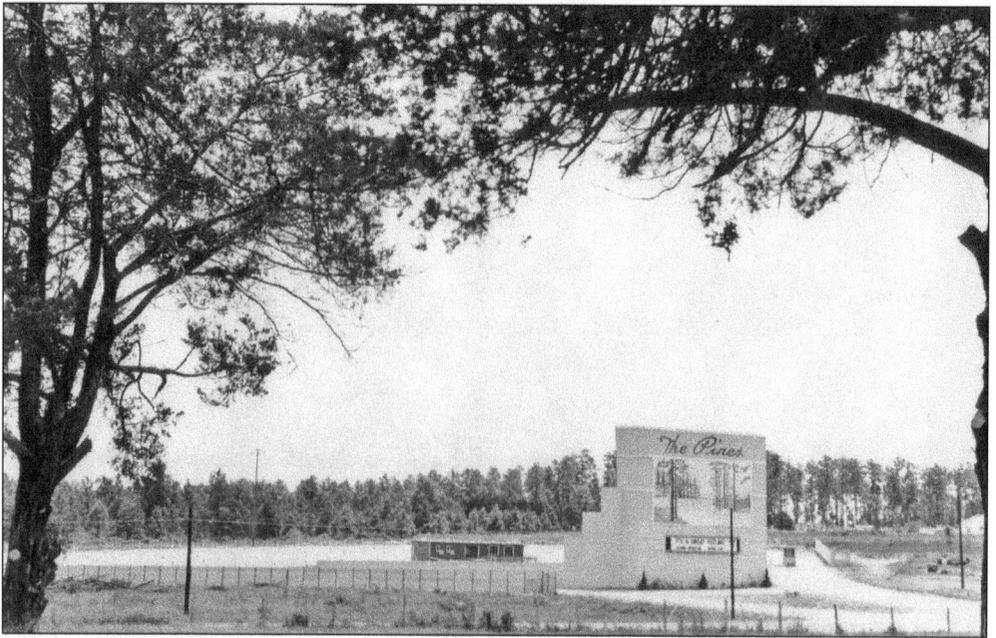

Drive-in theaters offered moviegoers the odd luxury of sitting in their cars. Pictured here is the Pines Drive-In around 1950. (Courtesy Huntsville Arts Commission.)

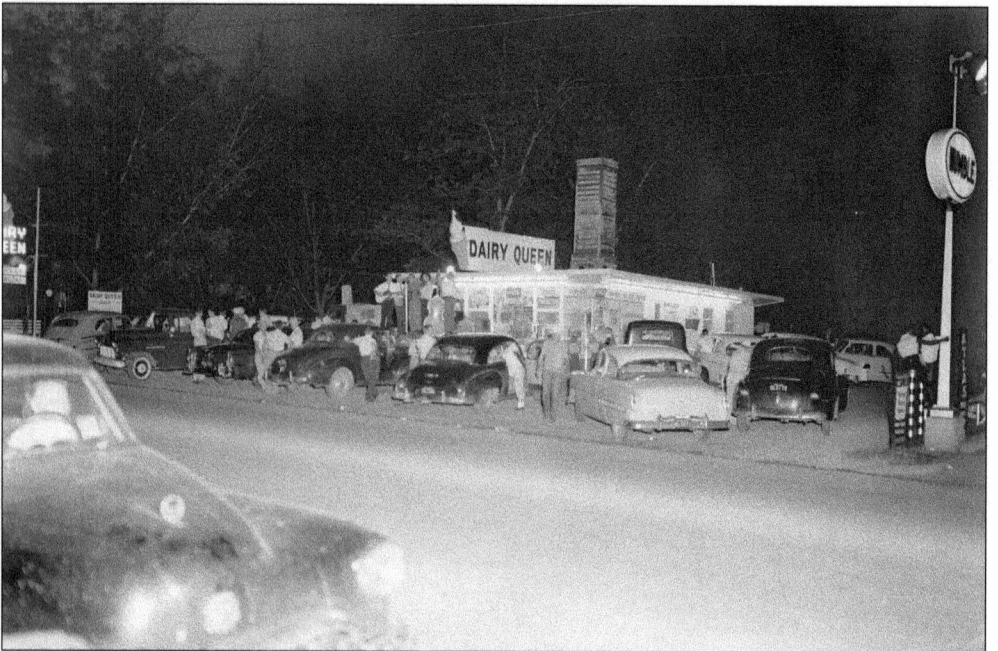

On May 19, 1956, young people gathered at the local Dairy Queen for live music and a bit of fun. (Courtesy Huntsville Arts Commission.)

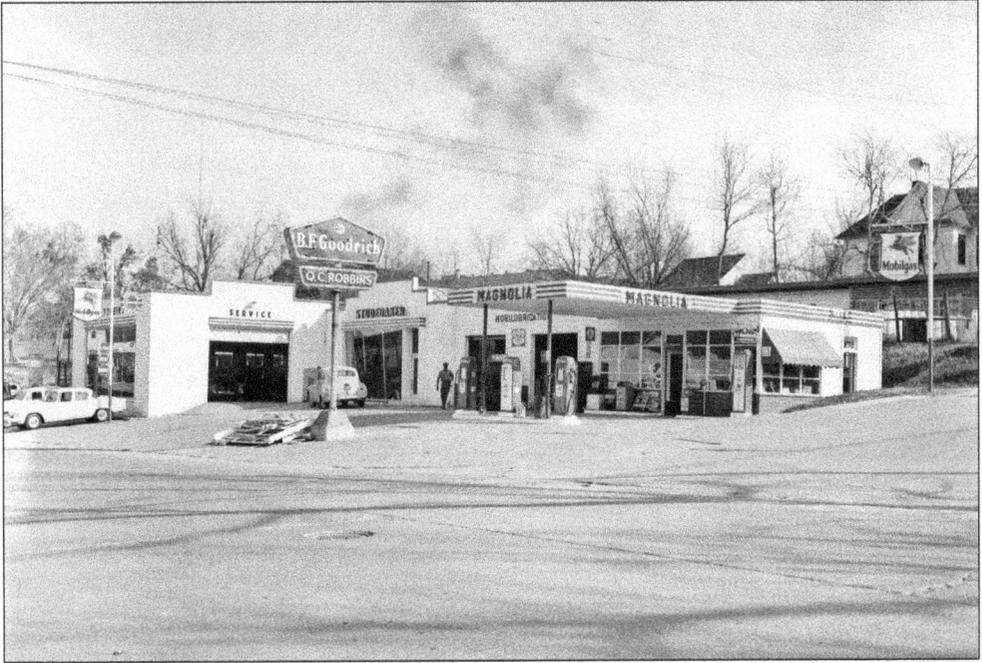

The thousands of automobile owners in Huntsville needed gasoline and a good mechanic. They could find both at B. F. Goodrich. (Courtesy Huntsville Arts Commission.)

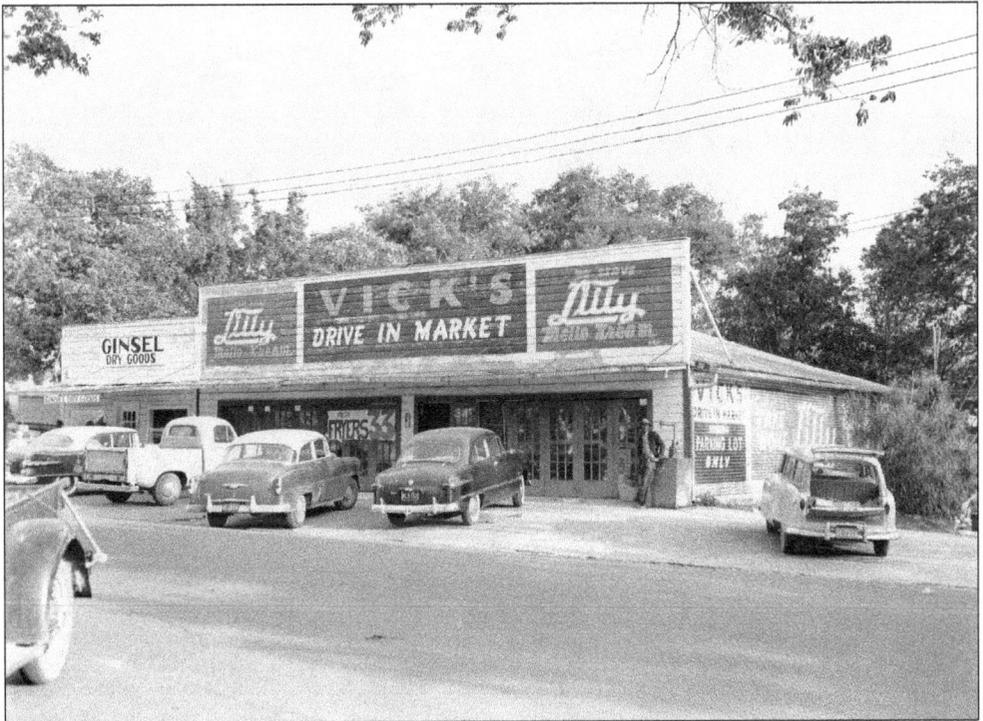

Vick's Drive-In Market was a popular shopping spot in the 1950s. (Courtesy Huntsville Arts Commission.)

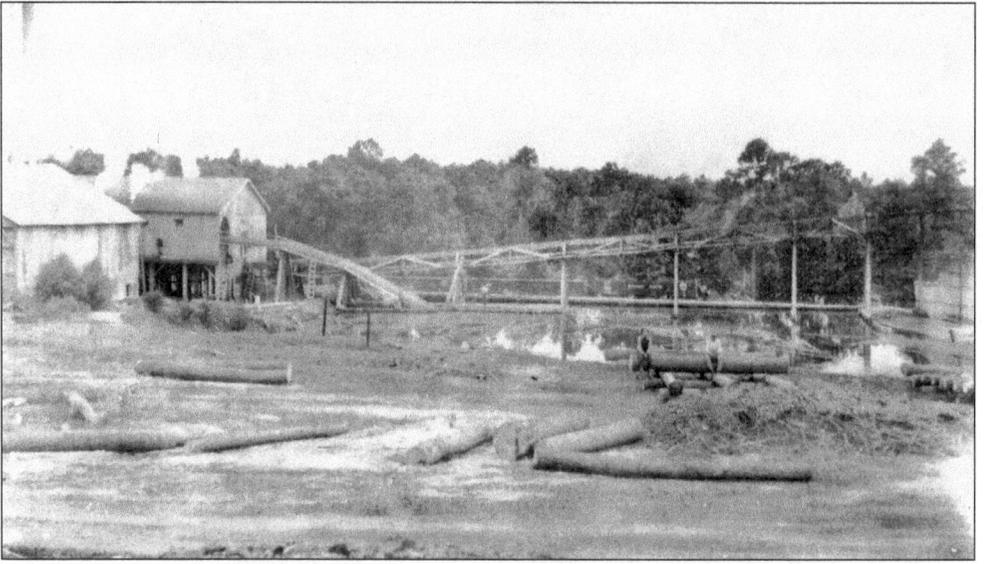

Edward Boettcher established a sawmill in Huntsville in 1928–1929. His initial landholding included 15 acres but was soon expanded to 45 acres. The mill employed more than 500 people before its demise in 1969. (Courtesy Boettcher Mill Oral History Project.)

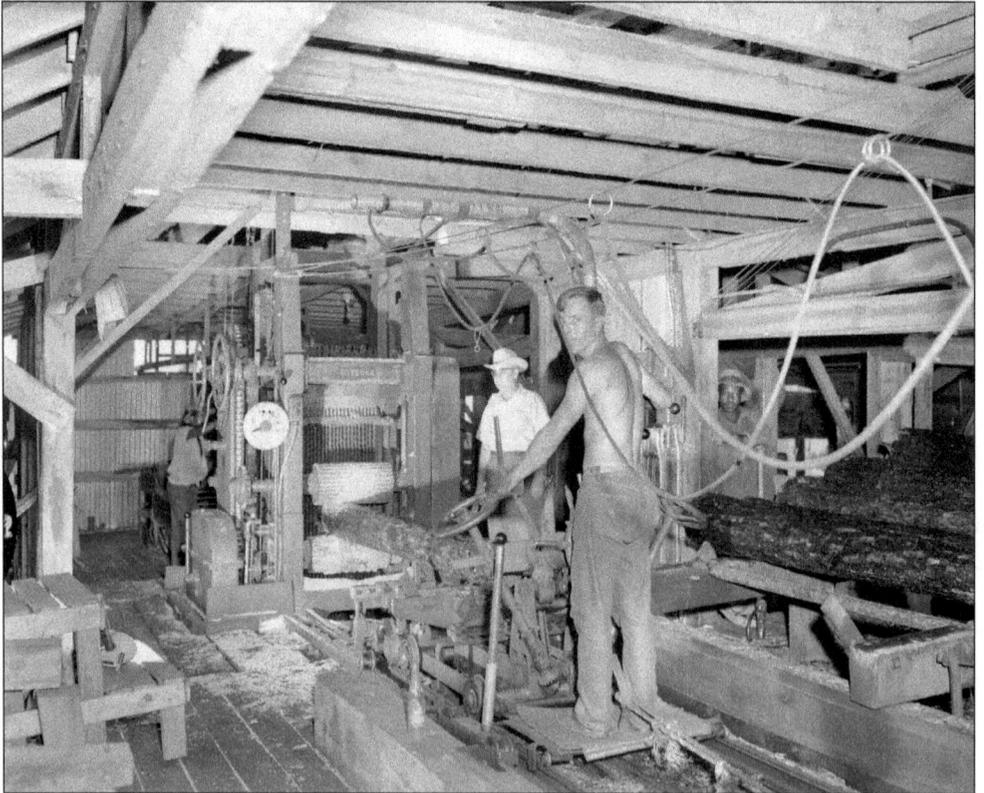

Pictured here are Walker County sawmill workers. The mills in the area provided hundreds of jobs for local citizens and contributed to the economic growth of the area. (Courtesy Huntsville Arts Commission.)

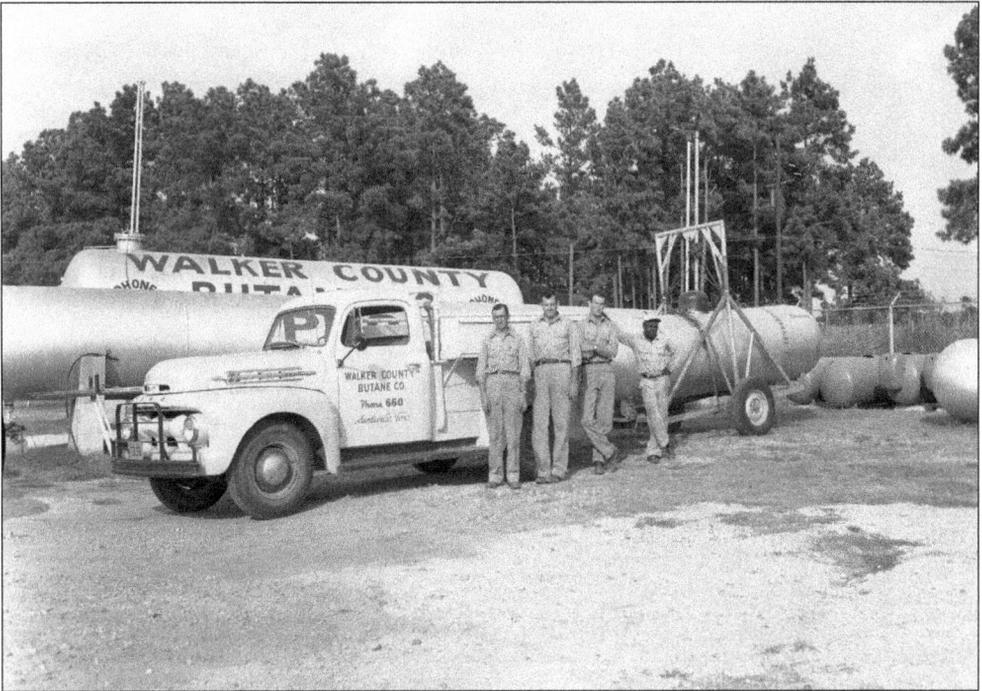

Wade Smith (left) and crew are pictured at Walker County Butane on March 12, 1953. (Courtesy Huntsville Arts Commission.)

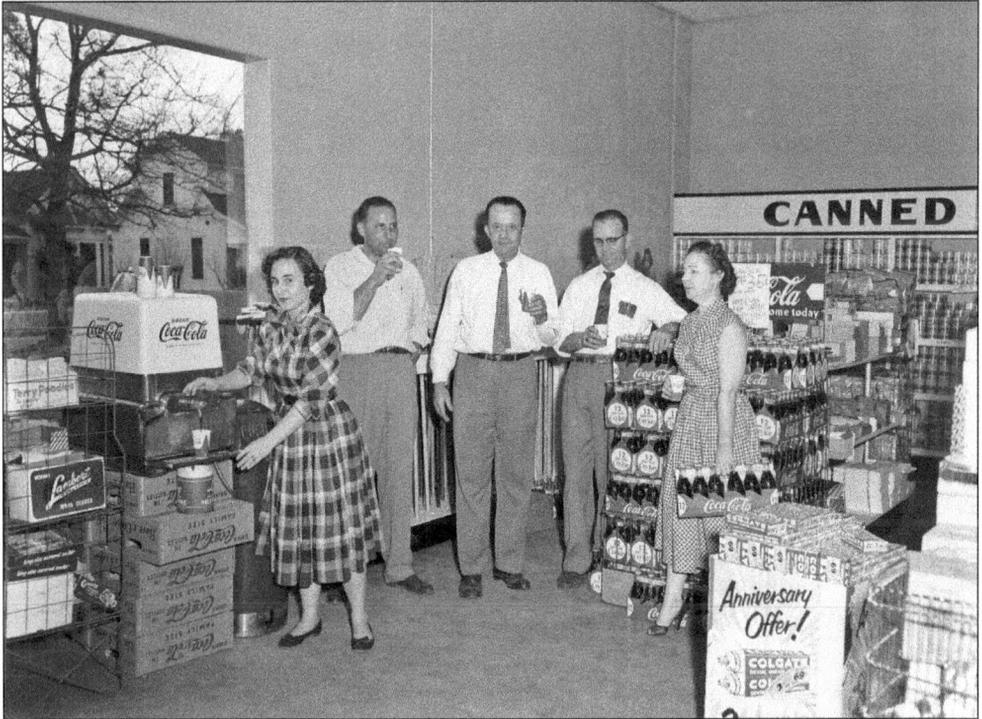

Employees at the local Brookshire Brothers Store gather around an old-fashioned Coca-Cola machine on February 17, 1956. (Courtesy Huntsville Arts Commission.)

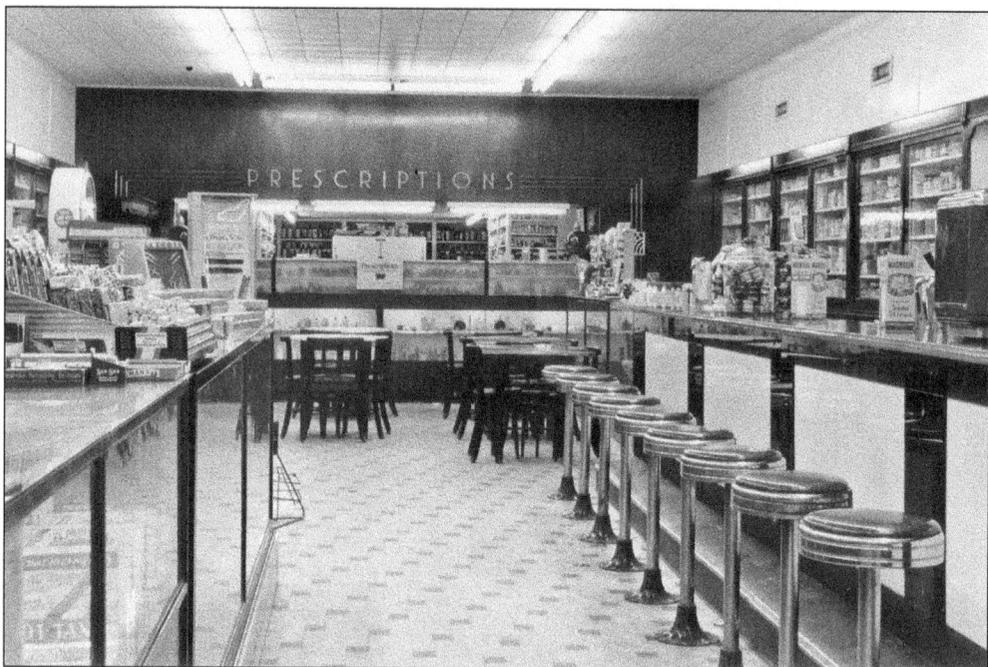

J. Robert King and his family operated a drugstore and soda fountain on the Huntsville square in the 1940s and 1950s. (Courtesy Huntsville Arts Commission.)

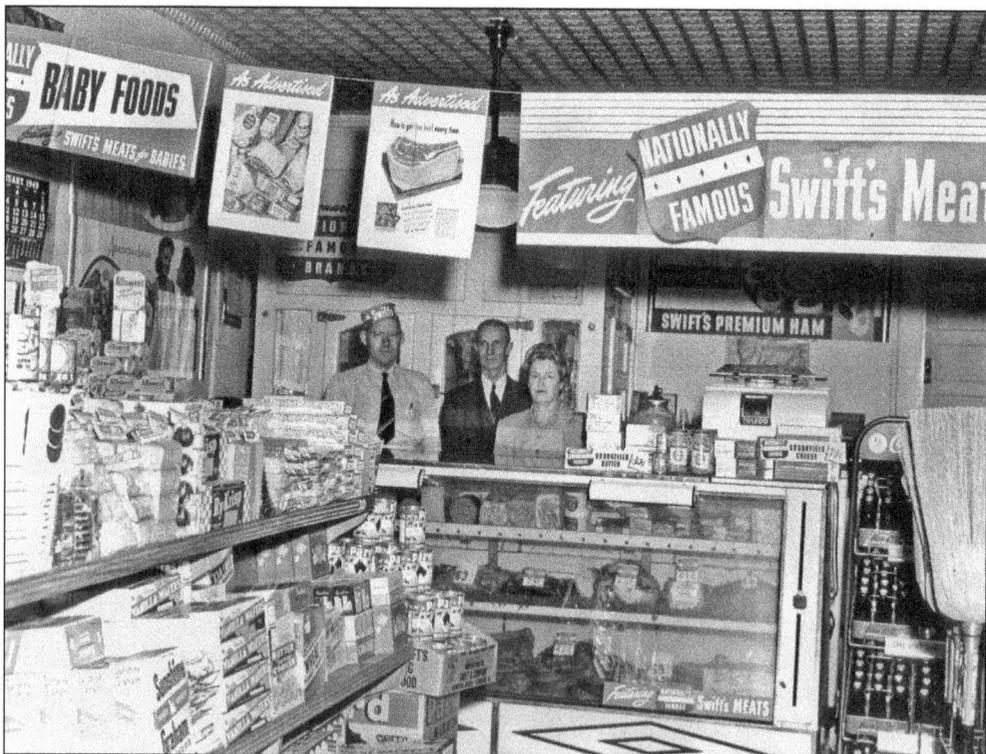

Pictured here is Ball Brother's Grocery on January 27, 1949. (Courtesy Huntsville Arts Commission.)

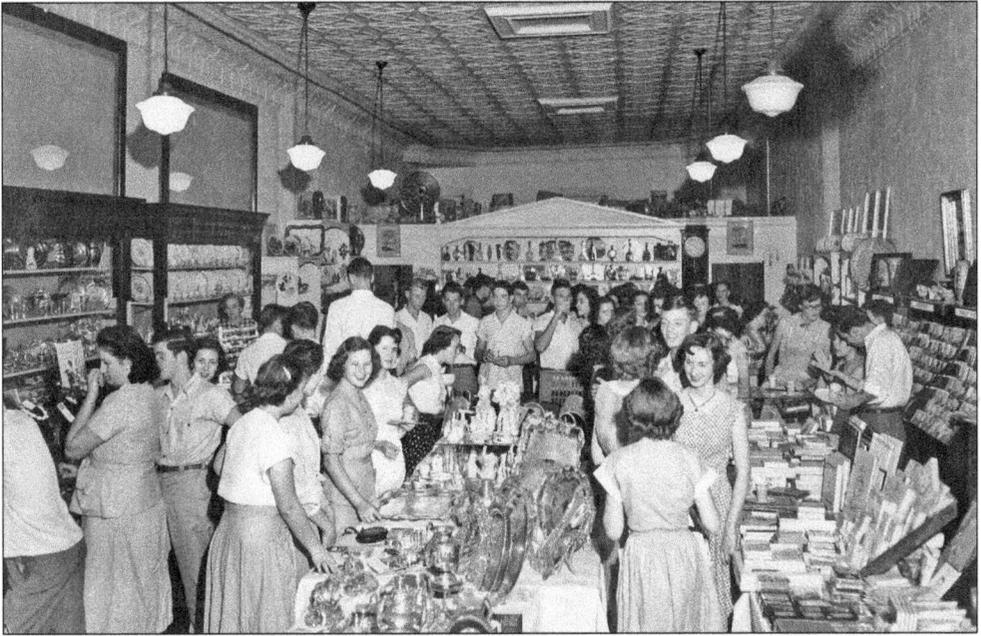

Sometime in the mid-1950s, young people crowded into Westmoreland Jewelry Store on the Huntsville square looking for a deal. (Courtesy Huntsville Arts Commission.)

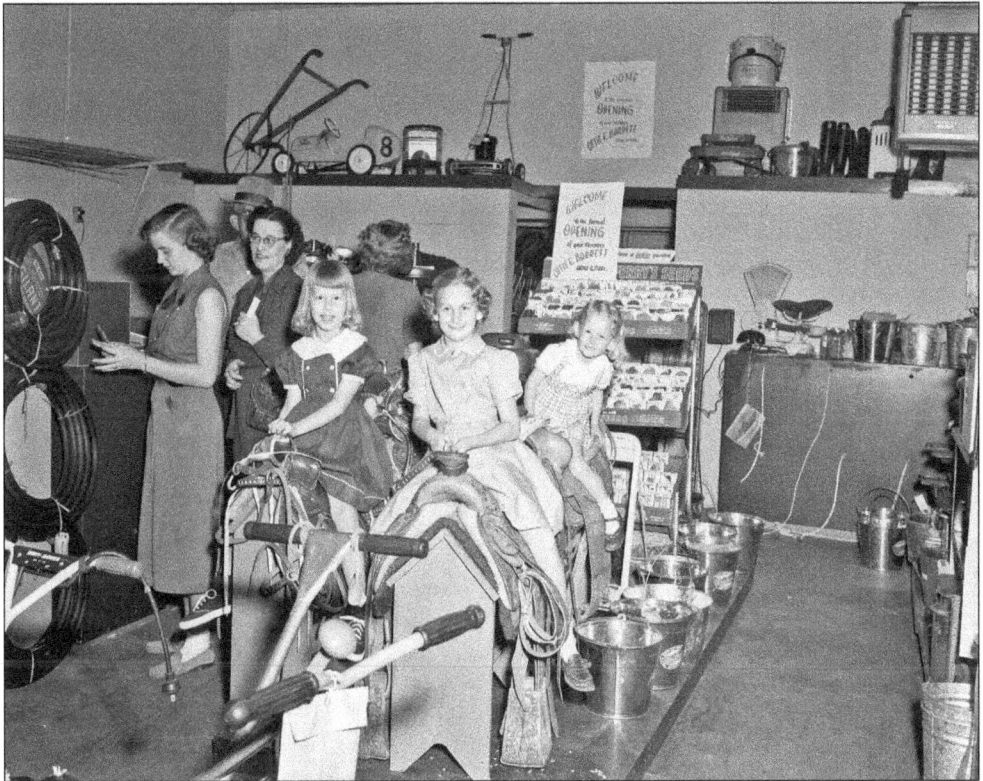

Huntsvillians turned out by the hundreds when Barrett Hardware Store opened on March 30, 1952. Here are three young children testing the wares. (Courtesy Huntsville Arts Commission.)

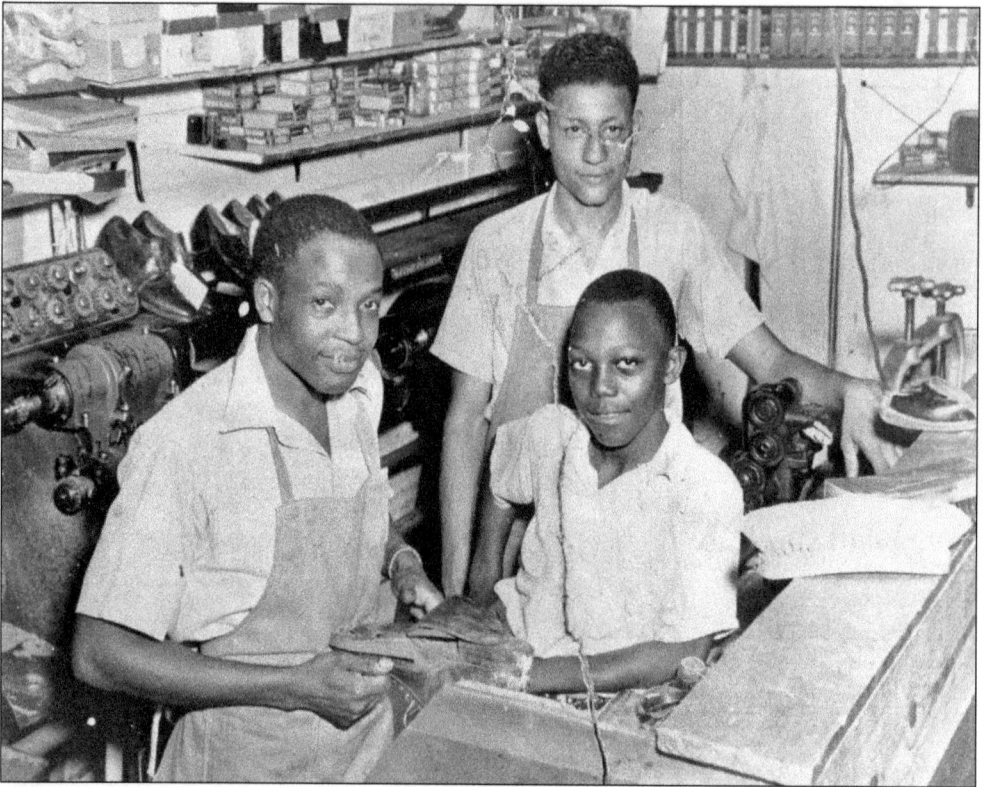

Pictured here are Felder Jones Sr. (left) and his assistants at Felder's Shoe Shop. (Courtesy Huntsville Arts Commission.)

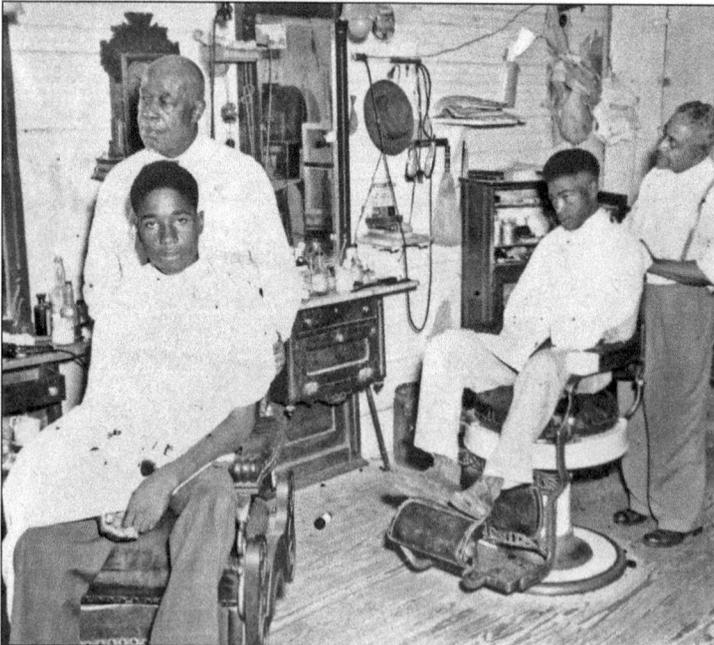

Crawford's Barber Shop was a popular local establishment in the African American community. (Courtesy Huntsville Arts Commission.)

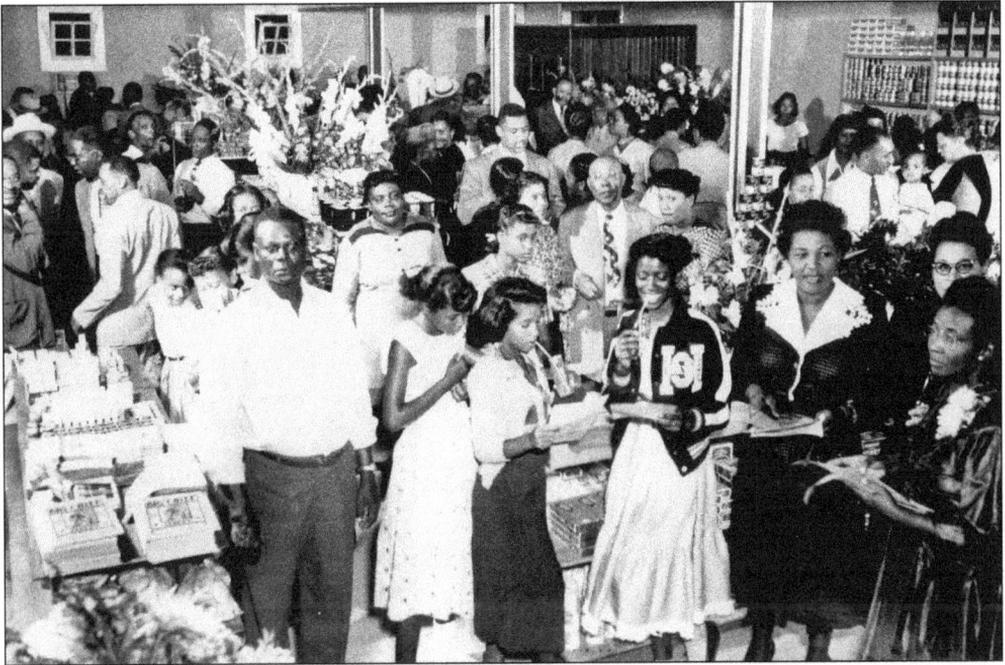

When K. H. Malone's Grocery opened in the mid-20th century, local shoppers were ecstatic. Here was a new store that would truly serve the African American community. (Courtesy Samuel Walker Houston Museum and Cultural Center.)

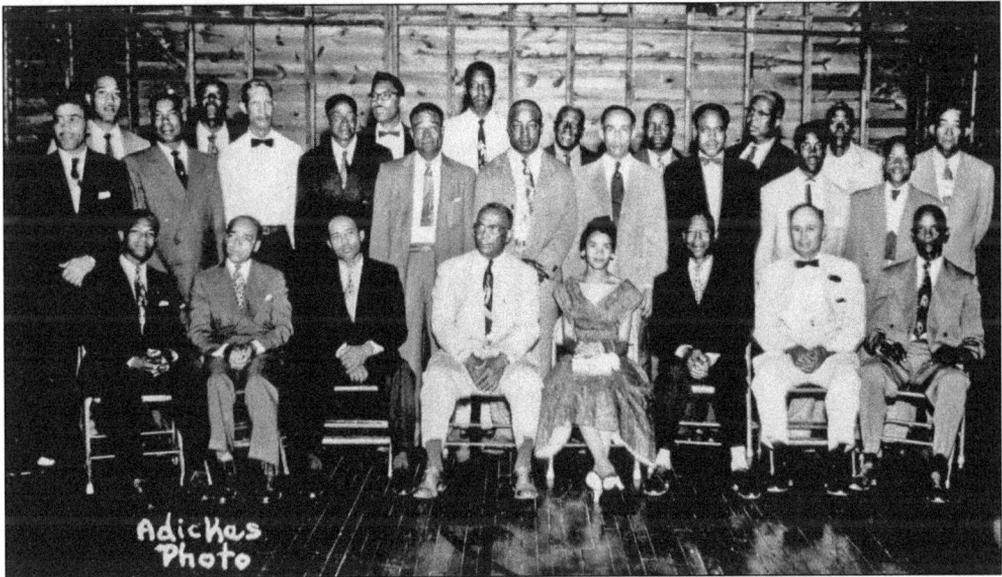

Pictured here is Huntsville's Black Chamber of Commerce in 1950. From left to right are (first row) Percy Howard, Dr. J. A. Johnson, Calvin Lewis, Scott Johnson, ? Holloway, Iowa Jones, O. B. Toliver, and K. H. Malone; (second row) Johnny Roberts, J. R. Powell, Alex Holt, unidentified, Ernest Grover Sr., Sapp Delaney, unidentified, George Oliphint, Aaron Curington, Herman Harper, and Lucas Smith; (third row) Andrew Perkins, John Sowells, Earl Larue, Cecil Williams, Earnest McCowan, Carny Allen, Goree McGlothlin, and Lucious Jackson. (Courtesy Samuel Walker Houston Museum and Cultural Center.)

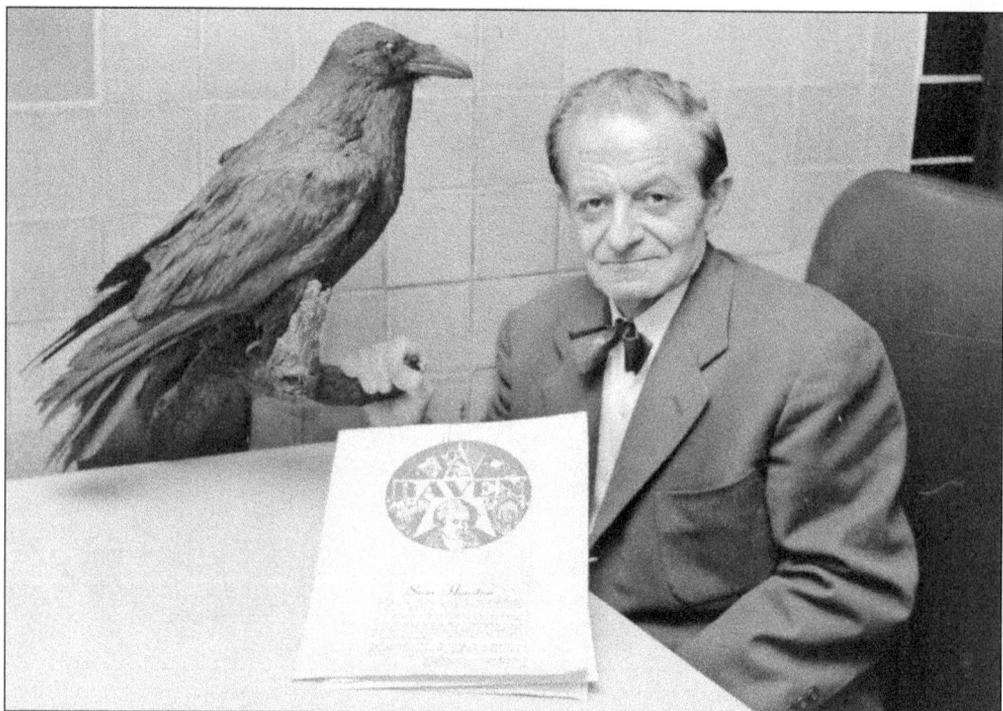

In 1930, Abe Dabaghi founded Café Raven with Fred Morris and Stuart Nemir Sr. Named in honor of Sam Houston—who was known as the Raven—the restaurant operated for 39 years (1930–1969). (Courtesy Huntsville Arts Commission.)

Here is Café Raven in 1950. The first air-conditioned restaurant in Huntsville, it also claimed the first neon sign between Dallas and Houston. (Courtesy Huntsville Arts Commission.)

Five

PRISON STORIES

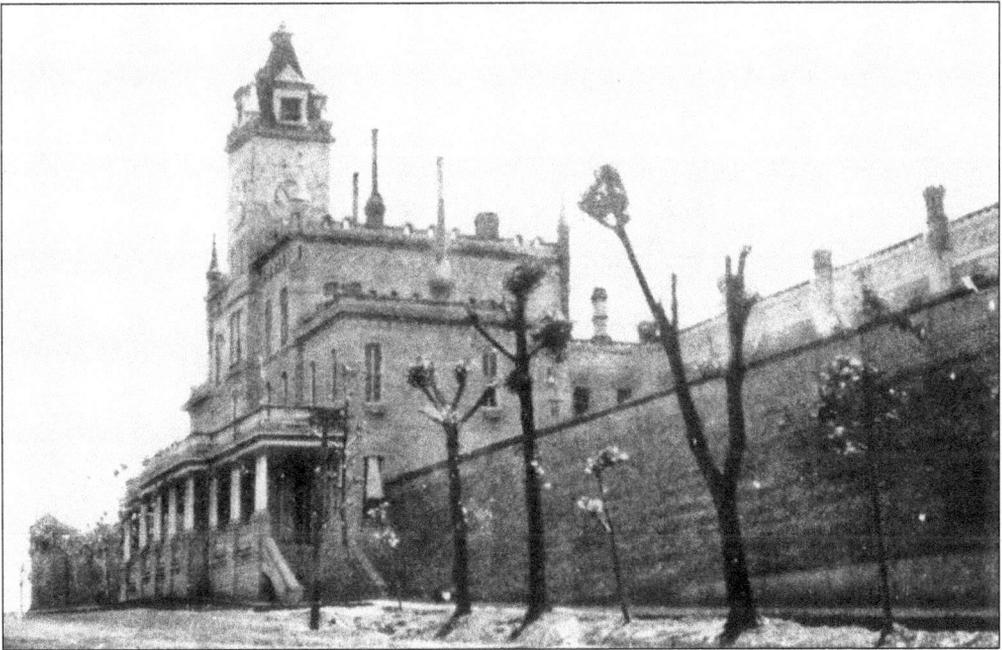

The Texas Penitentiary at Huntsville—known as the Walls Unit—is the oldest prison in Texas. Pictured here is the north entrance to the prison around 1920. (Courtesy Huntsville Arts Commission.)

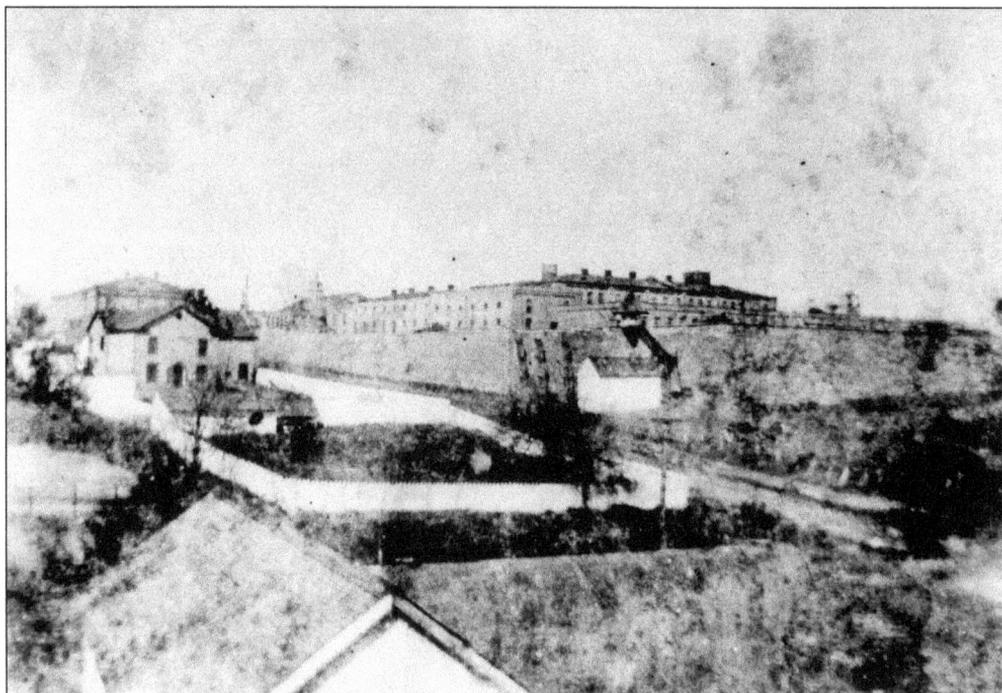

The Walls Unit opened in October 1849. Although the inmate population was initially quite small, the number of prisoners grew tremendously after the Civil War. Here is a c. 1899 photograph of the Walls Unit. (Courtesy Huntsville Arts Commission.)

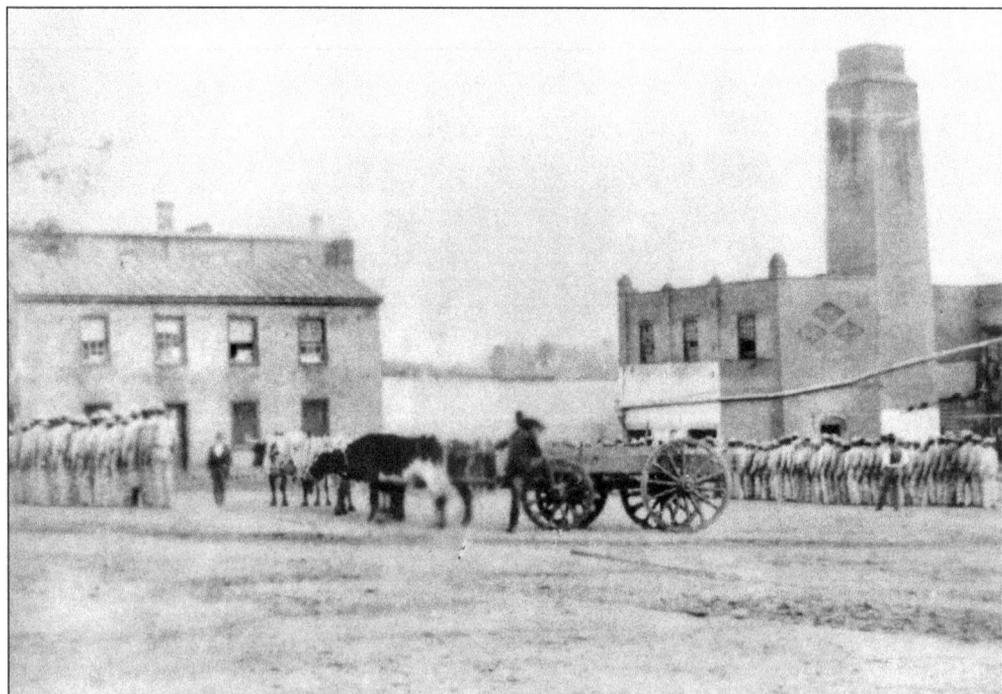

This is a group of inmates gathered in the yard at the Walls Unit around 1873. (Courtesy Huntsville Arts Commission.)

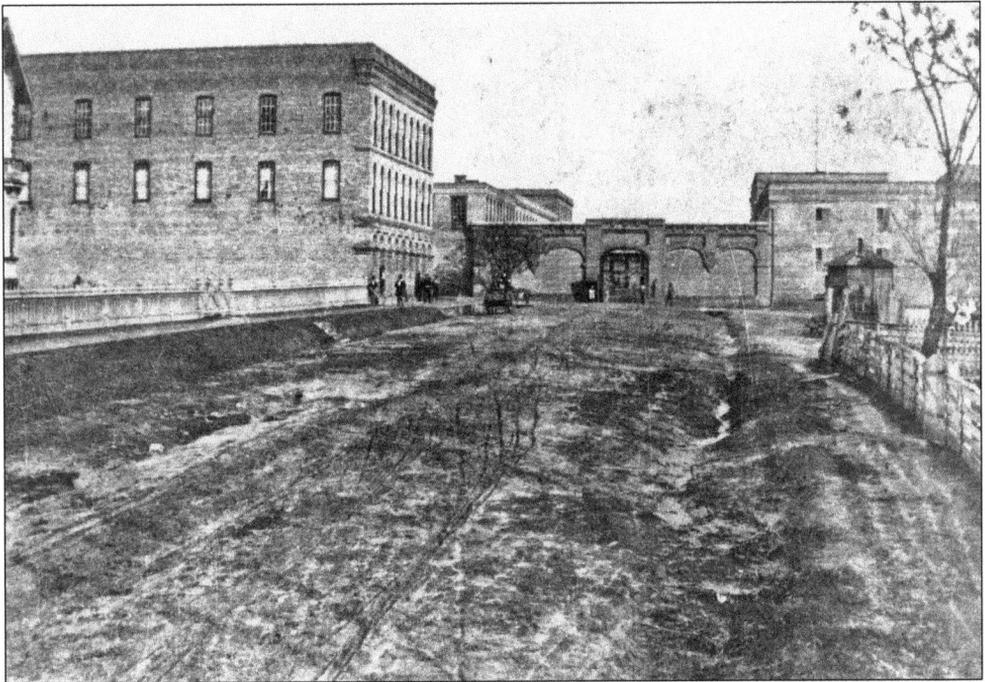

Here is a c. 1874 view of the West Gate of the Walls Unit. (Courtesy Huntsville Arts Commission.)

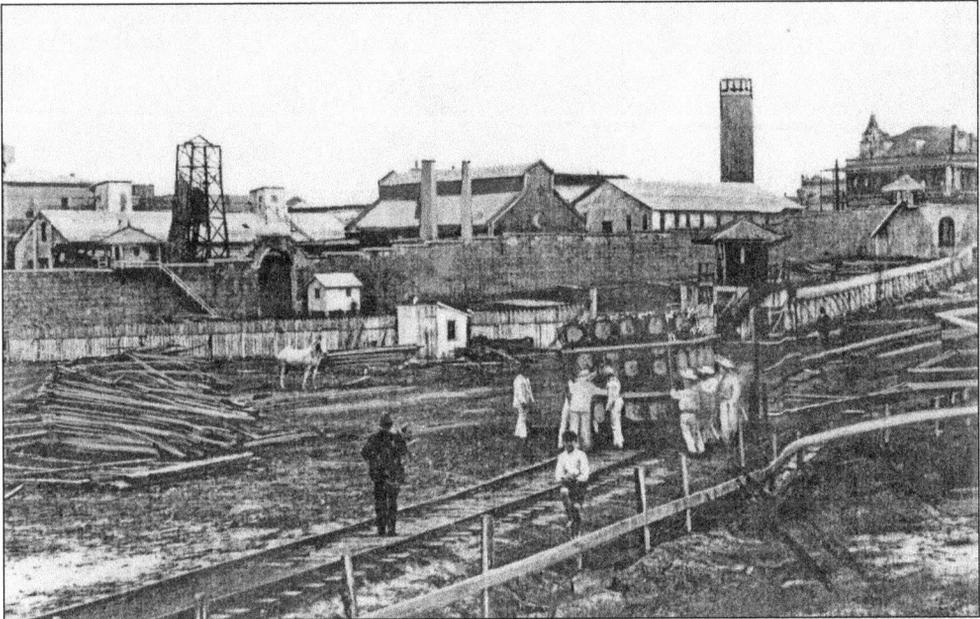

This photograph provides a c. 1908 southeastern view of the Walls Unit. (Courtesy Huntsville Arts Commission.)

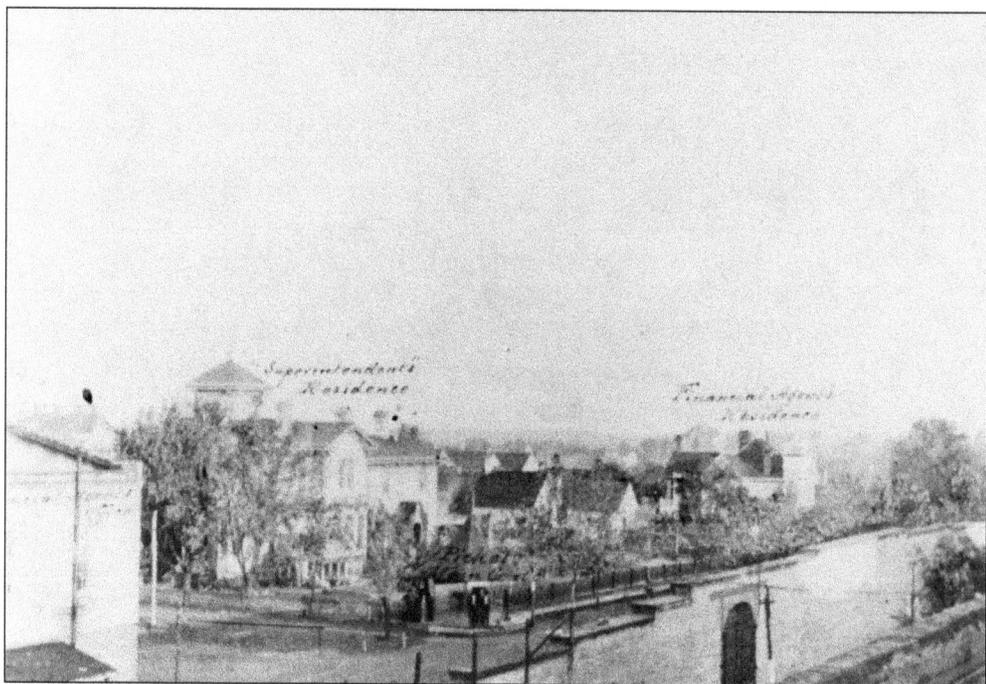

Pictured here is the west gate of the Walls Unit. This photograph highlights the homes of the prison superintendent and financial agent, who lived directly across the street. (Courtesy Texas Prison Museum.)

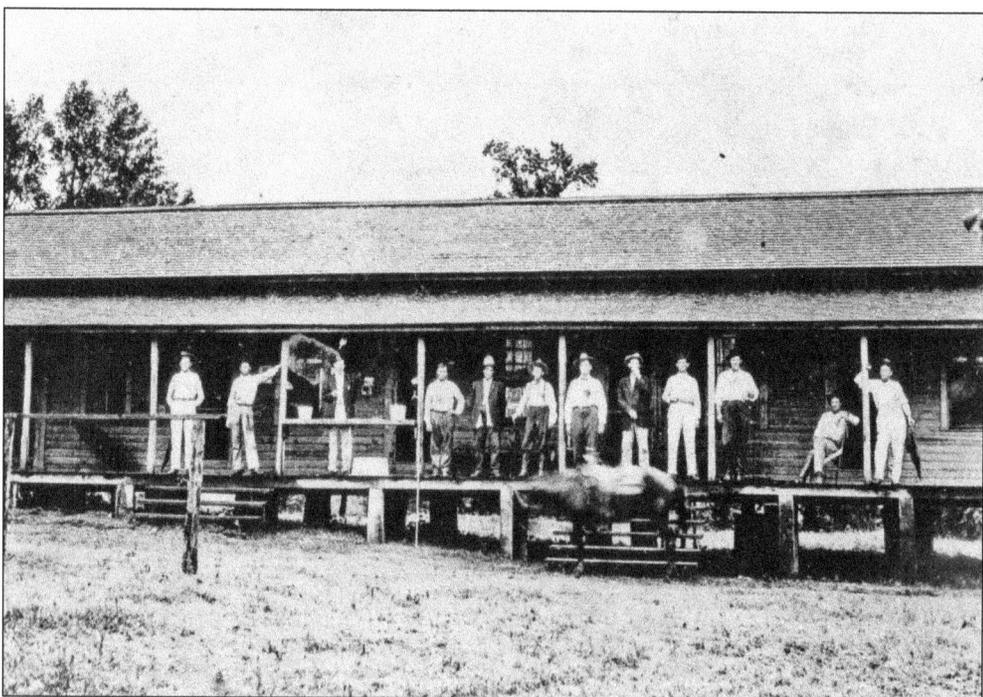

Guards at the Walls Unit lived and worked in quarters immediately adjacent to the prison. (Courtesy Huntsville Arts Commission.)

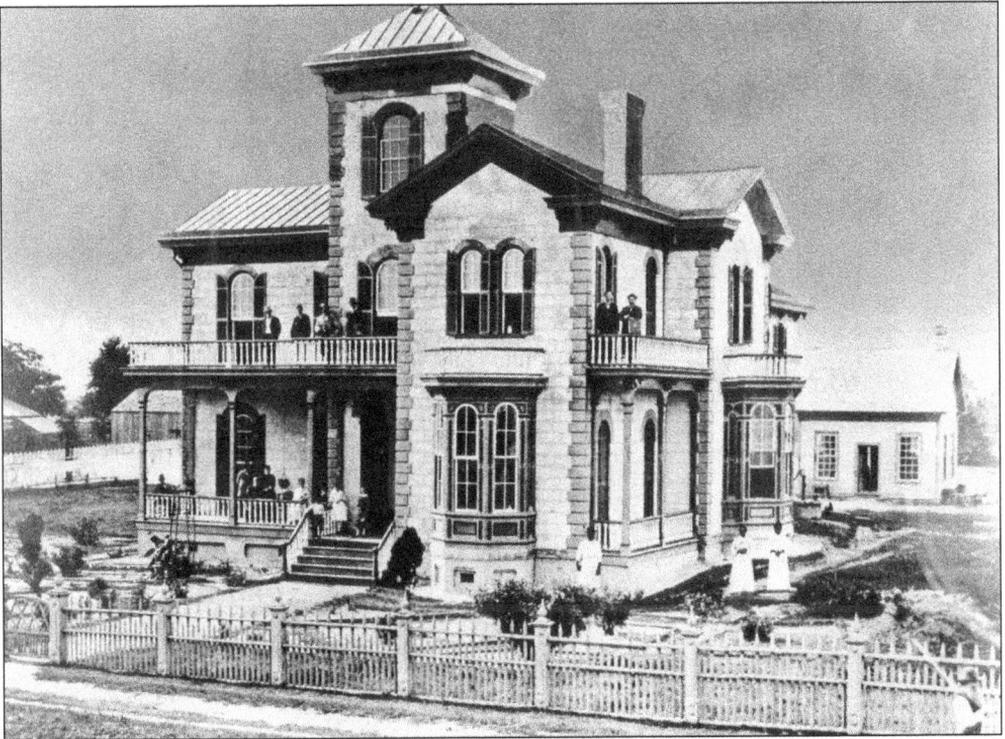

The superintendent of the Texas Prison System had a gorgeous home located across the street from the Walls Unit on Thirteenth Street and Avenue I. This photograph shows the home around 1900. (Courtesy Huntsville Arts Commission.)

The financial agent of the Texas Prison System lived down the block from the superintendent. This home sat at the southwest corner of Twelfth Street and Avenue I. (Courtesy Huntsville Arts Commission.)

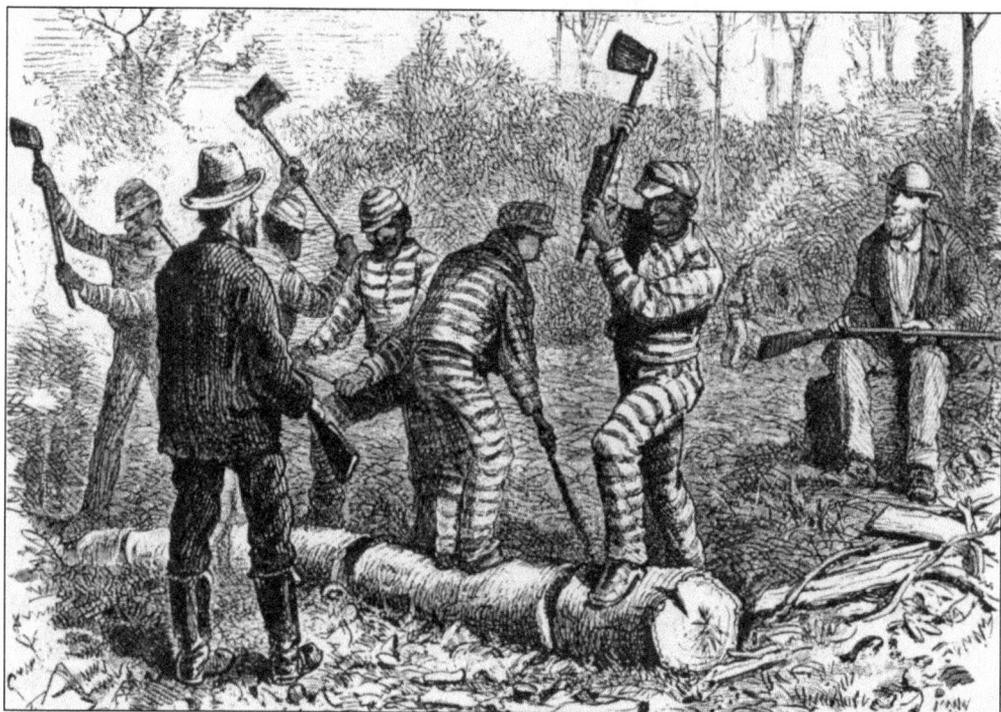

Between 1871 and 1883, the State of Texas leased the entire prison system to the highest bidding private company. The company, in turn, received the right to use or hire out the prisoners for private gain. This program, known as the convict lease system, led to terrible corruption and mistreatment. Here is a group of prisoners forced to work as part of the system. This illustration, by J. Wells Champney, appeared in Edward King's book *The Great South* (1875). (Courtesy the author's collection.)

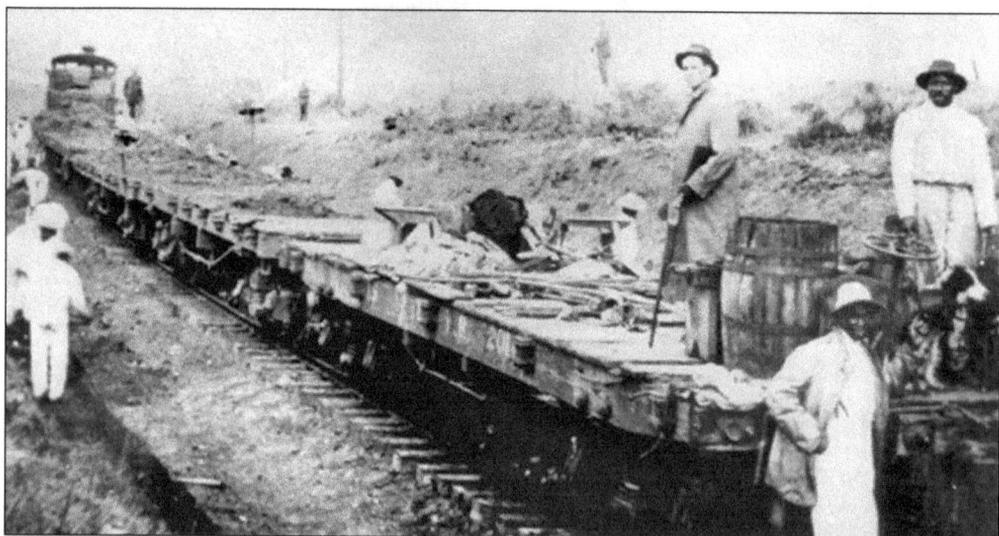

Under the convict lease system, prisoners worked for the railroad, timber, and construction industries without compensation or any type of labor protection. Due to abuses of the system, the state modified (in 1883) and then ended the program entirely (in 1912). (Courtesy Texas Prison Museum.)

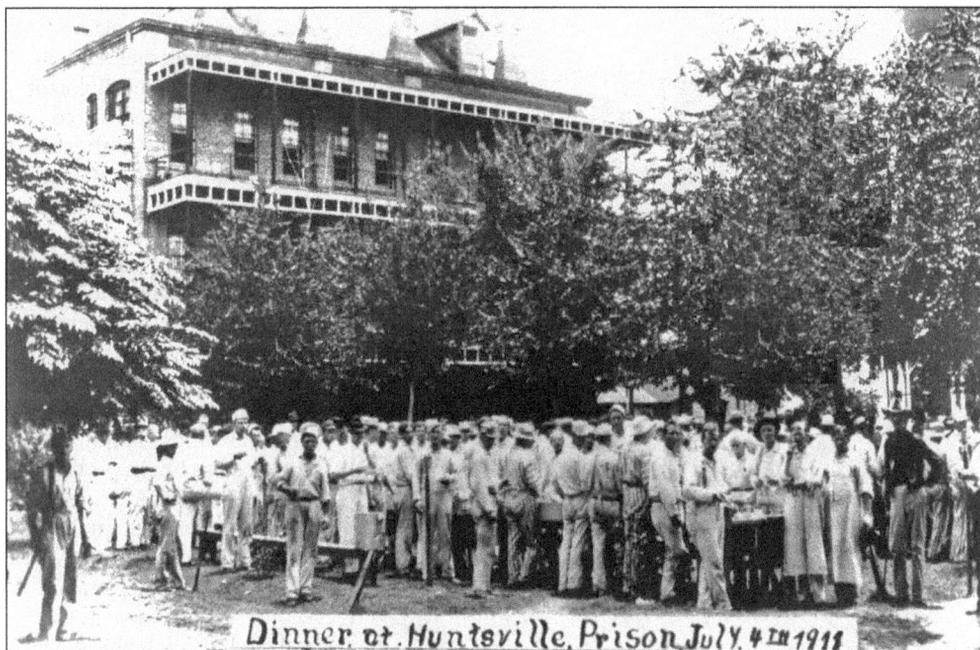

Pictured here are prisoners massing in the yard at the Walls Unit on July 4, 1911. (Courtesy Texas Prison Museum.)

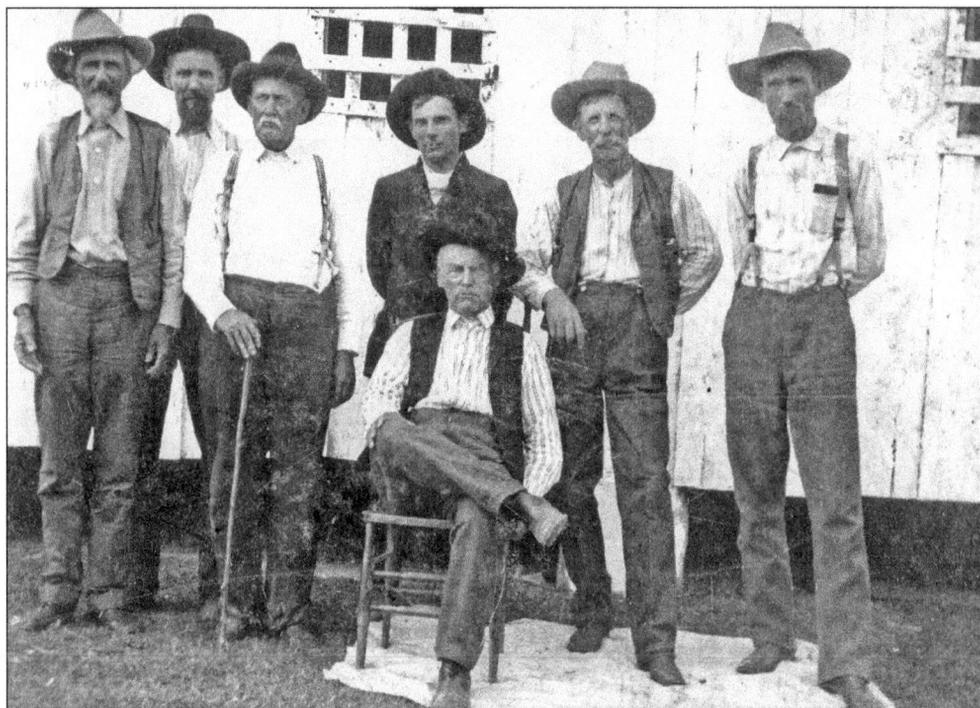

The Bowden Prison Farm operated as a private prison under the Texas convict leasing program at the end of the 19th century. Pictured here are Capt. Joshua Bowden with son Jerry and prison guards C. Kearse, T. C. Oliphint, S. Sterne, W. Sterne, and J. Talmage. (Courtesy Huntsville Arts Commission.)

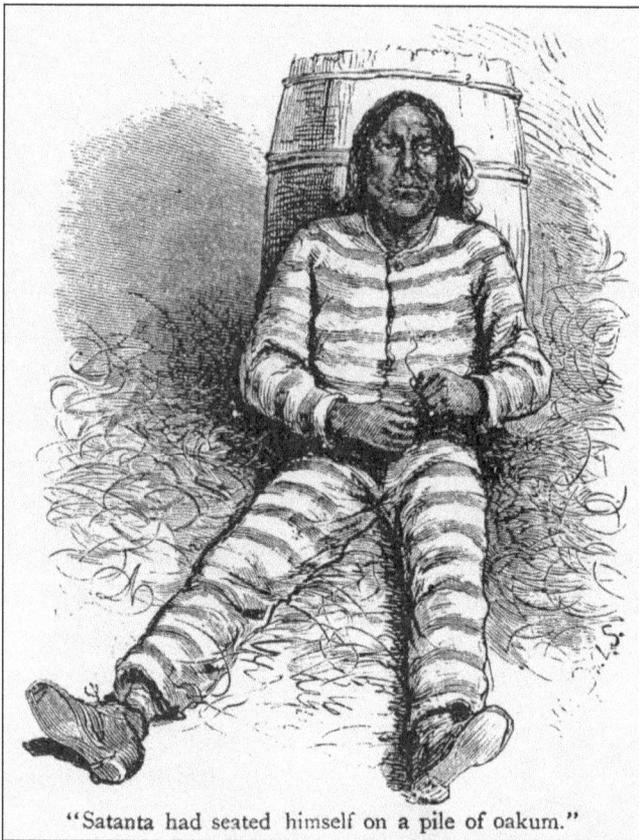

"Satanta had seated himself on a pile of oakum."

This illustration depicts a leading Kiowa chief named Santana. A famous diplomat and warrior, he negotiated numerous treaties with white migrants who were invading Native American territory. In 1871, Santana and his allies attacked a wagon train of travelers moving along the Butterfield Trail. Seven white men were killed in the raid, and Santana later accepted responsibility for the attack. After being sentenced to life in prison, he was sent to the Texas Penitentiary in Huntsville. In 1878, he committed suicide by jumping from a second-story window at the facility. This illustration, by J. Wells Champney, appeared in Edward King's book *The Great South* (1875). (Courtesy the author's collection.)

Santana was interred at the prison cemetery in Huntsville until 1963, when permission was granted to remove his remains and rebury them at Fort Sill next to his friend and fellow war chief Satank. (Courtesy Texas Prison Museum.)

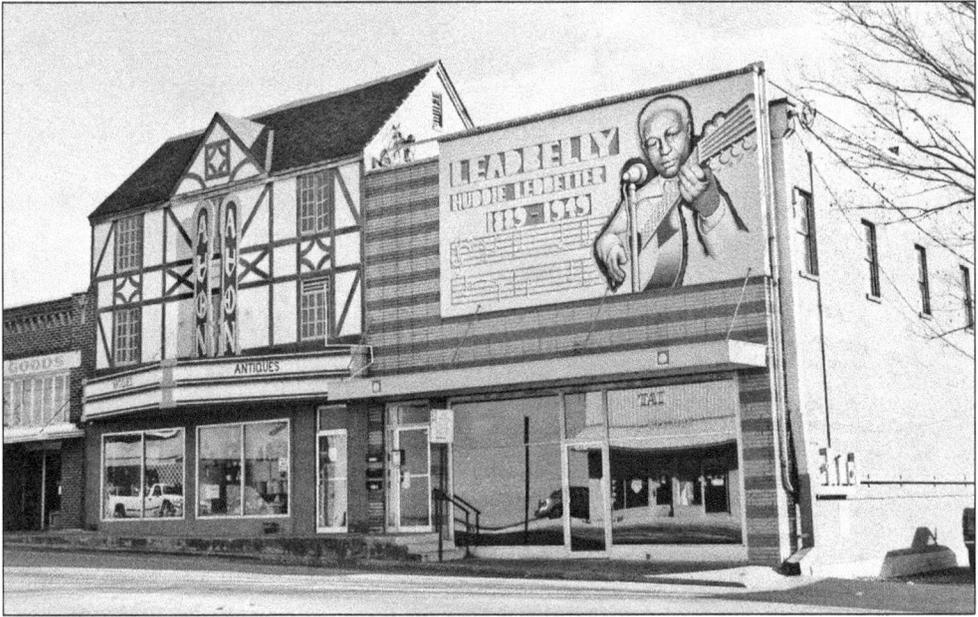

Huddie Ledbetter—better known as blues legend "Lead Belly"—spent time at the Shaw State Prison Farm in Rusk, Texas, during the early 1920s. The author of such memorable classics as "Midnight Special," "Rock Island Line," and "Black Girl," he was pardoned by Gov. Pat Neff in 1925. This photograph highlights the work of New York artist Richard Haas, who memorialized Lead Belly with a mural in downtown Huntsville. (Courtesy the author's collection.)

Bud Russell (right) was the chief transfer agent for the Texas Prison system for some 40 years. Known as "Uncle Bud," he was famous for his grey Stetson hat and no-nonsense attitude. Lead Belly immortalized Russell in one version of his famous song, "Midnight Special." In the second verse, he sang, "Here come Bud Russell, How in the world do you know? Well he know him by his wagon, and his forty-fo." (Courtesy Texas Prison Museum.)

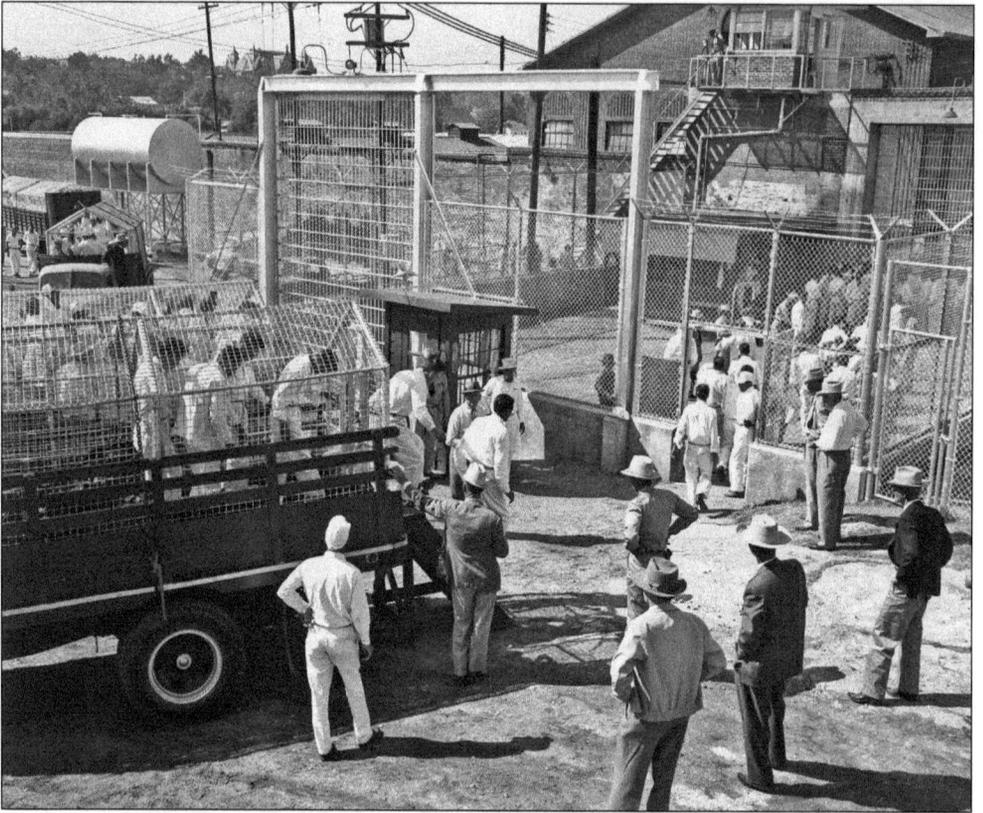

Here is a group of prisoners entering the south gate of the Walls Unit on August 30, 1949. (Courtesy Texas Prison Museum.)

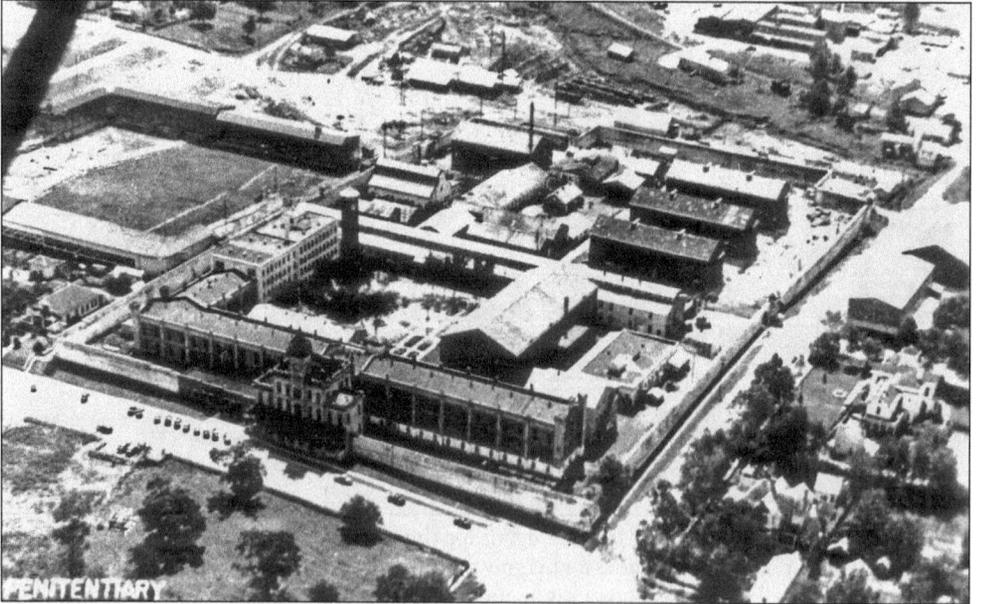

This photograph provides an aerial view of the Walls Unit in 1938. (Courtesy Texas Prison Museum.)

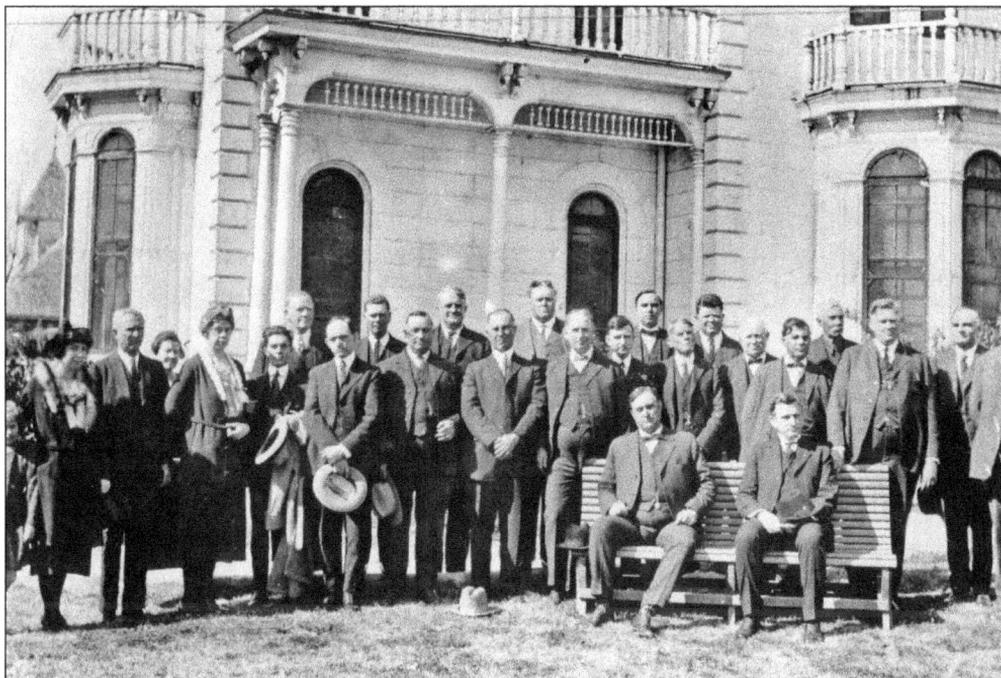

Pictured here are Gov. Pat Neff and a group of state officials in front of the director's residence at the Walls Unit around 1922. Governor Neff is seated on the right with his hat in his lap. (Courtesy Texas Prison Museum.)

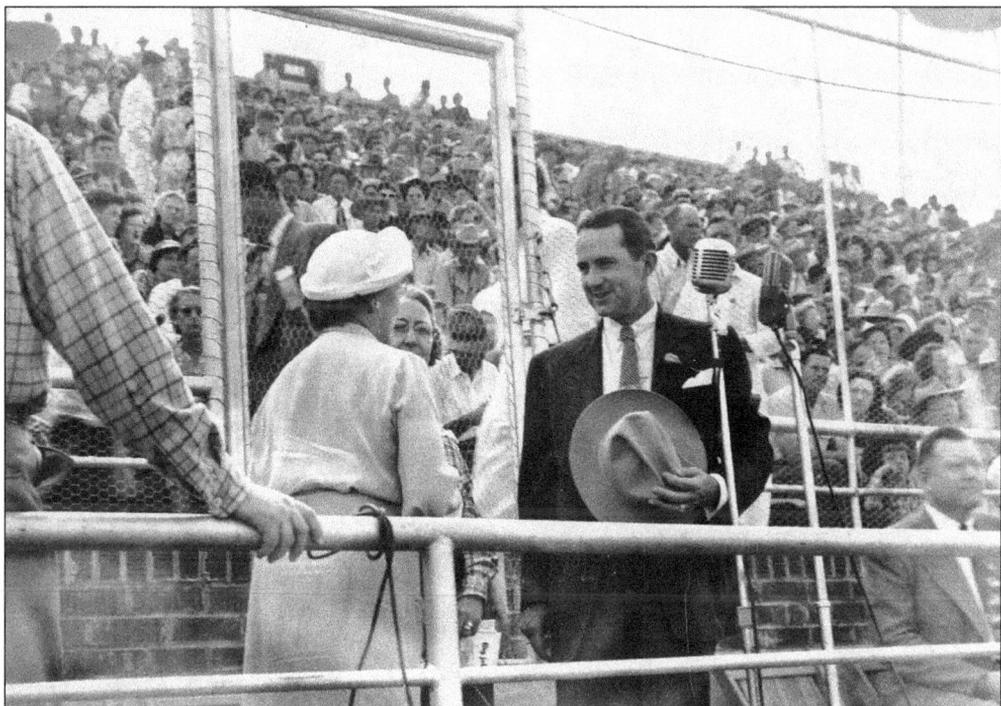

Pictured here is Gov. Alan Shivers, who visited the Texas Prison Rodeo during his term in office between 1949 and 1956. (Courtesy Texas Prison Museum.)

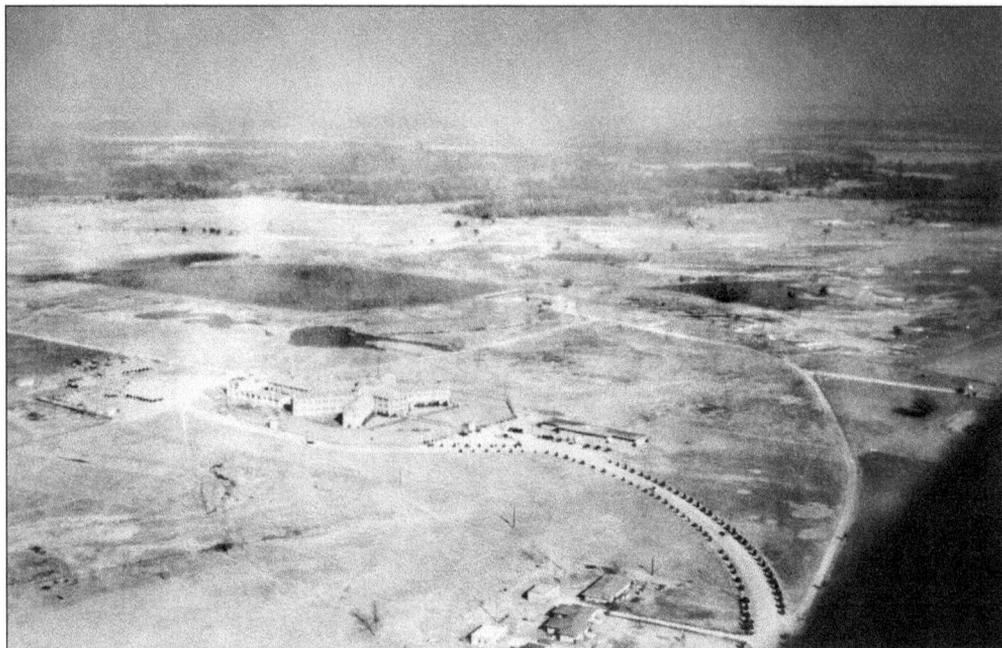

Land for the Goree Prison Farm was purchased by the Texas Prison System in 1900. Nine years later, a women's prison was constructed on the site, and it began operation in 1911. The Goree Unit operated as a women's prison until 1981, when female inmates were transferred to the Gatesville Unit. (Courtesy Huntsville Arts Commission.)

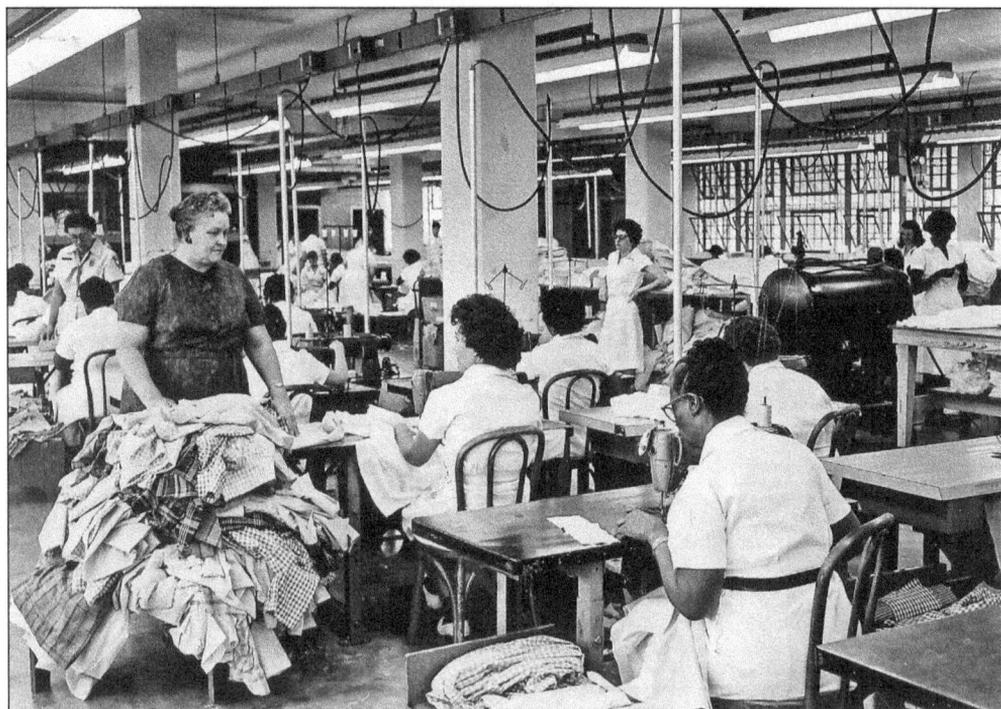

Warden Dobbs oversaw the Goree prison unit for many years. Here she is supervising sewing work in 1963. (Courtesy Texas Prison Museum.)

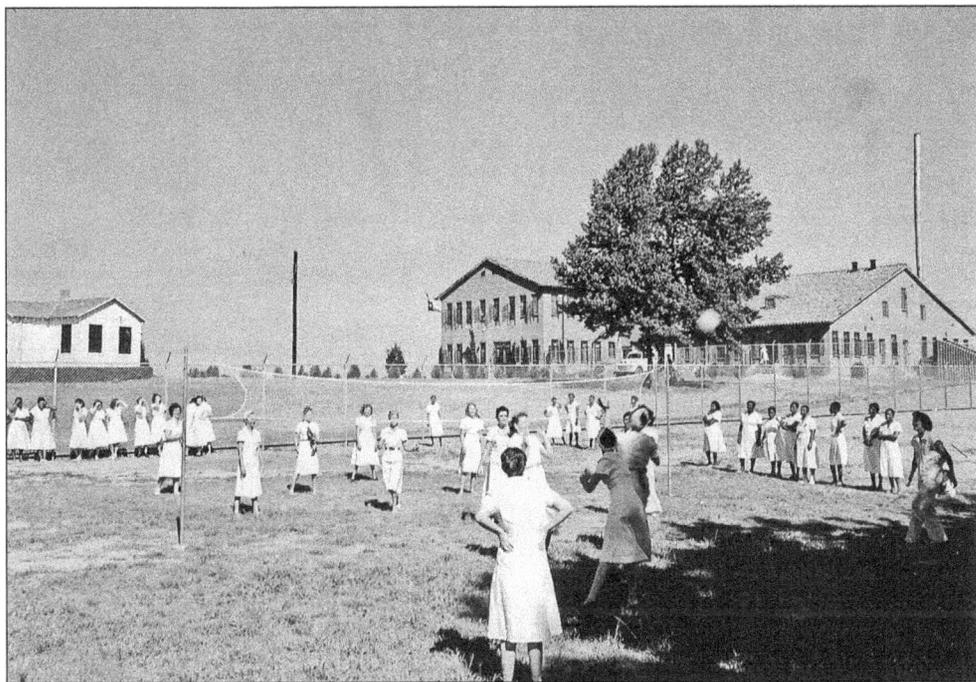
Pictured here is a volleyball game at the Goree Unit in 1964. (Courtesy Texas Prison Museum.)

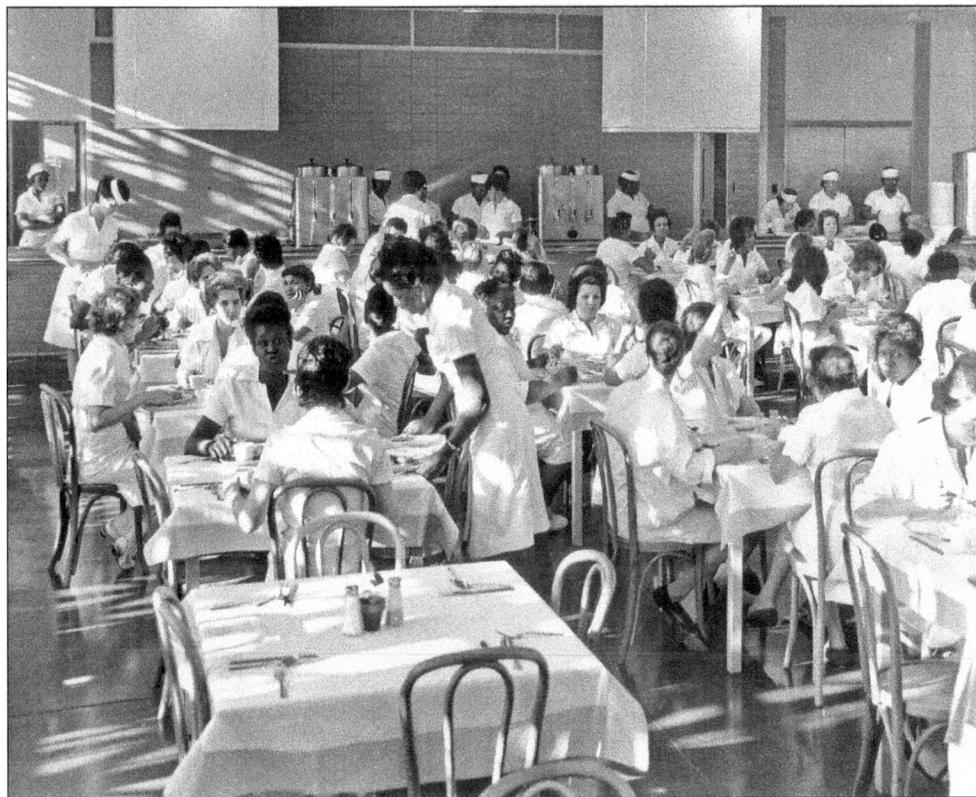
This is the lunchroom at the Goree Unit in the mid-1960s. (Courtesy Texas Prison Museum.)

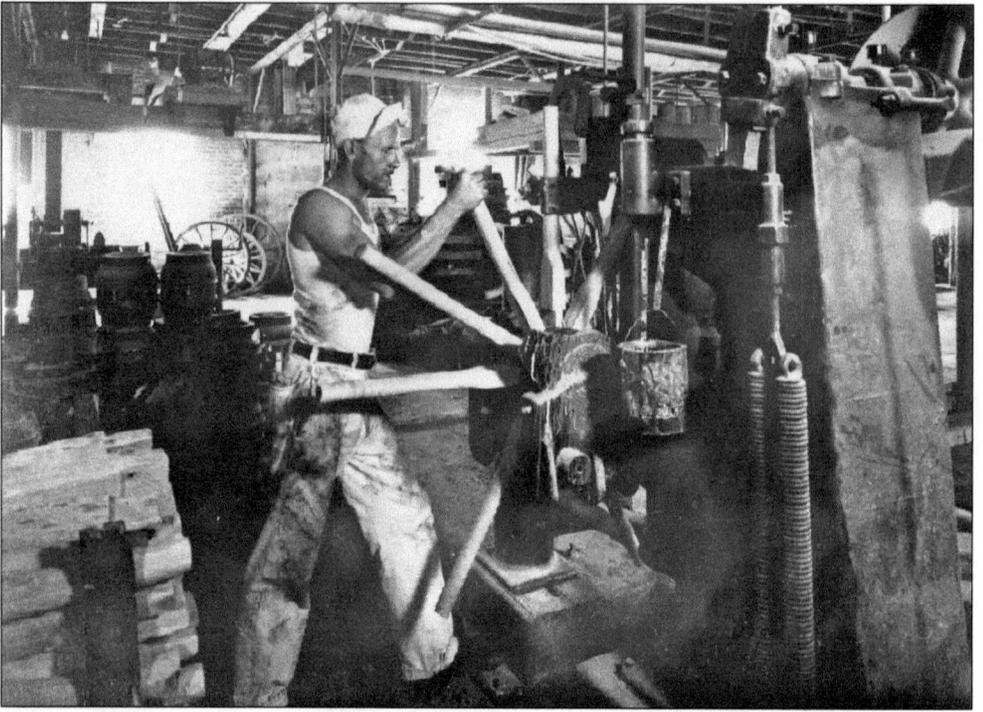

Prisoners in Texas continued to work for the state during the 20th century. Here is a convict making a wagon wheel in the Texas Penitentiary in Huntsville. (Courtesy Texas Prison Museum.)

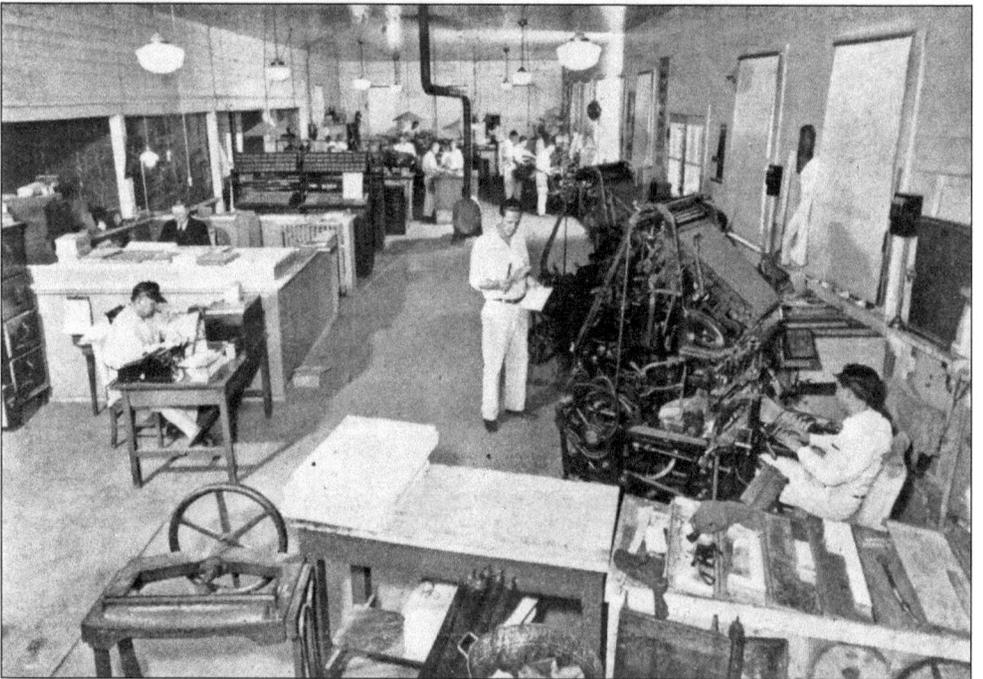

Inmates are encouraged to work in useful employment during their incarceration. One such opportunity is the prison printing office, which produces materials for the state. (Courtesy Texas Prison Museum.)

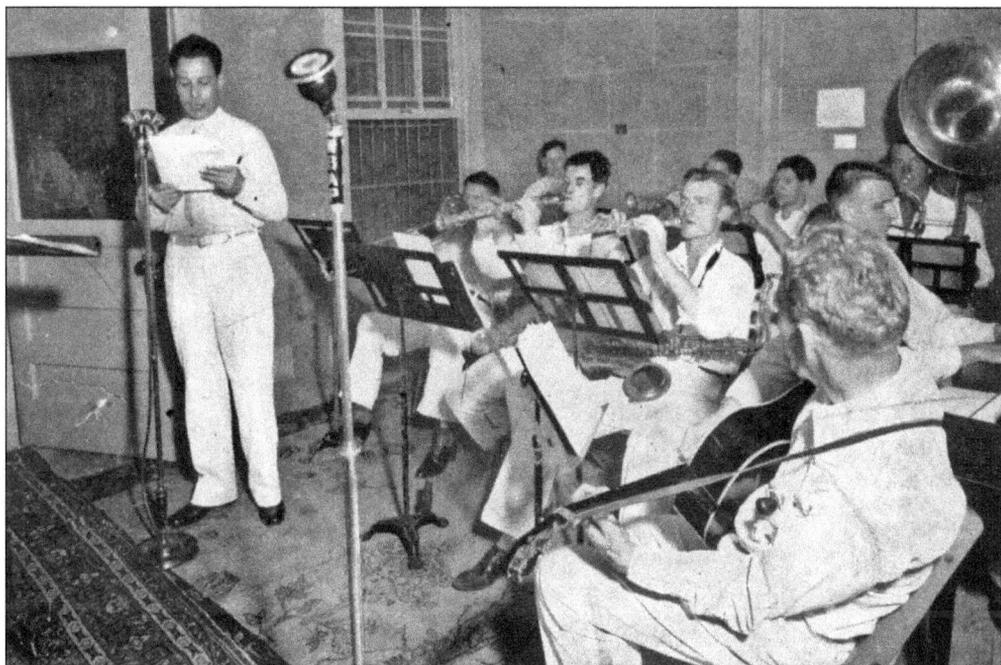

Pictured above are the original Boys in White, a prison band, as they looked on March 23, 1938, at 10:30 P. M., when *Thirty Minutes Behind the Walls* was broadcast for the first time. This event marked the first occasion that a prisoner's voice was heard on radio. (Courtesy Texas Prison Museum.)

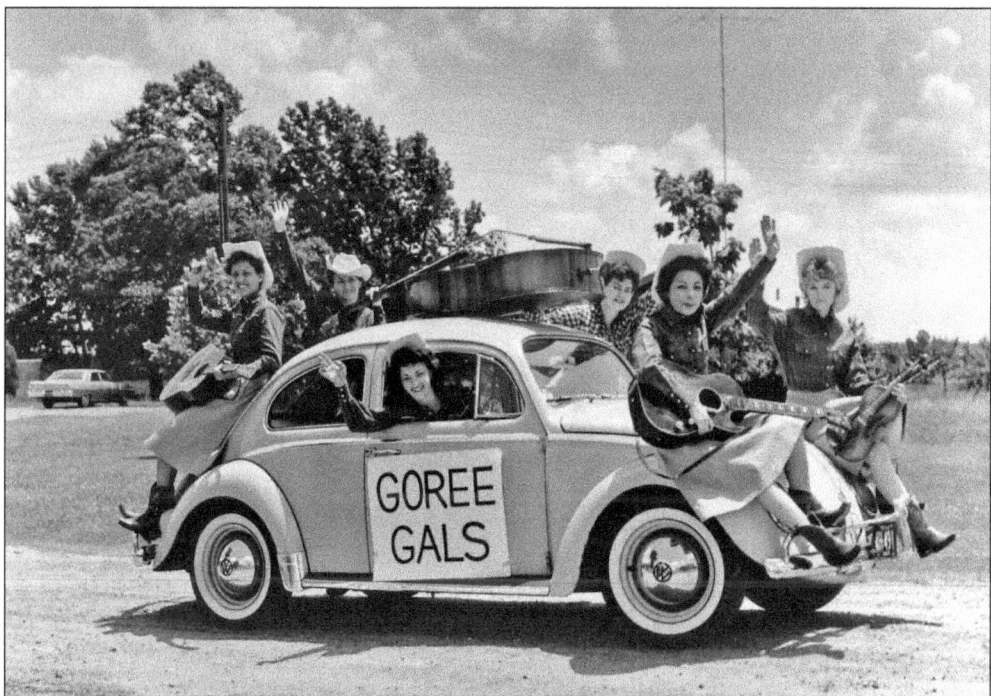

Like the Boys in White, the Goree Girls was a prison band. Here the band poses with a Volkswagen for a publicity shot. (Courtesy Texas Prison Museum.)

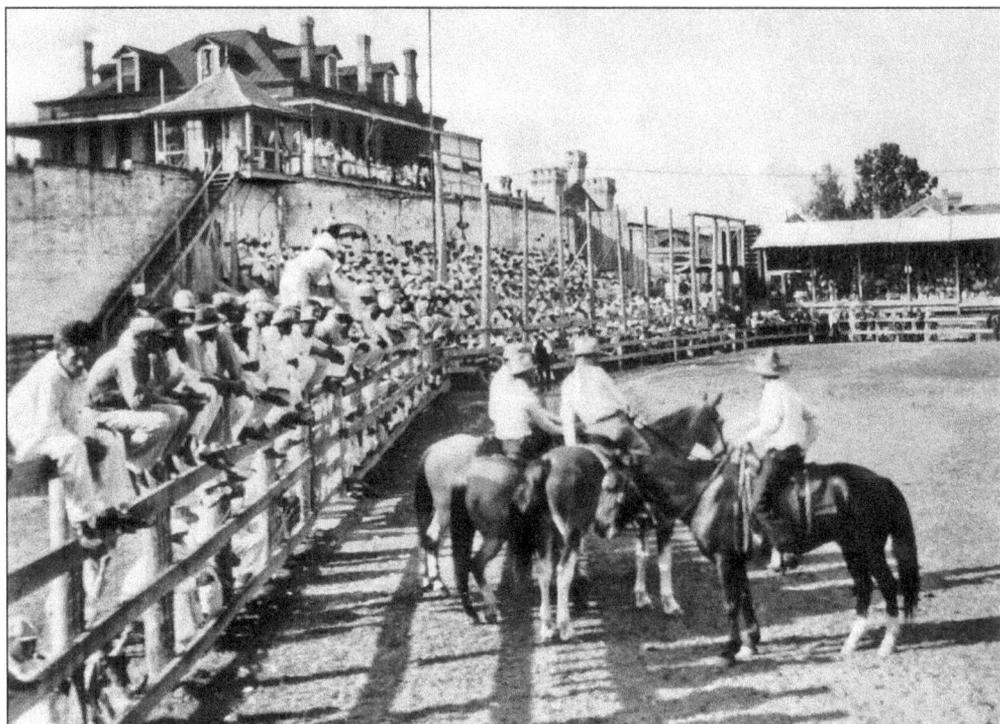

The first Texas Prison Rodeo was held in the Walls Unit in 1931. Devised by Lee Simmons, the general manager of the Texas Prison System, the rodeo was intended to entertain and raise money for the corrections system. By 1933, over 15,000 fans were attending the attraction, which soon grew to be one of the largest sporting events in the state of Texas. (Courtesy Texas Prison Museum.)

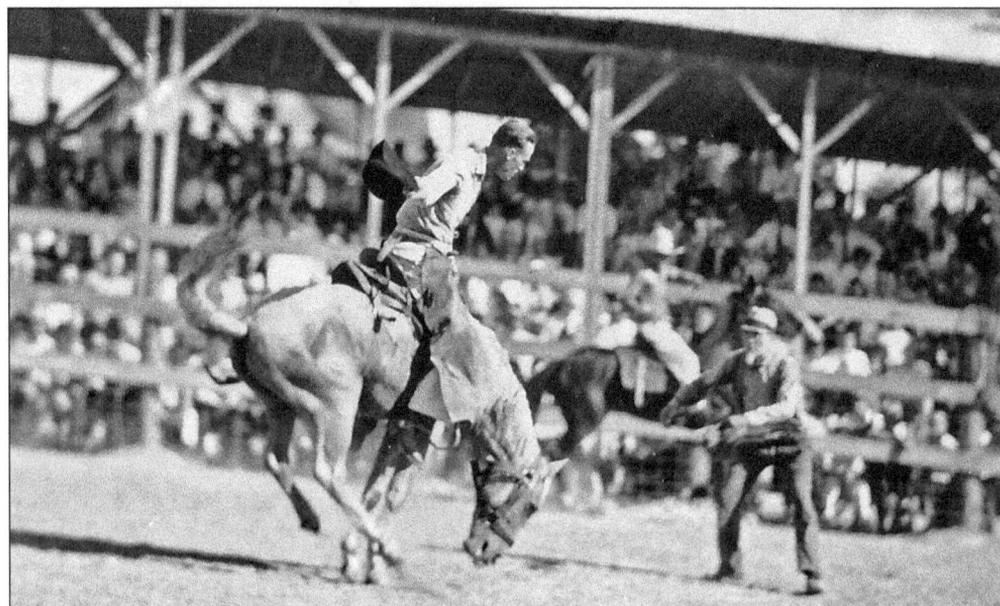

The Texas Prison Rodeo included typical Western events, including bull riding, cow milking, goat roping, bull dogging, and the ever popular saddle and bareback bronc riding. (Courtesy Texas Prison Museum.)

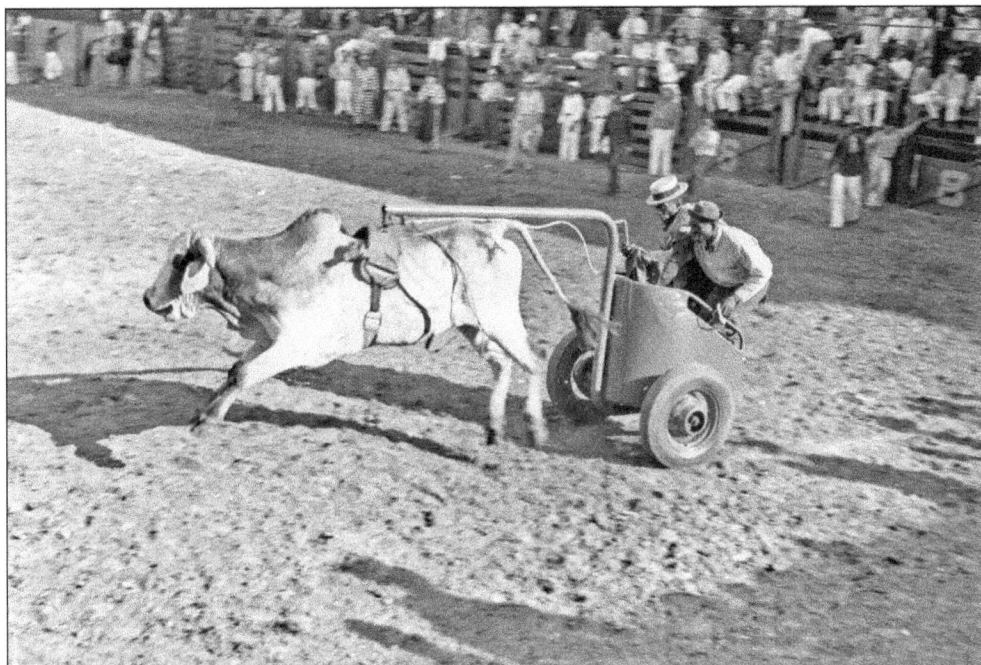

No rodeo would be complete without those famous rodeo clowns. (Courtesy Huntsville Arts Commission.)

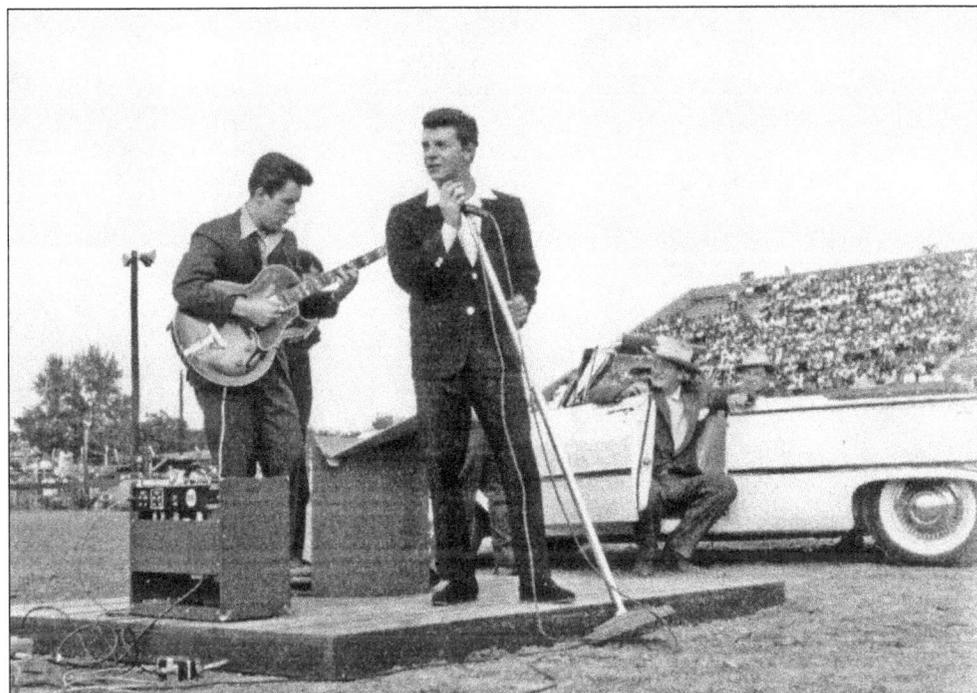

Pictured here are Frankie Avalon (at the microphone) and John Wayne (sitting in the open car door), two of the famous celebrities who visited the prison rodeo during its heyday. Others included Eddie Arnold, Johnny Cash, Ernest Tubb, Willie Nelson, Dolly Parton, and George Strait. (Courtesy Texas Prison Museum.)

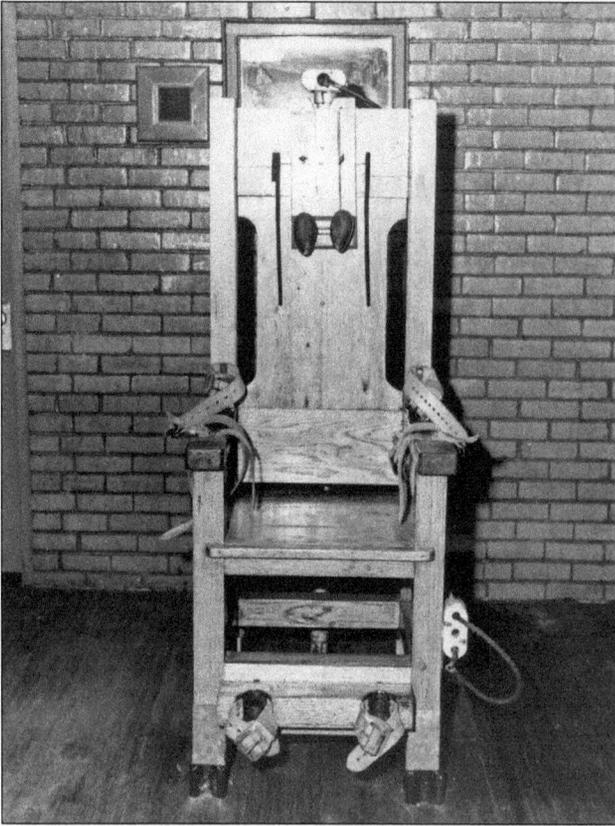

Inmate Belton Harris constructed "Old Sparky," the Texas electric chair, which was used to execute 361 people between 1928 and 1964. Today the chair sits in a small alcove at the Texas Prison Museum, a visible memory of days now past. (Courtesy Texas Prison Museum.)

In 1962, Capt. Joe Byrd, the assistant warden at the Walls Unit, oversaw a massive cleanup project at the prison cemetery. He and his team located over 900 graves and identified the burial places of dozens of prisoners. (Courtesy Texas Prison Museum.)

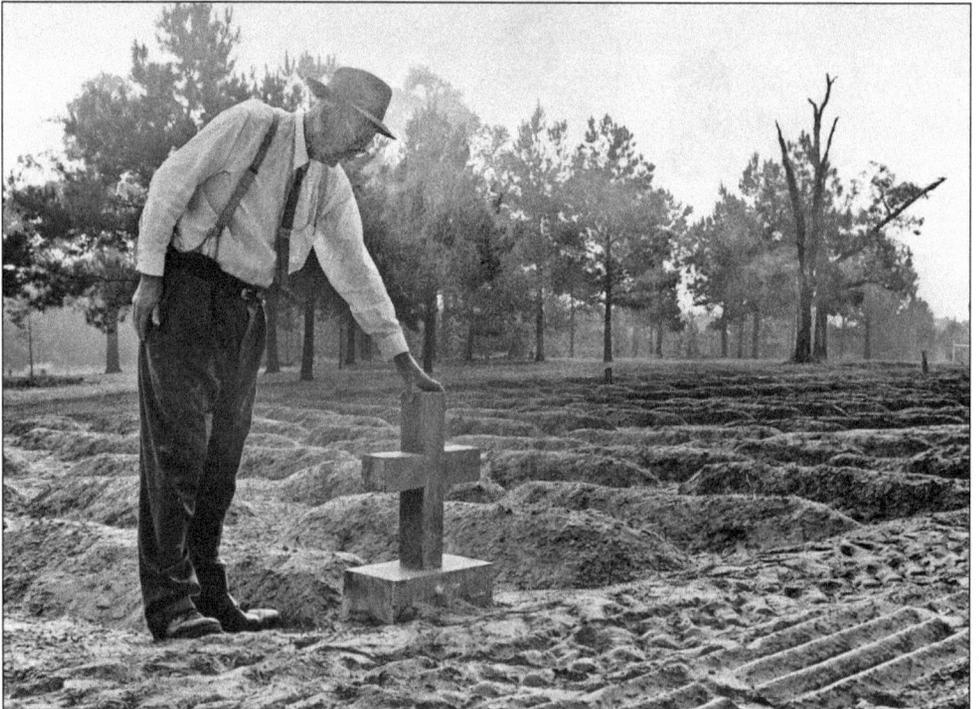

Six

NATIONAL CONNECTIONS

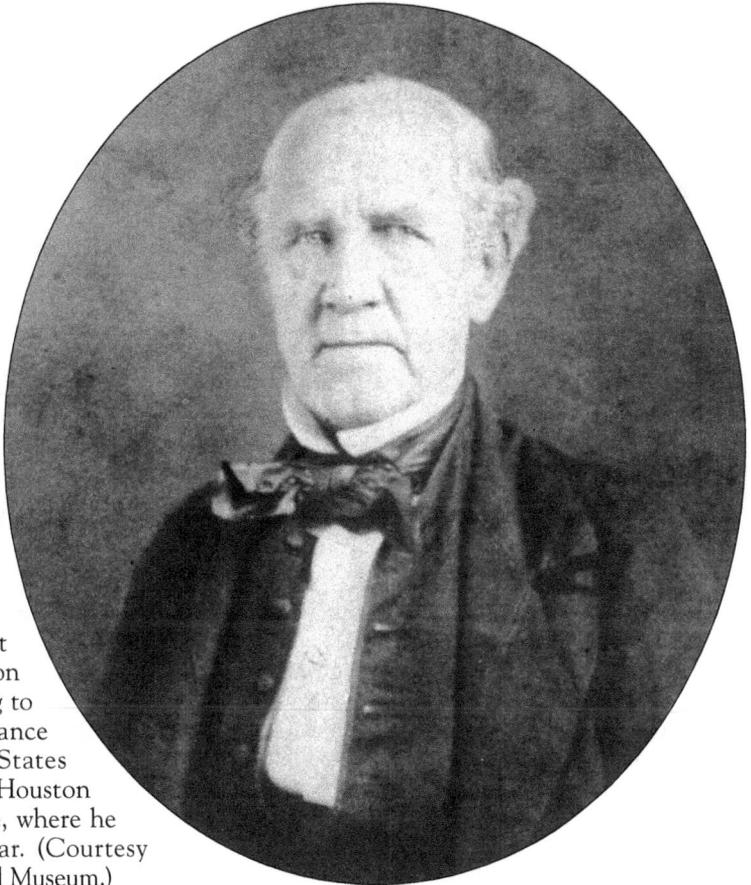

In August 1859, Sam Houston was elected governor of Texas. His inauguration took place on December 21, and Houston served the state until March 16, 1861. At that time, secessionist forces removed Houston from office for refusing to take an oath of allegiance to the Confederate States of America. In 1862, Houston returned to Huntsville, where he died the following year. (Courtesy Sam Houston Memorial Museum.)

GOV. SAM HOUSTON

On the Crisis.

HUNTSVILLE, Nov. 14, 1860.

To GENERAL HOUSTON,

 Dear Sir,—We, the undersigned, feeling a deep interest in regard to the Crisis which now impends over the country, and we fear threatens our liberty, property and prosperity, are desirous of having your opinion in regard to the best course to pursue in this important period in our history. We fear too hasty action may prove deleterious, and to prolong too much an expression of opinion may prove fatal to our best interests. Let us hear from you at your very earliest convenience.

Respectfully, &c.,

H. M. Watkins,	J. H. Whitehead,	W. H. Randolph,	Jesse A. Robinson,
P. W. Kettrell,	M. M. Singletory,	Jeremiah Randolph,	John W. Cary,
Sandford Gibbs,	W. T. Robinson,	John Randolph,	Thomas Aikin,
Robert P. Archer,	George Fearhake,	Epp L. Hallmark,	Thomas Carothers,
James L. Smither,	J. S. Wooton,	Isaac A. Carothers,	J. T. Simms,
G. M. Baker,	W. A. Rawlings,	Sam Y. Smith,	John R. Robertson,
Gus Wynne,	H. C. Oliphant,	J. W. Alexander,	Theo. W. Markham,
Wm. E. Archer,	A. H. Mason,	B. W. Walker,	S. A. Moore,
George R. Luff,	Arthur Eastham,	D. C. Smith,	P. H. Fullenwider,
L. B. Hightower,	Silas Morgan,	W. D. Wynne,	J. P. Harris,
W. F. Spivey,	Byrd Eastham,	C. S. Prescott,	Jo. Priestley,
S. E. Kulan,	W. H. Brooks,	Robt. L. Garcey,	J. C. Kenneymore,
Jas. A. Baker,	M. C. Rogers,	Wm. Viser,	B. Carington,
J. C. Hopkins,	Thomas Seargent,	L. O. Black,	P. M. Woodall,
F. Gibbs,	Ben. W. Robinson,	Levi B. Hatch,	J. T. Menshew,
Benton Randolph,	Wm. Robinson,	Geo. W. Grant,	A. M. Butler.

A letter from the residents of Huntsville was sent to Gov. Sam Houston regarding the election of Abraham Lincoln in November 1860. Sam Houston responded to this letter on November 28, writing, "I need not assure you that whenever the time shall come, when we must choose between a loss of our Constitutional rights and revolution, I shall choose the latter; but if I, who have led the people of Texas in stormy times of danger, hesitate to plunge into revolution now, it is not because I am ready to submit to Black Republican rule, but because I regard the Constitution of my country, and am determined to stand by it. Mr. Lincoln has been constitutionally elected and, much as I deprecate his success, no alternative is left me but to yield to the Constitution. The moment that instrument is violated by him, I will be foremost in demanding redress and the last to abandon my ground." (Courtesy Sam Houston Memorial Museum.)

Fighting for the Confederate army at Shiloh, Sam Houston Jr. (1843–1894) was wounded and taken prisoner. After the Civil War, he pursued medical studies at the University of Pennsylvania. He died in Independence, Texas, and is buried there in the City Cemetery. (Courtesy Sam Houston Memorial Museum.)

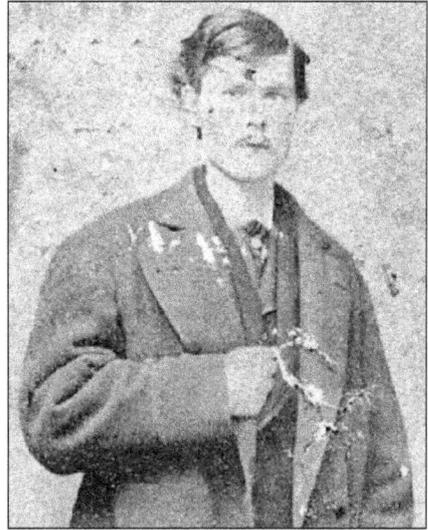

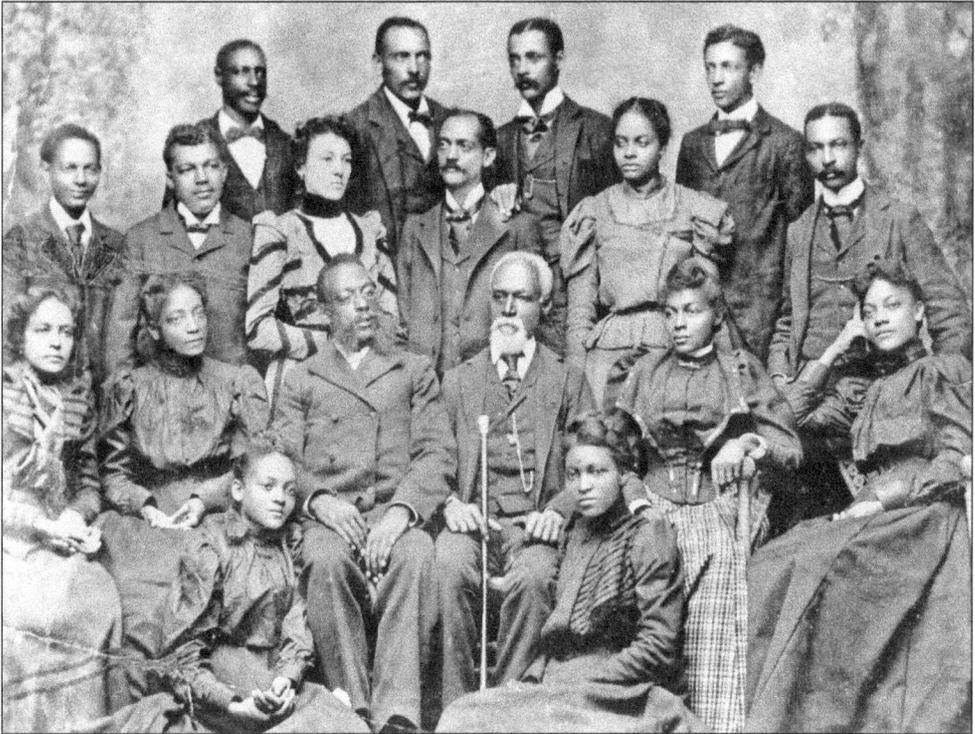

After the Civil War, Joshua Houston served as one of nine black delegates to the Republican National Convention in Fort Worth (1888). His descendants became leading figures in Walker County and the surrounding area. Pictured here is the Houston family in October 1898 at the wedding of Joshua Houston Jr. and Georgia Carlina Orviss. From left to right are (first row) Viola Wilson and Minnie Houston; (second row) Cornelia Orviss, Cadolie Wilson, Rev. ? Brooks, Joshua Houston Sr., Ellen Houston, and Ida Wilson; (third row) Clarence Wilson, Joshua Houston Jr., Georgia Carolina Orviss, George Wilson, unidentified, and Samuel Walker Houston; (fourth row) Lawrence Wilson, John Wilson, Israel Wilson, and Wesley (C. W.) Wilson. (Courtesy Sam Houston Memorial Museum.)

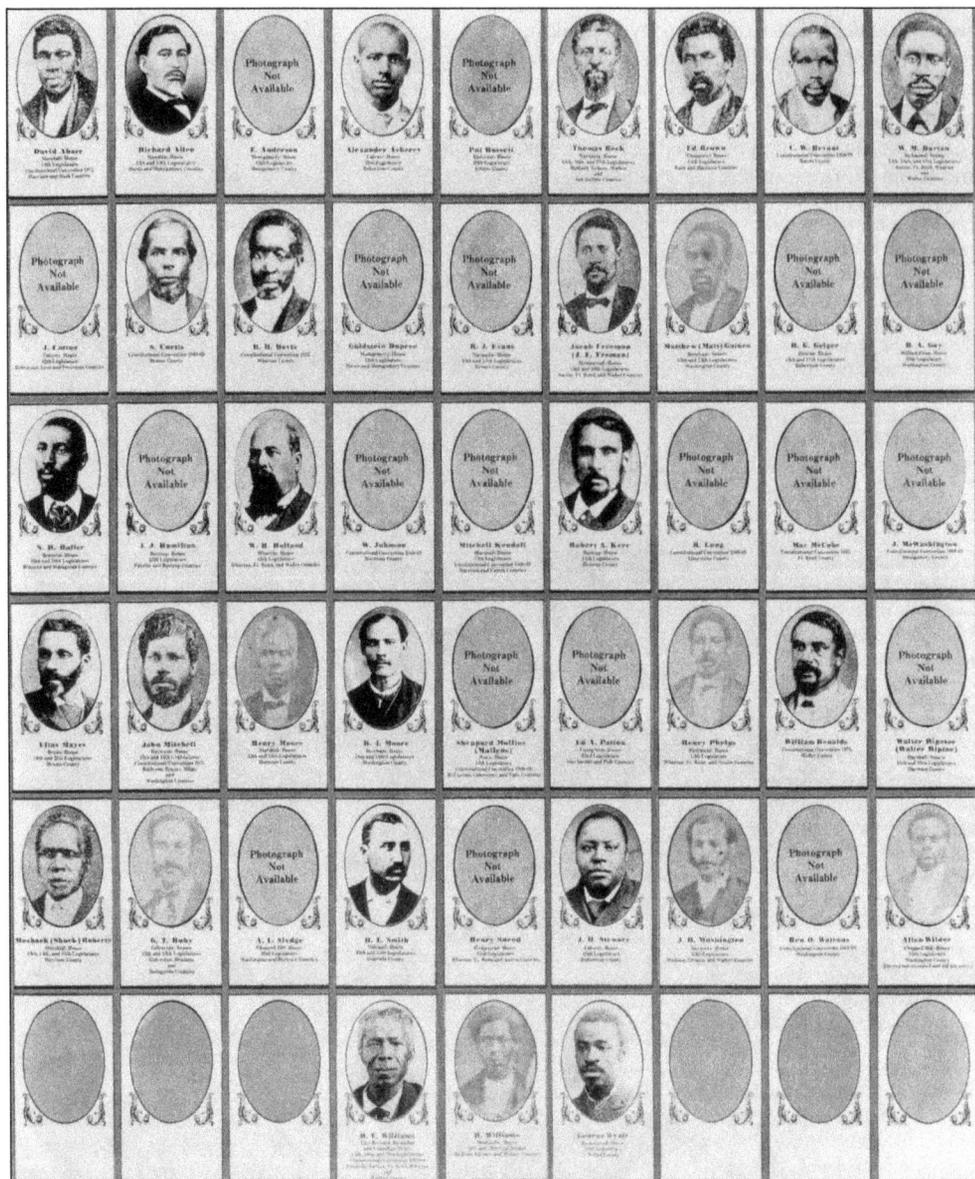

Pictured here are the African American politicians who sat in the Texas Legislature during Reconstruction (1865–1877). Two of these men are of particular interest for Huntsvillians. The first, Richard Williams (sixth row, fifth column), was a former slave who lived in Huntsville. He represented Madison, Grimes, and Walker Counties in both the 12th and 13th Legislatures. The second, James H. Washington (fifth row, seventh column), lived in Navasota and represented Madison, Grimes, and Walker Counties in the 13th Legislature. (Courtesy Institute of Texan Cultures, San Antonio.)

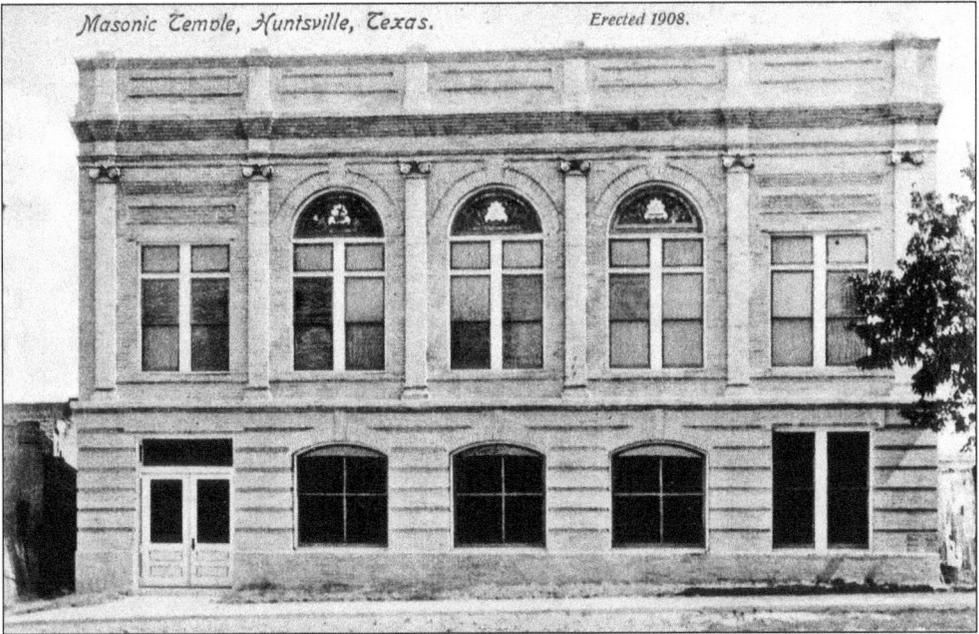

Masonic Temple, Huntsville, Texas.　Erected 1908.

Forrest Lodge No. 19 is the eighth oldest Masonic Lodge in Texas. Founded in 1844, its early members included Sam Houston and historian Henderson Yoakum. Another important member was William Martin Taylor (1817–1871), who published a handbook that brought order to Masonic rituals in Texas. This lodge building was constructed in 1908. (Courtesy Huntsville Arts Commission.)

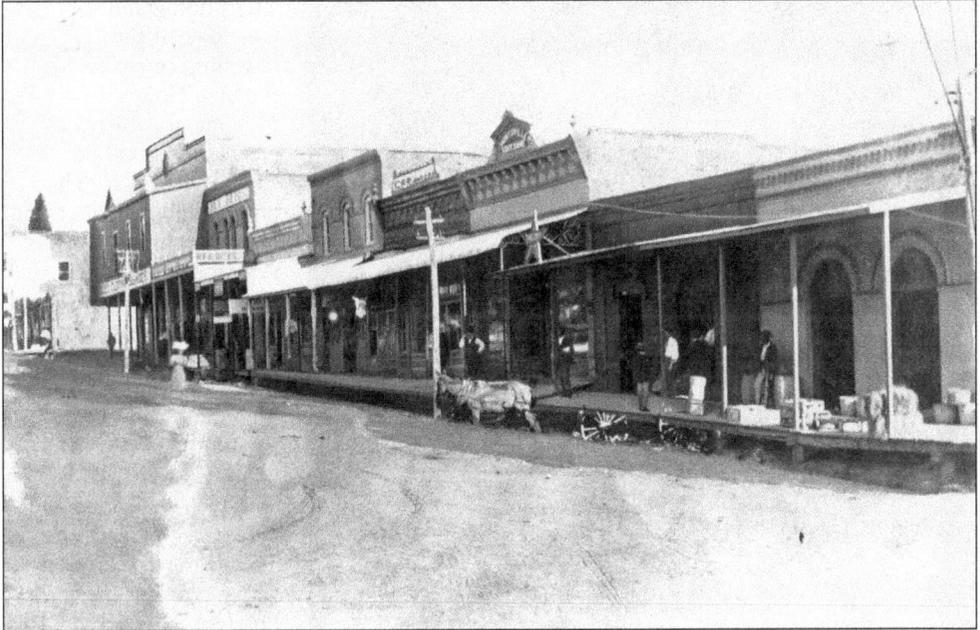

The Henry Opera House (last building at the top of the block) was constructed in 1880 as a lodge hall. It was initially used as a dry-goods and grocery store, but the second story was converted to a theater by owner John Henry (1828–1897). The opera house hosted traveling musicians, theatrical acts, magicians, and other performers. It was here that the first motion picture in the city was shown around 1909. (Courtesy Huntsville Arts Commission.)

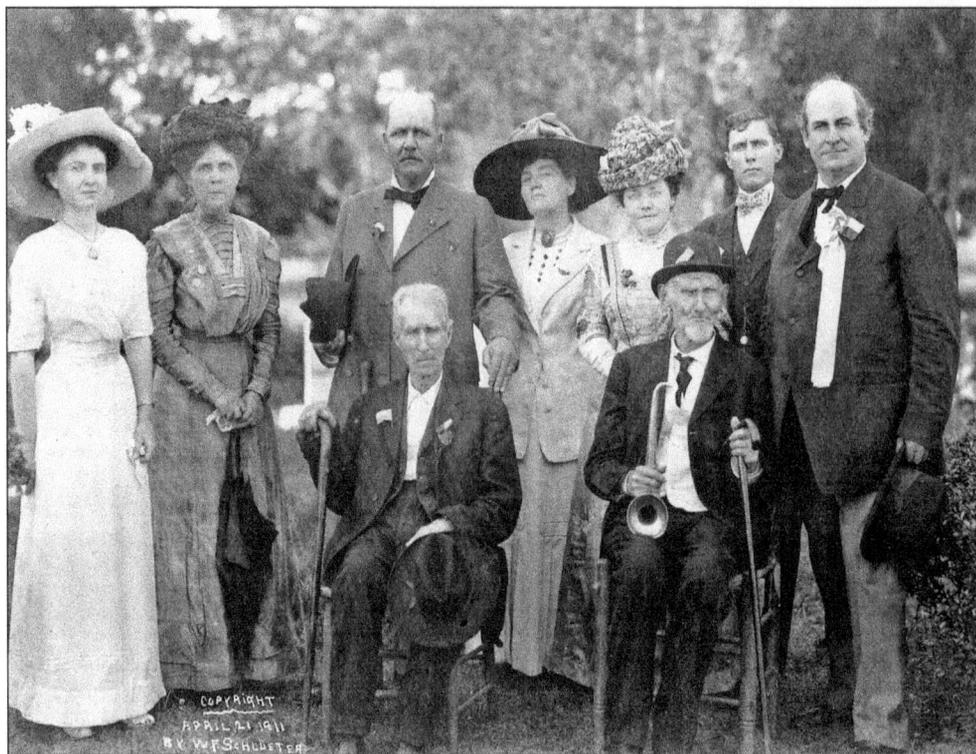

This photograph was taken at the unveiling ceremony for the Sam Houston Monument, which was erected in Oakwood Cemetery in 1911. The photograph includes three Houston children, two veterans of the Battle of San Jacinto, and William Jennings Bryan (far right). (Courtesy Sam Houston Memorial Museum.)

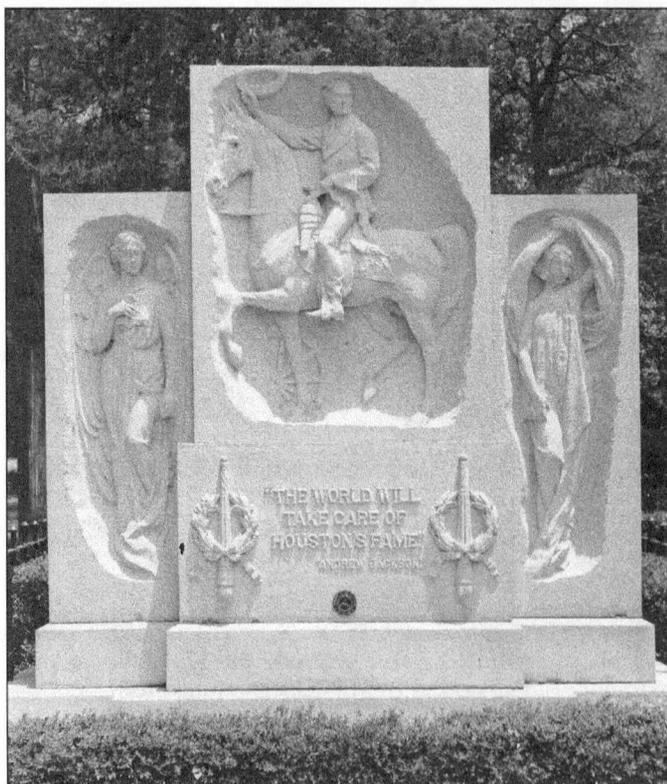

Pictured here is the Sam Houston Monument at Oakwood Cemetery. The shrine is embossed with a quote from Pres. Andrew Jackson, which reads, "The World Will Take Care of Houston's Fame." (Courtesy Sam Houston Memorial Museum.)

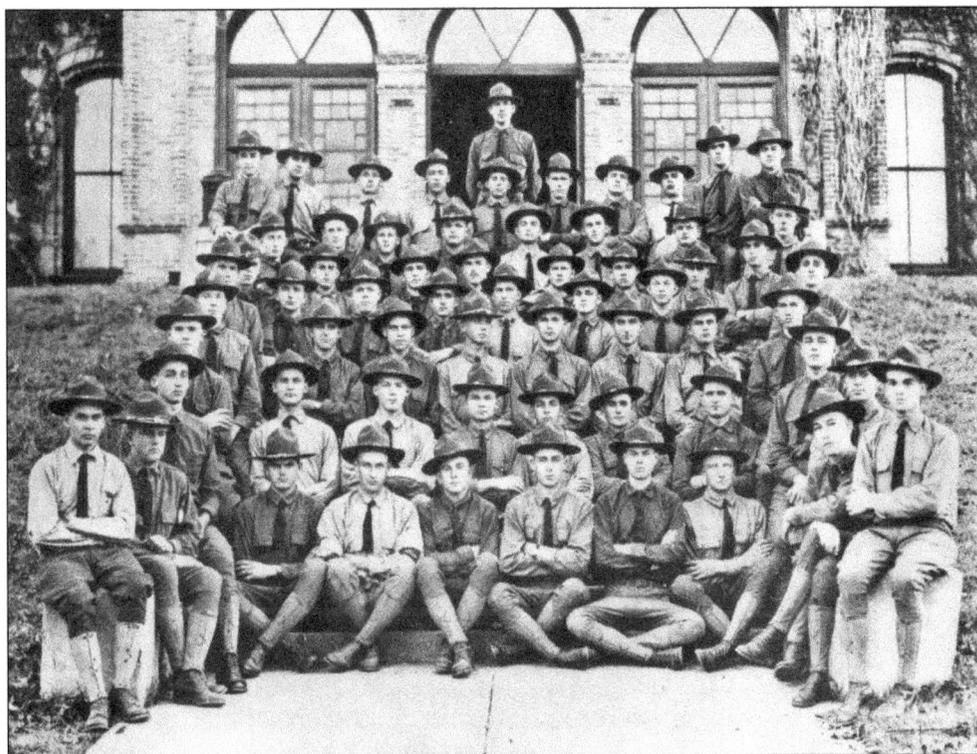

Here is a group of World War I soldiers pictured on the steps of Old Main around 1917. (Courtesy Walker County Historical Commission.)

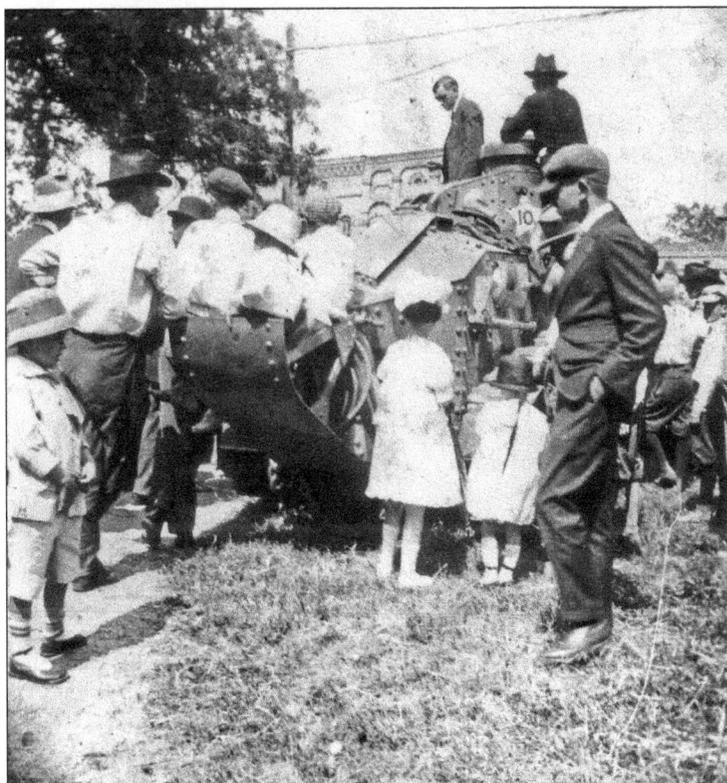

Pictured here is a World War I–era tank, which is being displayed on the Walker County Courthouse lawn. (Courtesy Huntsville Arts Commission.)

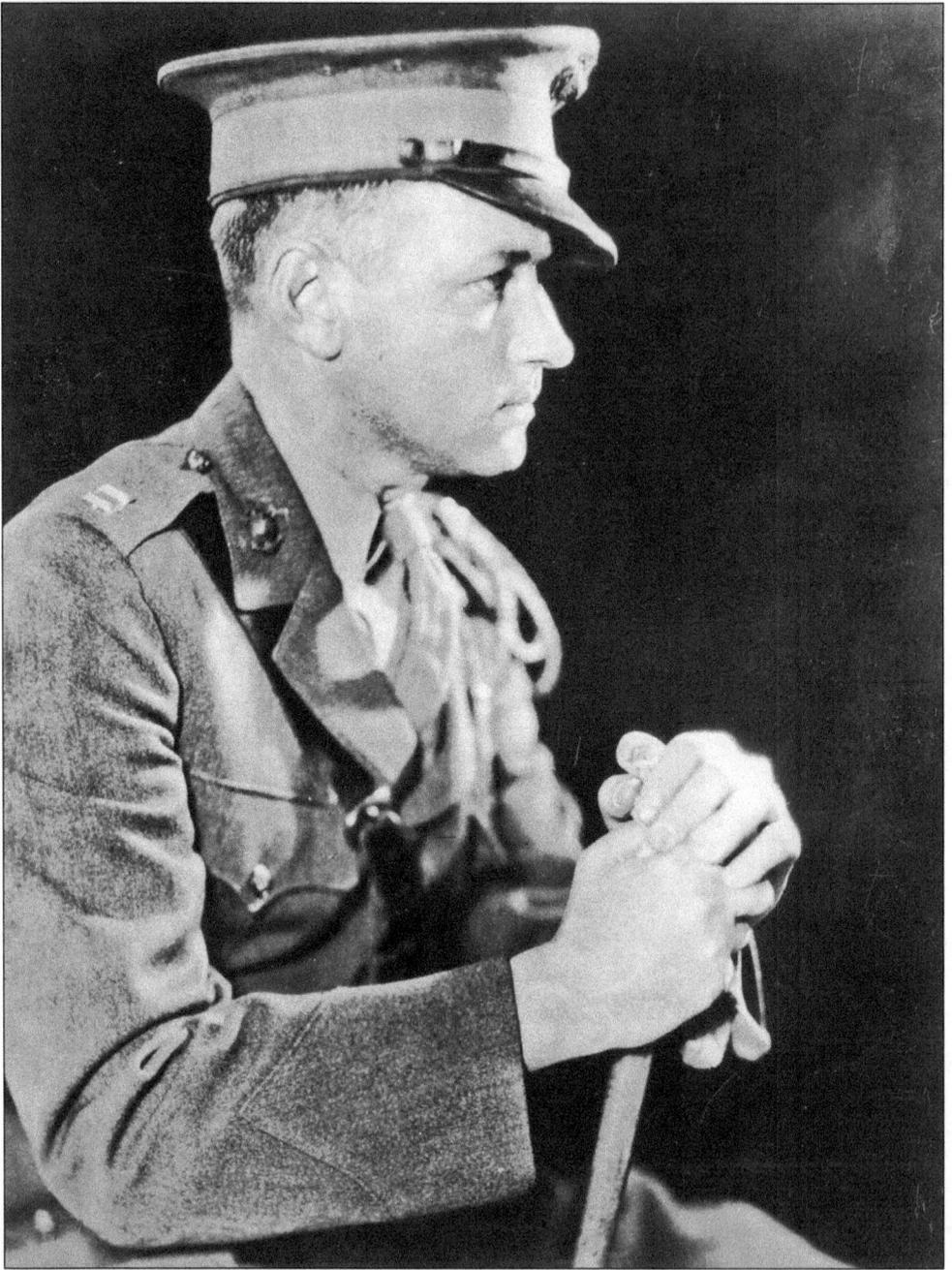

John W. Thomason Jr. (1893–1944) was a true Renaissance man. An author, artist, and U.S. Marine Corps officer, he was born in Huntsville and attended numerous colleges, including Sam Houston Normal Institute, the University of Texas, and the Army and Navy War colleges. After a brief stint in education, he joined the U.S. Marine Corps in 1917. Thomason served in both World War I and World War II. In addition, he published dozens of articles and popular books, including *Fix Bayonets* (1926) and *Gone to Texas* (1937). Thomason was awarded the Silver Star, the Navy Cross, and the Air Medal, among other military honors. He is buried in Oakwood Cemetery. (Courtesy Sam Houston State University Archives.)

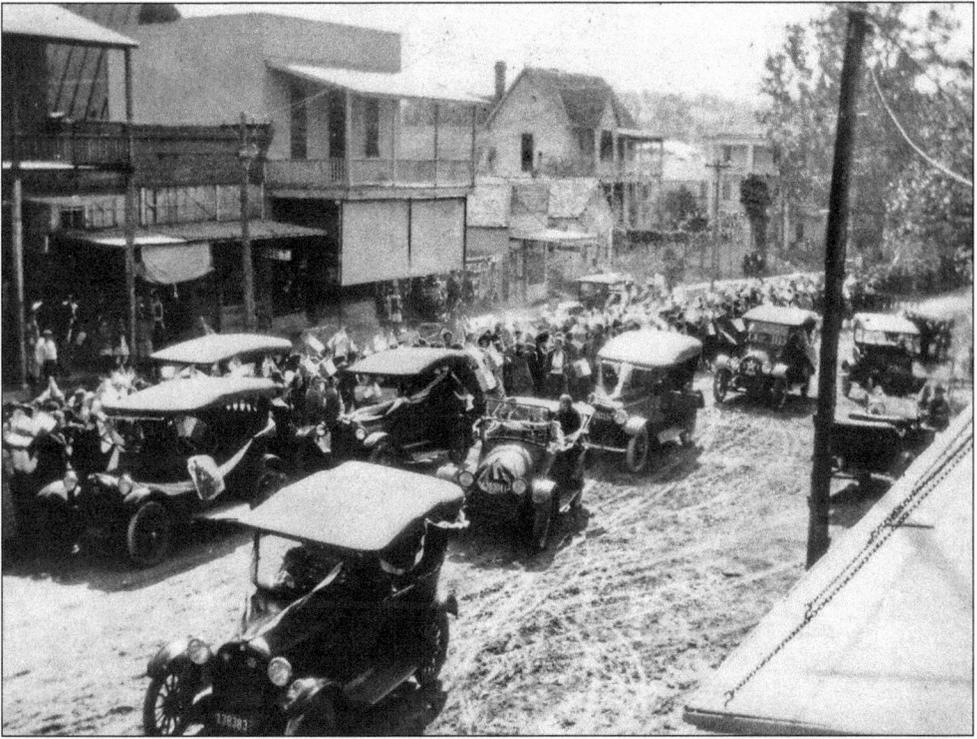

Although little definitive information about this photograph exists, it appears to be a women's suffrage march in 1917–1918. (Courtesy Huntsville Arts Commission.)

Born in New Waverly, Minnie Fisher Cunningham (1882–1964) was a leading figure in the women's suffrage movement. She cut her political teeth in Huntsville and briefly worked in the city as a pharmacist before moving to Galveston. In 1915, Cunningham was elected to serve as president of the Texas Equal Suffrage Association, and two years later, she initiated a campaign that opened state primary elections to women. Later Cunningham lobbied Congress to pass the 19th Amendment and helped organize the National League of Women Voters—becoming its executive secretary. (Courtesy Walker County Historical Commission.)

This historic photograph shows a float designed by the Daughters of the American Revolution around 1925. (Courtesy Huntsville Arts Commission.)

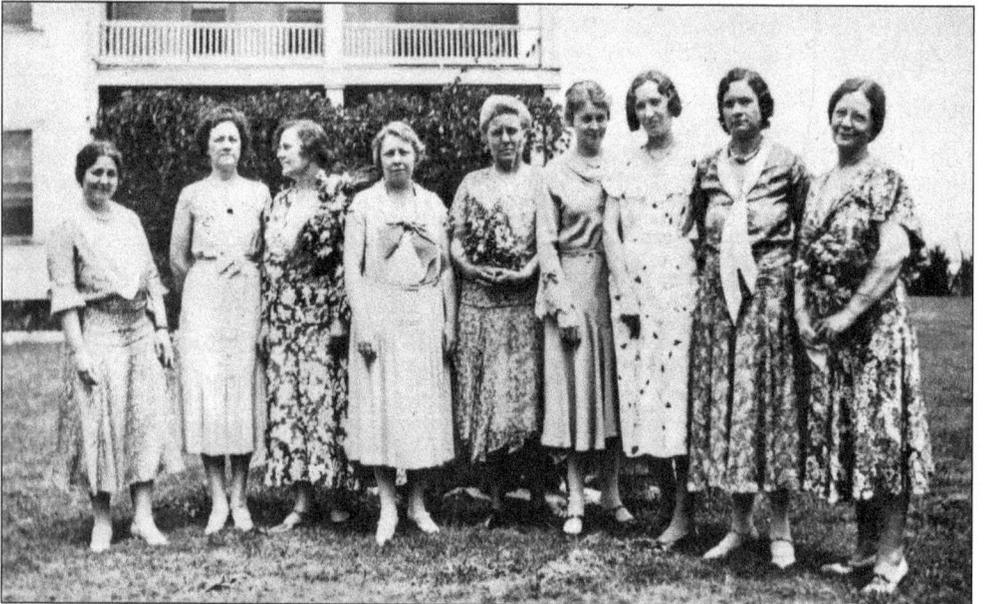

In 1929, women's groups around the country formed Delphian societies, named for the patron god of music and the arts. The societies encouraged women to play a role in the civic and arts communities in their local cities. (Courtesy Huntsville Arts Commission.)

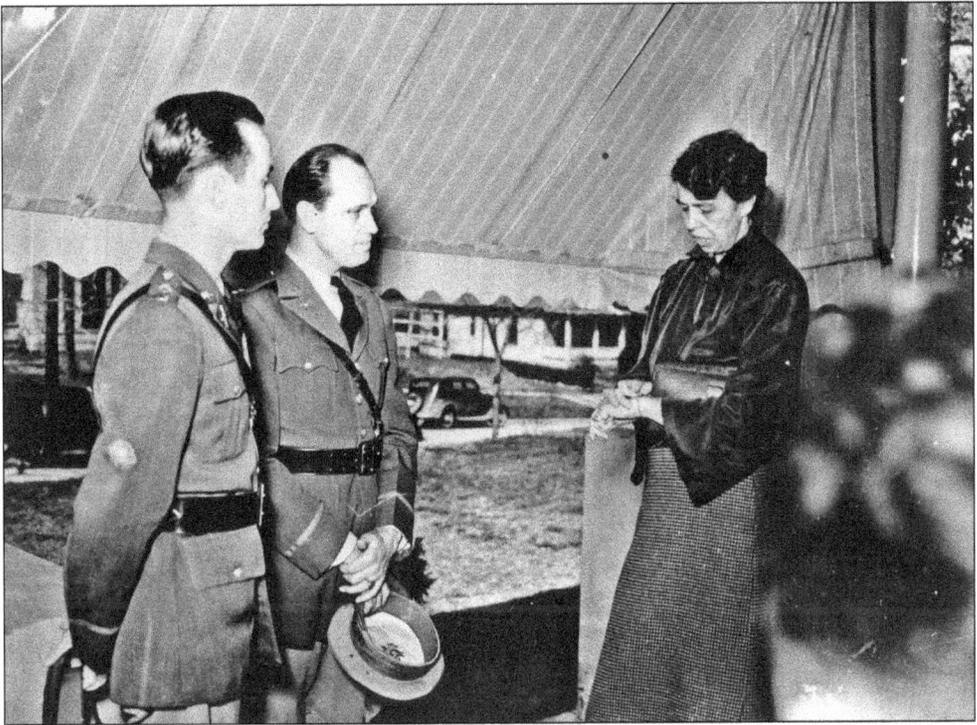

Taken in early 1937, this photograph shows First Lady Eleanor Roosevelt with K. K. Black (left) and Capt. Van B. Houston (center), the commander of Civilian Conservation Corps Company 1823. Known as the "Park Builders," Company 1823 was made up of a group of African American World War I veterans who built Palmetto Park, Huntsville State Park, Longhorn Caverns State Park, Kerr-Shreiner State Park, and Abilene State Park. (Courtesy Huntsville Arts Commission.)

Here is a rare photograph of the Civilian Conservation Corps camp that was established outside Huntsville. (Courtesy Bob Shadle.)

Robert A. Josey, a Huntsville native and Houston businessman, donated land for the Josey Boy Scout Lodge to be constructed in the mid-1930s. This building was built as part of a Works Progress Administration (WPA) project. (Courtesy the author's collection.)

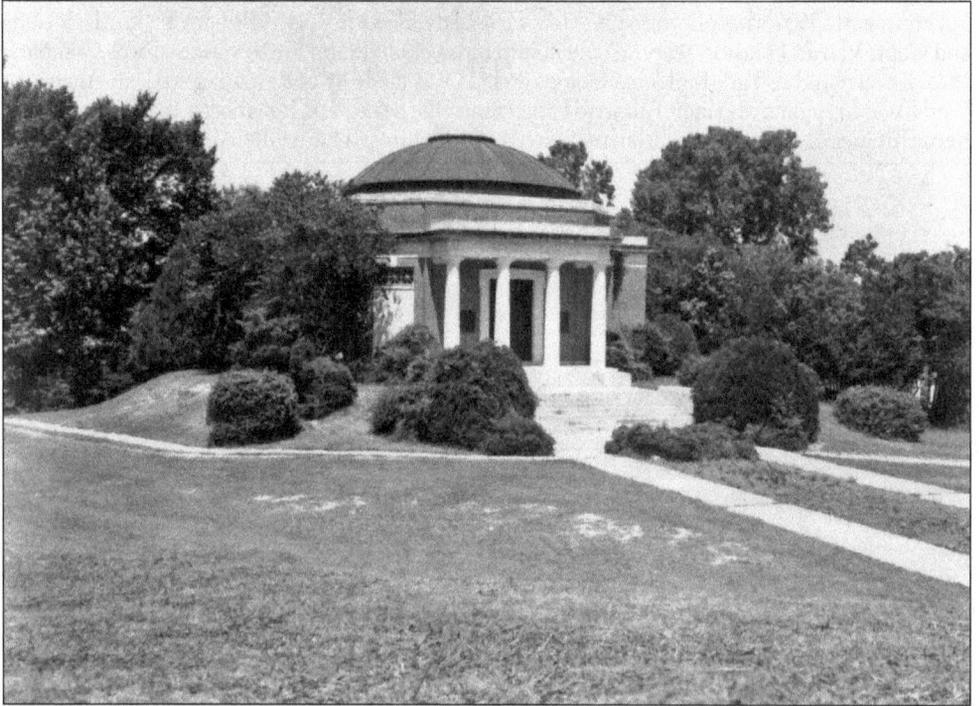

The Sam Houston Memorial Museum was built in 1936–1937 to coincide with the Texas centennial celebration. Dedicated to the memory of Gen. Sam Houston, the structure sits on an 18-acre site and remains the headquarters of the Sam Houston Memorial Complex. (Courtesy Sam Houston Memorial Museum.)

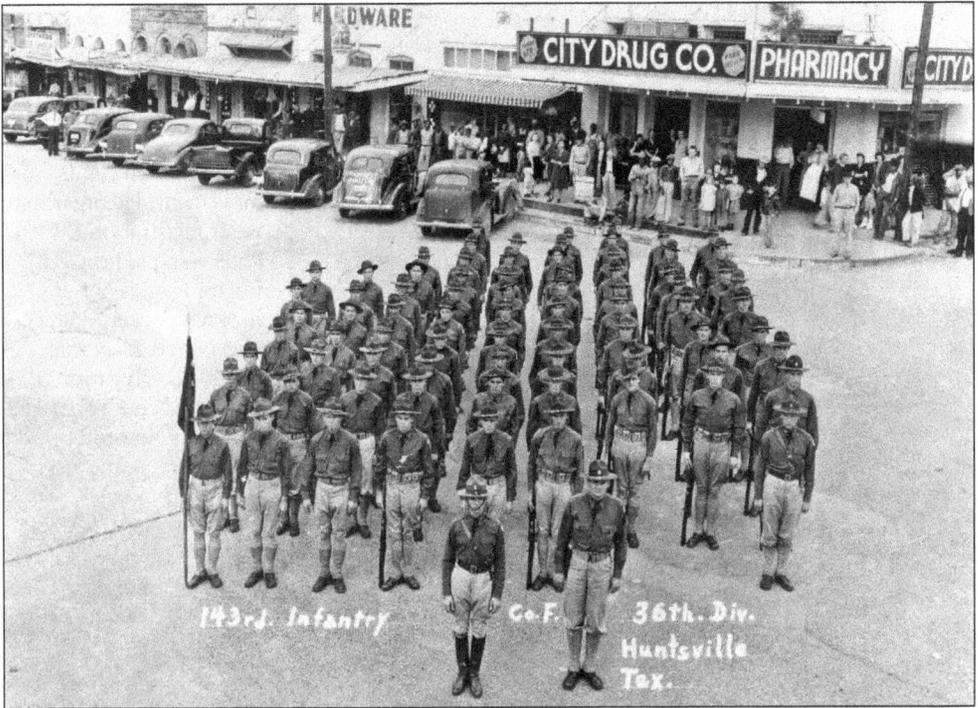

Pictured here is the 143rd Infantry, Company F, 36th Division, on the east side of the Huntsville square. (Courtesy Huntsville Arts Commission.)

Camp Huntsville was the first prisoner of war camp constructed in Texas during World War II. Completed in September 1942, the camp housed over 4,000 German prisoners at its height and was the only camp in the United States to offer a Japanese Re-education Program. (Courtesy Sam Houston State University Archives.)

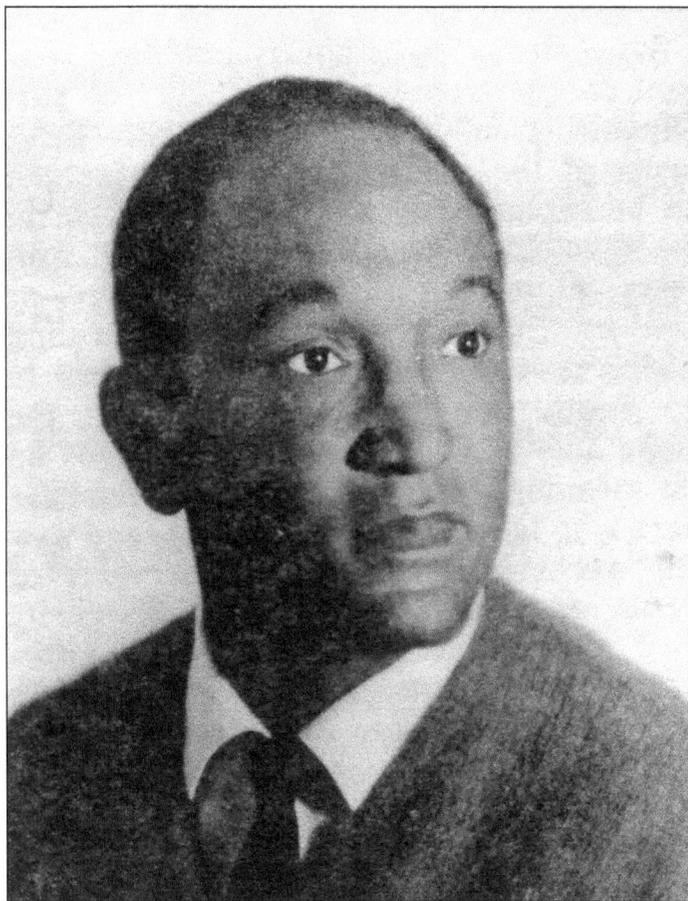

Following his service in World War II, Wendell Baker returned to Huntsville and became a leading figure in the local civil rights movement. He organized voter registration drives and often paid the poll tax for friends out of his own pocket. Baker also played a key role in the desegregation of the local school district and Sam Houston State University. (Courtesy Wendell Baker.)

The Texas Observer

AUGUST 6, 1965

A Journal of Free Voices A Window to The South 25c

'Hey-You' in Huntsville

Novel Tactics in the Campaign Against the Southern Caste System--A Participant's Report on Militant Negroes Winning Integration and Whites Going to Jail in Support of Them

Desegregation proceeded slowly in Huntsville, and local African American young people protested the delay. In the summer of 1965, led by Gerald Davison, Andy Polk, Robert Jones, and Larry Massey, young activists formed HA-YOU (Huntsville Action for Youth). This organization pursued a successful direct action campaign to desegregate local restaurants and movie theaters. (Courtesy the author's collection.)

126

In 1966, Scott Johnson (far right) was elected as the first African American city councilman since Reconstruction. Johnson was a longtime educator, and today Scott Johnson Elementary school is named in honor of him. (Courtesy Huntsville Arts Commission.)

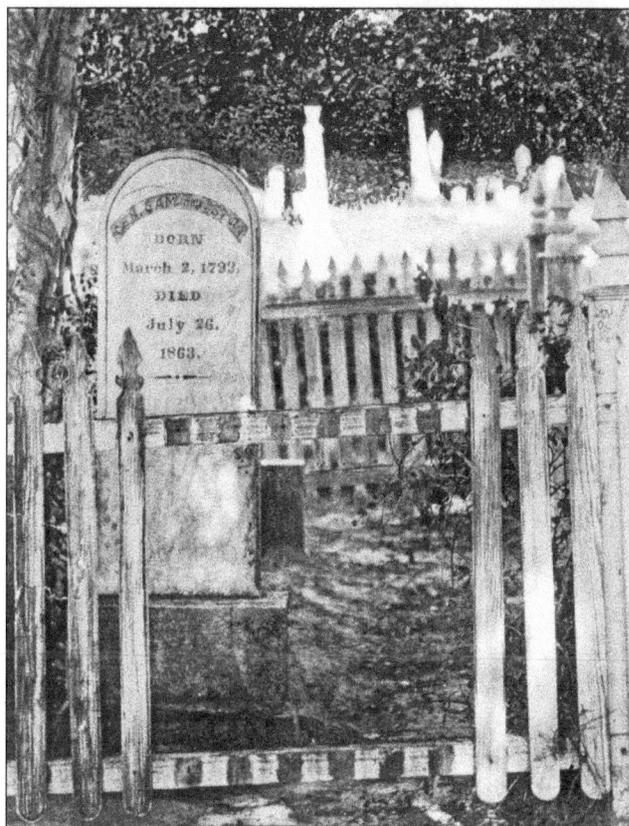

This is the first tombstone of Sam Houston, a man who said, "The benefits of education and of useful knowledge, generally diffused through a community, are essential to the preservation of a free government." (Courtesy Huntsville Arts Commission.)

Visit us at
arcadiapublishing.com

www.ingramcontent.com/pod-product-compliance
Lightning Source LLC
Chambersburg PA
CBHW050636110426

42813CB00007B/1826